Islamic Carpets
from the Joseph V McMullan Collection

Hayward Gallery London 19 October – 10 December 1972

Arts Council of Great Britain

Contents

Exhibition devised and installed by David Sylvester

© Arts Council 1972

Typography by Graham Johnson/Lund Humphries
Colour plates printed by F. Bruckmann KG, Munich, Germany
Cover and text pages printed by Lund Humphries, London & Bradford

Foreword

This is the first large-scale exhibition of early Islamic carpets held in this country since the legendary exhibition of Persian Art at the Royal Academy in 1931.

It is drawn from a single American collection, by common consent the finest private collection formed during the last half century. Because it is a collection that expresses a personal vision, we thought it appropriate that Mr. McMullan should introduce it to the public here through his own catalogue entries.

The collection is now one only in name, as most of it has already been dispersed in gifts to museums. We are thus deeply indebted, not only to Mr. McMullan himself for his enthusiastic and generous co-operation, but also to those museums to which most of the exhibits now belong: the Metropolitan Museum of Art, New York, the Textile Museum, Washington, the Fogg Art Museum, Cambridge, Massachusetts, the Art Institute of Chicago and the Victoria and Albert Museum. We owe particular thanks to the Metropolitan Museum, the owners of two thirds of the exhibits, for postponing the opening of their re-arranged Islamic galleries so that our exhibition could be held.

Dr. May Beattie has helped us greatly with expert advice on matters about which we have consulted her. We owe similar thanks to Dr. Ralph Pinder Wilson, Deputy Keeper in the Department of Oriental Antiquities in the British Museum.

We are also most grateful for valuable advice from members of the trade: Mr. C. John and Mr. David Franses of London and Mr. B. C. Holland of Chicago.

For assistance or information we should like to thank Mr. Virgil Bird of New York, Professor John Shapley of Washington, Mr. Michael Darby, Mr. Andrew Forge, Miss Margaret Wright, and the Textile Department of the Victoria and Albert Museum.

Robin Campbell
Director of Art

Norbert Lynton
Director of Exhibitions

On Western attitudes to Eastern carpets

David Sylvester

The presence of Eastern carpets in pictures by Giotto, Simone Martini, Fra Angelico, Van Eyck, Memlinc, Piero, Mantegna, Crivelli, Carpaccio, Bellini, Lotto, Holbein, Pontormo, Tintoretto, Veronese, Rubens, Van Dyck, Zurbaran, Velazquez, Terborch, Vermeer, De Hooch, Reynolds and Copley and also Matisse testifies to the strength of their allure for Western eyes. Delacroix, surprisingly, doesn't qualify, but did say that the most beautiful pictures he had seen were certain Persian carpets. The carpets in paintings reflect their usefulness to paintings and their ubiquity for centuries in European houses, palaces and churches, on floors, steps, tables, walls. Americans were importing them by the 18th century: there is a portrait of George Washington posed on an Ushak as there is of Henry VIII.

Scholarly collecting – collecting governed by a sense of history – entered the field in the 1870s. Till then, however cherished carpets may have been, little was known about their origins. In the 17th and 18th centuries they were called Turkey carpets regardless of whether they came from Turkey or Persia; in the 19th, they were all called Persian. But, of course, scholarly collecting, while beginning in the 16th century (with Vasari and Paolo Giovio, the resuscitator of the word 'museum'), was slow to enlarge its scope from its initial concerns with the Renaissance tradition and relevant aspects of classical antiquity. It started to embrace Islamic carpets at a time when it was rapidly becoming all-embracing – the time of the foundation of numerous museums or museum departments dealing with artefacts hitherto considered infra dig. This expansion, which began about the middle of the century, was twofold, relating on the one hand to media, on the other to cultures. The acceptable media now covered the whole range of 'applied' arts; the acceptable cultures came to include those of the Dark Ages, the Stone Ages, and other exotic and barbarous societies.

Islamic carpets were admitted, therefore, both for being carpets and for being Islamic. Islamic artefacts generally – miniatures as well as pottery and metalwork and so forth – were coming to be collected as works of art, rather than curiosities (as they had been by Sloane) or documents (as by Blacas), in the 40s and 50s. The carpets, however, were in a special case, being so familiar as household furnishings, articles bought as adornments and tokens of prosperity but also things on which the cat sat. And their popularity here was doing them no good. Although they had in any event passed their peak at least 250 years earlier and some areas of production had long been turning out degenerate work, there were other areas which maintained high standards until the mid-19th century, when a general rapid acceleration in the decline was brought about by Western interference. In the 60s Western merchants got a firm foothold in the organisation of the industry which enabled them to specify or even provide the designs to be followed by village weavers, even to supply their materials, so that the market abroad increasingly dictated what patterns and colours were used and not used. Now, some of the carpets exported from Asia Minor were made to European specifications as far back as the 16th century. If at first this caused no harm, it may have been because the indigenous tradition was more potent then, may have been because the European market had better taste then. In the mid-19th century, moreover, the West also succeeded in corrupting the industry on the technological side, by intro-

ducing the synthetic dyes first created in the 50s: Mrs Beattie goes into this, 'the greatest disaster which ever befell the Oriental rug'.

At this very moment, as so often happens, the West started applying its scholarly facilities and skills to the recovery and study of the golden age of the culture it was working to destroy. Research, then, was focused on carpets made before 1700: since these, the great carpets, were also the least widely known, the point had to be made that the familiar kinds were negligible beside their forebears and were not to be taken as representative of the line. Museum activities, on the other hand, were in some cases less exclusive. When the K.K.Österreichisches Museum in Vienna staged the first-ever major exhibition of oriental carpets, in 1891, the catalogue listed some 130 pieces ascribed to an early date and nearly 300 modern ones. Again, the great collection built up at South Kensington in the last quarter of the century was, in terms of numbers, predominantly modern. It was initiated in 1876 with the purchase of seven 19th-century pieces, three Persian, four Turkman. The following year the Shah of Persia donated eight rugs almost fresh from the looms. Purchasing continued steadily. In a memo dated 31st July 1880, the then Assistant Director, Caspar Purdon Clarke, noted: 'The remarkable loan collection of antique oriental carpets in the Trocadéro Gallery of the Paris Exhibition of 1878 first presented these objects to public notice, and it was then discovered that a high class branch of fine art production had hitherto been utterly ignored by Museum administration although well known to amateurs and commanding prices on a level with the most valued productions of the middle ages.'[1] But it was not until 1883 that the Museum first acquired a piece made before 1700, by which time it already possessed nearly 70 modern examples (almost half of them Caucasian). At the turn of the century its holdings comprised some 60 early carpets or fragments and about 180 late ones.[2]

The broadening of the purposes and scope of the museums resulted from new ideas about priorities in art itself. The prevailing trend was, of course, the growing recognition of the potency of abstract shape and colour. This made for an increasing subordination of concern with subject-matter to concern with form which led inevitably to an insistence that a fresco of the Crucifixion, a Chinese vase, a statue of Venus, or one of Osiris, an Islamic carpet and eventually an African mask be seen in the same light. Allegiance to one's own civilization is largely an allegiance to its iconography: once iconography is irrelevant, all civilizations are equal. Open-mindedness was the passive aspect of the new aestheticism. The active aspect was the search for exemplary types of abstract design, and the search inevitably turned its back on the main European tradition, with its long commitment to the anthropomorphic, and looked to cultures specializing in ornament – the Celtic, the Mycenaean, the Islamic.

Within the general tendency to look away from Europe for something different, there was the growing search for art that seemed to embody the virtues of the noble savage. Till now, admiration for the primitive in art had really been either (as with 'Les Barbus') a nostalgia for the origins of our own civilization or (as with Captain Cook) a wonderment that naked savages could make things which were beautiful by our standards. The first intimation of the idea that we might do well to try and make things which were beautiful by their standards probably occurs in 1856 in *The Grammar of Ornament*, where Owen Jones devotes the first three plates to

artefacts of 'Savage Tribes', demonstrates how they are models of aesthetic soph-istication, and declares that 'we must even be as little children or as savages; we must get rid of the acquired and artificial, and return to and develop natural instincts'.[3] In 1882, when Gauguin and Van Gogh had not long been having similar thoughts, Vincent Robinson, in a pioneering book on Eastern carpets, was inspired by a nomadic rug from West Kurdistan to say: 'It is a matter for reflection that many of the carpets which are found to add to the dignity and beauty of the palaces of Europe, were made by people whose primitive habits of life were at variance with those of civilized nations, and who needed no schools of art, nor expensive educational processes, to stimulate their imagination and direct their art instincts'.[4] Despite the note of condescension that harks back to an earlier period (and perhaps a note of sarcasm at the expense of the National Art Training School), enough is said to show that the rising curiosity about Oriental weavings could relate to the glamour of camels and tents as well as that of stately domes and glossy tiles.

But the Islamic carpet had an especial relevance to the moods of the time that made it much more than one among many appealing exotic phenomena. When Western painting was becoming concerned as never before with being coloured shapes arranged on a flat surface, what better precedent and example could it look to? That, of course, was what Delacroix was driving at. His remark was reported by Maxime Du Camp in 1883 when treating of his use of 'abstract colour' and 'colour for colour's sake'. Du Camp tells how, one evening, he saw Delacroix getting some extraordinary colour-effects by playing with some skeins of wool that happened to be there, putting them together, intertwining them, separating them out, then recalls his saying 'The most beautiful pictures I have seen are certain Persian carpets', and adds a word of doubt as to whether this was meant to be taken literally.[5] Whether it was or not is unimportant. What matters is that Dela-croix, when choosing to make a provocative remark about the autonomy of colour, singled out the Persian – or 'Persian' – carpet as the paragon of abstract colour. And it seems likely that by the 1880s this allusion was a common usage among artists, given the way Gauguin phrases his description of the self-portrait he painted for Van Gogh: 'The drawing is altogether peculiar, being complete abstraction. The eyes, the mouth, the nose are like the flowers of a Persian carpet, thus personifying the symbolic side.'[6] Between Delacroix's time and Gauguin's falls the crystalliza-tion of the drift towards the abstract, 'All art constantly aspires towards the con-dition of music', and, in the passage that builds up towards the gem-like aphorism, Pater writes: 'In its primary aspect a great picture has no more definite message for us than an accidental play of sunlight and shadow for a few moments on the wall or floor: is itself, in truth, a space of such fallen light, caught as the colours are in an Eastern carpet ... '[7] The date of publication was 1877, the year after the South Kensington Museum acquired its first Eastern carpets, the year William Morris got his first momentous sight of an early Eastern carpet, and the year Julius Lessing published the first book on Eastern carpets.

Each of these three events was motivated, not simply by an interest in the car-pets for their own sake, but by a will to improve contemporary design and work-manship. The South Kensington Museum came into being as part of an official

policy for 'the improvement of manufactures', was formed 'to contain fine examples of Ornamental Art, to which access may be had by students and manufacturers for the purpose of examination, study, and copying; and by the Public for general instruction'[8] (meaning mainly the improvement of consumer taste). Again, Morris got involved in Islamic carpets through his own work. He had started designing carpets in the early 1870s for some of the big established factories, was dissatisfied with this arrangement, and longed to set up looms of his own for carpets as for silks and tapestries. In a letter to Thomas Wardle dated 13 April 1877, he talks about his plans for weaving silks (which soon materialized), then goes on: 'The tapestry is a bright dream indeed; but it must wait till I get my carpets going; though I have had it in my head lately, because there is a great sale now on in Paris of some of the finest ever turned out: much too splendid for anybody save the biggest pots to buy. Meantime much may be done in carpets: I saw yesterday a piece of ancient Persian, time of Shāh 'Abbās (our Elizabeth's time) that fairly threw me on my back: I had no idea that such wonders could be done in carpets . . .'[9] Within a year or two, he finally began making hand-knotted rugs, and the often superb pieces he produced during the next decade or so were clearly inspired by early Persian examples. (Photographs of Kelmscott Manor[10] and Kelmscott House[11] show that he collected nomadic and village rugs, including one of the same type as no.118 in this catalogue, as well as Persian pieces such as the early vase carpet belonging to the V. & A. But the others seem to have had no direct influence on his own designs.) The way in which he borrowed from his models did not betray his ambition that his carpets 'should by no means imitate them in design, but show themselves obviously to be the outcome of modern and Western ideas'.[12] The shapes and configurations are abstracted from the Persians; the breadth and simplicity of statement and the colour-range are decidedly 'modern'; the overall feeling is profoundly 'western', often extremely reminiscent of Elizabethan and Jacobean weavings and embroideries. To say that Morris's adaptation of Persian designs was an achievement comparable to what Gauguin and Van Gogh and Monet were concurrently doing with and for the Japanese colour print would probably be to underestimate it.

The book by Julius Lessing published in 1877 in Berlin[13] – and in 1879 in London, as *Ancient Oriental Carpet Patterns after pictures and originals of the fifteenth and sixteenth centuries* – consists of a brief text with thirty chromo-lithographic plates reproducing fifty-odd designs, almost all of them after pictures, not originals, and resembles pattern-books like *The Grammar of Ornament* – not surprisingly, because its whole purpose was to stimulate improvement in current carpet design. Lessing was Director of the Kunstgewerbe Museum in Berlin and was therefore much concerned with contemporary industrial design. His work on Islamic rugs was associated with that of Wilhelm von Bode, whose field, in contrast, was the fine arts, primarily Renaissance and Baroque, and who was on the staff, becoming Director in 1880, of the Gemäldegalerie in Berlin. Their efforts to seek out early examples related to acquisition as well as study. Finds were purchased whenever this was practicable either for the Berlin Museums or for Bode's private collection, which he later passed on to the Museums. For the classification and dating of early types, examples in paintings were as valuable in their way as extant pieces. Pictures

recorded many types of which no actual examples had survived, and the presence of a given type in a painting of known date proved that the type was current by that date. On the other hand, the pictures could provide no direct clue as to a type's place of origin. Just how uncharted the field was at the outset is shown by the fact that careful collating of paintings and documents was needed to establish the simple realization that the designs depicted till about 1600 came from Asia Minor.

Bode was certainly the senior partner, but I am not clear how close the association was, nor at what point and to what extent there was contact with the other key figure in early carpet studies, Alois Riegl, who was a younger man and was based in Vienna. Bode's memoirs make no mention of Riegl whatever, or of Lessing in regard to carpets, and the various references to him over other matters are invariably disparaging – but so are most of the references to colleagues. What the memoirs do establish is that Bode bought an early rug for next to nothing on his first visit to Italy as a student, in 1871,[14] and that on subsequent visits he bought, for ludicrously small sums, many more which had been lying for centuries in churches. Lessing tells us, writing in 1891, that the considerable holdings lately built up by the Berlin Museums also included a number of items purchased when a Viennese dealer exhibited some old and modern carpets at the Gewerbemuseum.[15]

Because it was imperative not to spoil the market, Bode and Lessing were anxious to keep their activities as secret as possible, and resolutely refrained from publishing. Apart from the pattern-book and the anonymous account of a lecture by Lessing on carpet-weaving which appeared in a provincial museum bulletin in 1889,[16] no evidence of their researches got into print till discretion became pointless when in 1891 the huge exhibition in Vienna let the cat out of the bag. But by then museums in London and Paris and Lyons as well as Berlin had been able to build the foundations of major collections, unobtrusively and economically. (Certain great collections, Vienna's above all, had ready-made foundations in royal treasures.)

A conceivable reason why Lessing's pattern-book was the exception was that its missionary purpose outweighed other considerations. A likelier reason is suggested by the belief he expressed in the text that there were very few surviving actual examples of the types that concerned him – those from Asia Minor. This was why he was resigned to taking most of his designs from pictures, and it may also have been why he had no inhibition about publishing: only afterwards did he know better. As to his limiting his choice of designs to Anatolian types, a sufficient reason, given the book's practical purpose, would have been that their austere geometry and hard clean colour made the ideal antidote to the fussy, turgid, floral designs typical of current products, whether made in European factories or imported from Asian looms. The book had a marginal influence. In 1891, Lessing said that his patterns had reached the Orient, via the art schools and trade contacts, and come back embodied in some recently imported Indian rugs.[17] It may be that these rugs were some of those which convicts in India were being set to weave at that time. If this was the case, the use of Lessing's patterns here and not elsewhere may have been due to their having appealed to some enlightened bureaucrat who did not have to pay too much attention to commercial pressures. There are also weavings done long after by European amateurs which look as if they were based

on Lessing's patterns. But the book's main influence may well have been on German linoleum designs in the late 19th and early 20th centuries, some of which faithfully resembled early Anatolian carpet patterns.

In the course of the fourteen years between the appearance of Lessing's pattern-book and the spate of publications unleashed by the Vienna exhibition – years during which scholarship made rapid and crucial progress and several major European museum collections were built up more or less from scratch – the only intimations in black and white of all the activity were three books and a few articles and sale catalogues. One of the books, published in Leipzig in 1881, was the first full-length scholarly work in the field – a highly theoretical essay by Joseph Kara-bacek[18] chiefly remembered for its brave attempt to fix the date and place of origin of the Caucasian dragon rugs, a topic that was going to drive scholars to distraction for another fifty years. Another full-length book was the first anecdotal work in the field – Herbert Coxon's[19] account of a journey to the Caucasus to buy rugs in Daghestan, a *B.O.P.* adventure story right down to the style of its illustrations and condescending attitude to the natives. Finally, there was the book by Vincent Robinson cited earlier, which was the first picture-book of carpets in the flesh, with a learned introductory essay by George Birdwood and Robinson's commentary on the twelve large colour plates reproducing the author's sister's watercolour drawings – eight of them details – after a dozen assorted rugs, half early, half not. Publication would have been motivated by interests which were the exact counterpart of those motivating the museum men not to publish: Robinson was a prominent dealer; his examples were pieces he had handled. The book's effect was not entirely advantageous to him. He had not foreseen that it would become a successful pattern-book. 'It had not occurred to me as possible that by means of such a work any attempt could be made of using the designs for the purpose of manufacturing imitation carpets with the title of "Reproductions" of these splendid old examples.' The reproach appeared in the opening paragraphs of a companion volume issued in 1893,[20] the year Robinson clinched the most celebrated deal in the history of the carpet trade.

The Venus de Milo of the carpet world became famous overnight when in 1892 it was suddenly revealed to the West, at Robinson's showrooms in Wigmore Street, as the centrepiece of an exhibition otherwise consisting of two early carpets and a score of fairly modern ones. It was a Northwest Persian medallion carpet exceptional in its beauty and size and condition and in bearing an inscription with a date. The date corresponded to 1539–40, and evidence was adduced to suggest that from that time till very lately the carpet had been housed in the Mosque at Ardabīl, Persia's capital in the 16th century.

The timing of its appearance on the scene was nicely judged, for the Vienna exhibition had suddenly made carpets something to talk about, and the Ardabīl was a very spectacular piece with a highly romantic provenance. The press deemed it to be incomparably the finest Persian carpet, or the finest carpet, in the world, and expert opinion tended to agree. South Kensington was extremely anxious to acquire it, but the price was £2,500. The top prices previously paid by the Museum – and these were already quite exceptional – had been £380 for a vase carpet in

1884 and £308 for a hunting carpet in 1883. The so-called Chelsea carpet, a medallion carpet as early as the Ardabīl and possibly more beautiful, had been bought in 1890 for £150, though this was an extraordinary bargain: 'I have lately seen many Persian carpets for sale at Bardini's in Florence', wrote Thomas Armstrong, the Director, in a memo dated 25 November 1890, 'and from what I learnt there of their prices I can see that such a dealer as Bardini would ask at least £800 for this one'.[21] Since then prices had risen, especially in the wake of the Vienna exhibition, and the Ardabīl was double the size of the Chelsea. The Museum's only concern about the price, therefore, was where to find the money. The Department was thinking of providing something in the region of £1,500 towards the cost. Purdon Clarke wrote in a memo dated 9 January 1893: 'I consider the carpet a bargain at £1,500 or even double that sum.'[22] Armstrong solicited letters of recommendation from William Morris and Sir Frederick Leighton. On 13 March 1893 Leighton replied: 'It would give me the deepest satisfaction were I to learn that the Department of Science and Art was prepared to increase to £1,750 the sum apportioned to the purchase of the magnificent Ardabīl Carpet which moved my covetousness so acutely last year when it first appeared in London.' Morris wrote on the same date that 'no reasonable man who understands the subject would think it an extravagant price for such a remarkable work of art . . . For my part I am sure it is far the finest Eastern carpet which I have seen . . . The carpet as far as I could see is in perfectly good condition . . .' In an informal covering letter he put it this way: 'It would be a crime to let it go. I never saw such a design in my life. The Vienna ones don't come within a mile of it'. And as a postscript: 'By the way, if extra money is wanted I will add my mite, say £20'. The following day the Department raised its provision to £1,750. The balance of £750 was contributed by public subscription.

When the catalogue of an important American private collection, the Yerkes Collection, was published in 1910, it disclosed the existence of a medallion carpet with all its borders missing which was undoubtedly the pair to the Ardabīl carpet at South Kensington.[23] It now became clear that Robinson and his partner Stebbing had not divulged the facts that the carpet they had launched in 1892 was a made-up piece and that they also had its mutilated twin in stock. The inference was that its borders had been partly filched from the carpet they sold subsequently to Yerkes. But there was also a possibility that a third carpet had been cannibalised. A former partner in the firm of Ziegler & Co., from whom Robinson was known to have bought the goods, published a letter in an obscure journal in 1952 in which he said that the first carpet 'was in very poor condition and was carefully restored by utilising portions of a smaller carpet (or it may have been two) of the same design and colouring',[24] and very recent research seems to support the suggestion that there may indeed have been two other carpets. In any case, the secret operation, performed nobody knows where – possibly the East, possibly the East End – left incidental remnants in the form of small border fragments one of which is no.9 in this catalogue. The final mystery is whether any of the carpets came from the Mosque at Ardabīl. A. F. Kendrick wrote to Stebbing from the Museum on 5 June 1914 stating reasons for doubting this provenance and requesting further information, but there was no reply. What is beyond doubt is that at £2,500 the carpet was

reasonably priced and would soon have cost far more.

Publications as well as prices multiplied now, to a degree that will not be evident from the number of those that can be mentioned here. Lessing brought out his second volume of colour reproductions with an introductory text (already cited) in 1891. The sixteen plates illustrated acquisitions of the Berlin Museums — early Persian, Anatolian, Turkish Court Manufactury and Spanish examples, including the crucial dragon-and-phoenix rug, made in Asia Minor around 1400, which Bode had bought five years before in Rome. Bode himself did not come out with a book at this time, but in 1892 surveyed and classified the early types in a long, masterly two-part article[25] which provided carpet studies thereafter with a method and a foundation. The article was expanded into a book which appeared in 1902[26] and re-appeared in 1914, 1922 and 1955 in editions revised by Ernst Kühnel. The fourth edition included some radical revisions, such as the placing of the Turkish section before the Persian. Its English version by Charles Grant Ellis, first published in America in 1958,[27] was further updated in consultation with Kühnel. 'Bode/Kühnel' remains, just about a century after the work leading up to it began in an uncharted domain, one of the two indispensable books on Islamic carpets. The other, first published in 1955, is Kurt Erdmann's densely detailed and brilliantly argued short history, also translated by Ellis.[28]

Alois Riegl, the other outstanding scholar to enter the lists at the time of the Vienna exhibition, was, like Bode, primarily a historian of Western art, unlike him, an academic and essentially a theorist, still by far the most noted theorist to have become involved in carpet studies. It may be significant that all his writings in the field appeared between 1890 and 1895 and that it was during this time that he published his key work on the genesis and evolution of ornament, *Stilfragen,* and his study of folk art, *Volkskunst, Hausfleiss und Hausindustrie.* In *Altorientalische Teppiche,* 1891, he made the first attempt published to write an overall historical outline, but his chief preoccupation here seems rather to have been to draw parallels with artefacts of other cultures and to fit Islamic carpets into the framework of his concept of the history of ornament. His other major work on carpets was the descriptions of the plates in a weighty set of books commemorating the Vienna exhibition with a selection from the exhibits supplemented by important pieces which had not been there.[29] His analyses are often coloured by his theory that ornament originates in observation of nature and that geometric stylization is characteristic of late stages in the history of a culture and not of archaic ones: this helps him to get some things right and some things wrong.

The massive monument to the Vienna exhibition – one volume of text, with Riegl's entries following essays by various hands, and three volumes of plates – was the first of several emperor-sized de luxe ultra-limited-edition carpet publications with sumptuous colour plates thenceforth produced from time to time, always in Vienna, until the Depression. The next decade brought a single-volume supplement to the exhibition set, with a text by Friedrich Sarre,[30] and F. R. Martin's monumental historical survey.[31] And in the 20s came the pair of georgeous anthologies, with texts by Sarre, Hermann Trenkwald and Siegfried Troll, the first covering Vienna's holdings, the other the rest of the world's.[32] Boardroom-table books you might call them, were it not for their scholarly texts, none of which was

ever re-issued in a cheaper edition.

Martin's was the most important of these texts, and the most richly illustrated. It was a courageous attempt to construct a comprehensive chronology, and it was anything up to three centuries out of true. Martin made the mistakes of assuming that similar forms in different media were probably contemporaneous and that archaic-looking forms spelled early dates. Thus he ascribed the tree carpets, such as no.26 in this catalogue (plate 8), to *ca.* 1350.[33] We assign them to the 17th century. But we are still left with the problem of their place of origin. McMullan suggests North Persia; Bode/Kühnel gives them to the Caucasus[34]; Erdmann places them among the diverse types to which he gives the canny label 'Caucasian-Northwest Persian'.[35]

There ought to have been an H.M. Bateman drawing of a gathering of carpet connoisseurs. The offender at whom the glares of enraged disbelief are directed is the man who said he wasn't *absolutely* sure that all the best carpets were Persian.

Morris's letters make it clear that for him the Persians had another dimension than other Eastern carpets. Bode was an assiduous student and collector of Anatolian and Caucasian pieces, but, when he wrote an essay – it was his contribution to the Vienna exhibition souvenir – on the theme of animal figures in early carpets, drawing comparisons between Persian medallion carpets, Caucasian dragon rugs and the Anatolian dragon-and-phoenix rug, he took it as a matter of course that the Persian pieces were the great works of art, the others were items of great historical interest. Riegl's descriptions in the same volume go into raptures about the flowing, swinging, elegant arabesques of the Persians and even about their 'costly materials' and make no pretence of concealing his dissatisfaction at their absence from the Caucasians and Anatolians: he finds dragon rugs inartistic and 'almost repulsive', deals with medallion Ushaks as if he were watching the clock[36] (this in spite of his avowed belief, a keystone to his whole theory of art, that every style should be judged according to its own standards and that the ideal art historian would have no personal tastes). Lessing acknowledged that we had every reason to regard Persia as the most important centre of production,[37] but almost as if bowing to a convention. He might even be the pariah in the Bateman drawing, for, in his picture-book of Berlin accessions he apportions five plates to Persians, six to Anatolians, five to the rest (and this was not imposed by any shortage of Persian material). In the Vienna commemorative tomes, three-quarters of the hundred plates are given to the Persians.

Picture-books such as these – anthologies as against histories – are a true guide to period taste in that they represent a free choice, less subject to circumstance than choice in exhibitions or collections. It is pretty significant, then, that in the subsequent picture-anthologies published by the Vienna Museums – in 1908, 1926 and 1929 – where the next generation of scholars takes over, the balance is about the same: a count covering all three books shows that 70 per cent of the plates are Persian. As to words: Kendrick and Tattersall, in 1922: 'Beyond all question the best carpets in the world are the Persian, whether the point of view taken be that of design, colour, or craftsmanship.'[38] Sarre, in 1929: 'In the study of Islamic art the conviction becomes more and more emphasised that Persia was the great

creative force.'[39] Maurice Dimand, in 1935: 'The finest known Oriental rugs were made in Persia during the 16th and 17th centuries.'[40]

This sort of readiness, which was common, to lump together the 16th and 17th centuries – like not knowing the difference between sugar and saccharine – betokens a passion for Persian carpets rather than a passion for the greatness of great Persian carpets. For example, 15 per cent of the plates in the Vienna exhibition souvenir and 10 per cent of those in Sarre and Trenkwald are given to Polonaise rugs, a group of effete, ingratiating fabrications designed as courtly gifts for European notables – confectionery full of Western promise. It is as if the luxury of Persian carpets counted for as much as their mystery.

The potency of Persia's spell is also evident in the frequent marked preference among Turkish types – Riegl, Sarre and Dilley[41] are among the many who show it – for those of the Ottoman Court Manufactury, which were influenced to the point of assuming a Persian flavour. These rugs, of course, were made outside Asia Minor – in Cairo or Istanbul – but the liking for Turkish rugs that are not too Turkish has also guided preferences among Anatolian weavings. It is certain that, of all the types of Turkish rug manufactured in the late 17th, the 18th and the 19th centuries, the most popular in the west have been the prayer rugs from Ghiordes and Kula. These are among many types of later Turkish prayer rugs descended from the column prayer rugs of the Ottoman Court Manufactury, but they differ from others in that they have generated themselves as if in isolation, without crossbreeding with indigenous Anatolian types. Their popularity has meant that the West's mental image of the quintessential Turkish prayer rug has been shaped by types that have gone on quietly echoing Persia's greatest wave of influence.

'By the common consent of all qualified observers Persian carpets outrank all others', wrote Arthur Upham Pope in 1926.[42] Let us consider this incontrovertible statement with the phrase 'Persian carpets' replaced by 'Italian paintings' and by 'Greek sculptures'. As to the second variation, the statement would have been valid throughout many centuries – in the time of ancient Rome and again from the beginnings of the Renaissance till early in the present century. As to the first variation, the statement would be valid enough over several centuries, though at times with the very important qualification that there were one or two individual artists from elsewhere (notably Rembrandt and Velazquez) who surpassed all the Italians. But there's a very crucial difference between the original and the variations. When we talk about 'Greek sculpture' or 'Italian painting', we mean a production extending over half a millennium. We mean an agglomeration of work with an enormous range of styles – from the kouroi to the Laocoon, from Cimabue to Tiepolo – from which different periods could pick and choose different periods. When, on the other hand, we speak of 'Persian carpets', we mean the production of the last three-quarters of the 16th century and the first quarter or half of the 17th – the output of a single century. Therefore the true variations on Pope's statement would read (by choosing periods at which the stage of development corresponded): 'By the common consent of all qualified observers 16th century Italian paintings outrank all others' and ' . . . 5th century Greek sculptures outrank all others'. And in fact there have been periods during which these statements would indeed have been valid. Now, there are times when current orthodoxy is sensible and there

are times – they are often more creative times – when current orthodoxy is silly. And it does seem likely that, at times when it was sensible, the orthodox view would be that Italian paintings of the 16th century and Greek sculptures of the 5th century and Persian carpets of the 16th century outranked all others. It is not the notion of Persian supremacy that is odd, but the unreflecting sense of certainty of the consensus, till about twenty years ago.

For myself, I would have thought that the types which have to be measured against the greatest Persians – meaning medallion and vine scroll and early vase carpets – would be the Seljuks and the Mamluks, certainly, and probably the Ushaks (from the 15th century to the early 17th) and the 15th and 16th century Spanish carpets from Alcaraz.

Of these, only the Mamluks evoked superlatives in the period 1870–1940: Trenkwald, indeed, said of the example that had belonged to the Hapsburgs, that 'the incomparable colour-effect of this silk carpet raises it above all known carpets'.[43] For the rest, the underestimation which is most striking and symptomatic is that of the Seljuk carpets and fragments of the 13th century from Konya,[44] the first three of which to come to light were published in 1907 by Sarre. Sarre did not put them in his anthology in 1929, but he did include Bode's dragon-and-phoenix rug dating from about 1400, and in reference to this and some early Caucasians, used a pair of revealing phrases in explaining his arrangement of the plates: he talked of the 'simpler, primitive examples' as against the 'finer carpets in their full beauty'.[45] What is curious here is that the time was the late 1920s, when there was a widespread predilection for the archaic – a preference for Greek sculpture of the 6th century to that of the 5th, a preference for the Trecento and Quattrocento to the Cinquecento. Despite this tendency, it is comprehensible that at that time the somewhat expressionistic dragon-and-pheonix rug was still too tough to swallow and that Bode/Kühnel could say in the 1922 edition that 'the design is very barbaric; in fact, it is almost a caricature',[46] whereas the 1955 edition speaks of 'a linear draughtsmanship which may appear barbaric, yet is extremely suitable'.[47] But it is not so comprehensible that those soberly majestic 13th-century pieces were generally treated more as documents than as works of art. So civilised a critic as Dilley, in 1931, saw nothing in them but their 'dilapidated condition'.[48] On the other hand, R. M. Riefstahl, in a major scholarly article about them published in the same year, said that 'the beauty and robustness of their designs has often been commented upon'[49] and proceeded to question the assumption that these rugs were to be equated with those which Marco Polo had called, after his sojourn with the Seljuks, the most beautiful in the world. 'The appreciation of the primitive is a conquest of our latter-day aestheticism. It would indeed be surprising to find it in a Venetian business man of the 13th century ... We may be attracted to these rugs on account of their rarity, we may be interested in them as documents of early rug weaving, we may indeed like the primitive designs and be attracted by their simplicity and robustness, but there is no reason to think that at the time of their making they were considered as high-class rugs, still less the "finest in the world".'[50] Riefstahl goes on to argue his historical case convincingly, but it is difficult to identify those with whom he is arguing his heads-I-win-tails-you-lose critical case, apart from Erdmann, on account of a recent article,[51] for, although the 1922 edition

of Bode/Kühnel equates the extant pieces with those Marco Polo had admired, the tone seems to convey that they were outstandingly beautiful only in their time,[52] and this view seems to have been more generally held among the specialists than one which would have admired them because of rather than in spite of their primitivism. Perhaps he was arguing with his students. His warnings about our latter-day aestheticism would be widely relevant today. If I for one feel that no.80 in this exhibition (plate 27), a coarse peasant rug in which the Seljuk spirit vividly survives, is a very great work of art, I doubt whether I could have seen it as such but for Matisse.

With most of the Ushak types, the usual treatment – applied even by Pope, who writes about them with great feeling – has been to regard them as products of a Persian cultural colony. Kendrick and Tattersall claim that Persian influence in Asia Minor 'prevailed to such a degree that it almost becomes a question whether the best carpets made there should properly be called Turkish'.[53] This is more immoderate than is customary. But there are frequent suggestions that the excellence of Turkish carpets in the 16th century was due to the alleged transportation of Persian weavers to Asia Minor after the conquest of Tabriz. There is constant emphasis on the debts to Persian types of the medallion Ushaks and the double-ended prayer rugs. Yet the divergences here outweigh the affinities. The Persian red envelops the beholder; the Ushak red confronts him. The Persian carpet is eternal movement; the Ushak a solid stillness. The tension in a Persian medallion carpet derives from the superimposition or intertwining of several layers of pattern within a simple centralised composition; the tension in an Ushak medallion carpet derives from an interplay in the same plane between an ostensibly centralised composition and an implicit repeat pattern. This sort of persistence in Turkish rugs of more or less evident infinitely extendable repeat patterns is symptomatic of the strength of their separate identity. It was failure to recognize the extraordinary continuity and integrity of the indigenous Anatolian tradition that provided the basis of the customary view of the relationship between the Ushaks and the Persians.

Erdmann's alternative interpretation of the place of Persia's masterpieces in carpet history takes off from the designs preserved in Persian miniatures of the 15th century.

'In the second half of this century the illustrations of rugs in the miniatures show that more and more the old designs were replaced by new. Instead of cross, star and rosette appear medallions and vines with blossoms and arabesque leaves, and in place of subdivision into small-scale rows or large-scale rectangles there are compositions which accentuate the middle of the field. The changeabout is radical. Everything that hitherto has held importance for the patterning of a carpet – the geometric or else the still prevailingly geometric character of the individual forms, the similarity in scale of the elements employed, their arrangement in endless rows – vanishes and makes way for new forms, principally floral ones, which are arranged in what appears to be a finite grouping about the field's centre. The violent release of the potential is achieved. The breach with the past is decisive . . .

'The procedure is clear: the traditional patterns were inadequate to satisfy the new demands which certainly were not postulated merely upon the broader tech-

nical potentialities for fabrication. To expect help from the actual weavers of the carpets, who doubtless did not work from cartoons at all, would have been unreasonable. Therefore they turned to the masters of book illumination who controlled the Persian art of the period. Miniaturists and illuminators were commissioned to draw up new designs. They created designs in which they brought their own form world over to the carpet. Medallion and vine designs, which henceforth are the decisive factors, are forms typical of the art of the book ...

'The new forms are thoroughly alien to carpets; for the greater part they are not even proper for textiles. They are based upon a mutual collaboration of the art of the book and the art of the rug, in which that of the book frequently has the upper hand. The outcome of this collaboration is a "golden age", such as could nowise have been foreseen. Accordingly one is quite justified in seeing the 16th century as the "high point" of rug development, but in so doing one must not forget that this "high point" was not attained by the true and characteristic evolution of the carpet but through outside intervention. Hence it would be just as warranted to consider the true evolution of the carpet as ended at that point where it begins to prosper under domination by the art of the book. Actually this is not necessary, for the coexistence of all stages of development side by side readily supplied counterbalances which saw to it that the "revolutionization of the design" worked itself out in a variety of forms and degrees in the different individual districts. In the great workshops of Turkey the effects were not as incisive as in Persia, where in many places the roots were completely severed, not to speak of rural Anatolia, the Caucasus and Turkestan where the old designs often could maintain themselves with little change. Even in Persia the union of book and carpet, together with the disintegration of the weave both in plan and execution, takes effect in diverse ways. Many workshops preserve a residue of the old textile constraint and produce carpets which, even if on a new level, are merely one of the many links of a chain following the same sense as in earlier times. Other carpets, to the contrary, in which we recognize correctly the true products of the court, are individual works of art of imcomparable form. Admiration has always given them the highest rating. This they indeed deserve. In these truly magnificent works with their richness of layout in several layers of design, one laid down upon the other, or else intertwined with one another, always intricate but carefully thought out to the last detail, Oriental genius has found consummate expression. They are sublime examples of the cooperation of important designers and all testify to the expertness of both weaver and dyer, yet they are merely a side line which will prove itself a cul-de-sac when capacities flag. To adopt these pieces as a measure, as is still freely done today, is to misunderstand the knotted rug's true nature and must lead to a false picture of its evolution.'[54]

Elsewhere Erdmann summarizes his picture of that evolution: 'The past four hundred years are no more than a portion selected from the entire history of carpets. They include merely one short golden age, which existed under peculiar conditions, together with the decline which followed it, while the incomparably longer ascending line of development remains veiled in shadow. This period during which the carpet evolves from modest beginnings into a work of art of a high order, and in the course of which the multiplicity of its technical forms, the laws

governing its design, and the wealth of its ornamentation are perfected, is simply the initial but decisive chapter of this history. Indeed in the "golden age" of the 16th century the seeds of future disaster are so noticeable to the attentive student that he must ask himself whether it were not more accurate to regard the Seljuk and Mongol era, or in other words the 13th to the 15th century, as the "classic period" of the knotted rug; and to consider the 16th century, in spite of (or, better still, precisely because of) its brilliant achievements, as the first phase of its deterioration.'[55]

Bode/Kühnel provides a summary of the present situation in large-scale private collecting. 'Most of the rug treasures which had for centuries past been the property of German, Austrian and English noble families have now changed ownership, and private collections once of significant repute (Goupil, Yerkes, Ballard, Figdor, Sarre, Cassirer, Widener, Clark etc.) long since have passed out of existence. In the U.S.A. they are largely a thing of the past, their contents having come under museum control. The brilliant collection brought together by J. V. McMullan even now is undergoing this process. It is doubtful if any systematic collectors of rugs in the grand style are still to be found in Europe, and likewise in America we know of no new names which we can add at the present time'[56]

Since this was published there have been rumours of the formation of two or three major collections in Europe, one of them here. But, if the McMullan collection happily turns out not to be the last of its line, it will still have been the first of its kind. Not that it set out to be different, for it was formed (beginning about 1930) quite haphazardly and intuitively. But it gradually evolved a distinctive identity which, in effect if not in intention, crystallized a coherent and original attitude to the history of Islamic carpets. At the same time, it remains a highly, even an unusually, eclectic collection.

The other great American private collections have been dominated by Persian holdings. Some contained almost nothing else, some a token representation of other regions, one – the Williams Collection – first-rate examples of many classic Turkish types. There was one exception, the Ballard Collection, which was predominantly Turkish in content, but specialized precisely in those types I called Turkish rugs that are not too Turkish. Nearly half of the McMullan collection is Turkish; his catalogue of it contains this determined aside: 'The well known prayer rugs called Ghiordes and Kula find no place in this collection. They deviate markedly from the main stream of Turkish thought in both design and colour, and they do not possess the robust character and spirit which is in the great tradition of Turkish rug weaving.'[57] His whole credo is implicit there.

First, there is the commitment to 'the robust character and spirit' of the Turkish tradition. Obviously that commitment relates to an instinctive predilection ('he likes an honest rug', as a friend of his said to me), but it is not a simple matter of taste, since the collection includes Persian pieces of a marvellous subtlety and elegance. Second, there is the concern with 'the main stream of Turkish thought'. That main stream, already in full flow in Seljuk times – the point at which our limited knowledge picks it up – continued through and alongside the classic Ushak types into village weavings down to the late 19th century. What kept the

tradition alive in those village products was the will and the ability to go on and on creating local and personal variations on the inherited types.

McMullan was the first among collectors of Islamic carpets to attribute a major importance and value to Turkish village rugs. In collecting them he has been able to use his eye in an area in which there were no received opinions as to what might be desirable acquisitions, and has pursued, with an excitement manifest in his catalogue entries, affinities between things made at a remove of several centuries, tracing back some local peasant product to its remote prototype. His collection is a celebration of the beauty of the interplay between tradition and the individual talent.

References

[1] Archives of Textile Dept. of the V. & A., Nominal File for Vincent J. Robinson.

[2] *V.* Registers of the Textile Collection of the V. & A.

[3] Owen Jones, *The Grammar of Ornament*, London, 1856, ch.I.

[4] Vincent J. Robinson, *Eastern Carpets. Twelve Early Examples*, London, 1882, opp. pl.5.

[5] Maxime Du Camp, *Souvenirs littéraires*, Paris 1882–3, in Paris 1962 edn, p.270.

[6] Letter to Émile Schuffenecker, 8 October 1888.

[7] 'The School of Giorgione', *Fortnightly Review*, London, 1877, reprinted in 3rd edn of *The Renaissance*, London, 1888.

[8] H.M.S.O., *First Report of the Department of Practical Art*, London, 1853, p.2, p.378.

[9] Philip Henderson, ed., *The letters of William Morris to his family and friends*, London, 1950, pp.89–90.

[10] Gerald H. Crow, *William Morris: designer* (special number of *The Studio*), London 1934, p.67

[11] Philip Henderson, *William Morris: his life, work and friends*, London, 1967, pl.58.

[12] Quoted in C. E. C. Tattersall, *A History of British Carpets*, Benfleet, Essex, 1934, p. 75. Source untraced.

[13] Julius Lessing, *Altorientalischer Teppichmuster nach Bildern und Originalen des XV und XVI Jahrhunderts*, Berlin, 1877.

[14] Wilhelm von Bode, *Mein Leben*, Berlin, 1930, vol. I, p. 124.

[15] Julius Lessing, *Orientalische Teppiche*, Berlin, 1891, para.2.

[16] 'Die orientalische Teppichweberei', *Mitteilungen des Märischen Gewebemuseums in Brühn*, VII, Brno, 1889, pp.195–7.

[17] Lessing, *Orientalische Teppiche*, para.1.

[18] Joseph Karabacek, *Die Persische Nadelmalerei Susandschird. Ein Beitrag zur Entwicklungs-Geschichte der Tapisserie de Haute-Lisse*, Leipzig, 1881.

[19] Herbert Coxon, *Oriental Carpets, how they are made and conveyed to Europe, with a narrative of a journey to the East in search of them*, London, 1884.

[20] Vincent J. Robinson, *Eastern Carpets. Twelve early examples*, 2nd series, London, 1893.

[21] Archives of Textile Dept. of the V. & A., Nominal File for Alfred J. Cohen.

[22] For this and letters *re* Ardabīl from Leighton, Morris, Kendrick, cited below, Archives of Textiles Dept. of the V. & A., Nominal File for Vincent J. Robinson.

[23] John Kimberly Mumford, *The Yerkes Collection of Oriental Carpets*, London, etc., 1910, pl. XXVII and entry.

[24] W. L. Flinn, letter in *The Standard Car Review*, vol.14, no.9, Sept. 1952.

[25] Wilhelm von Bode, 'Ein altpersischer Teppich im Besitz der Kgl. Museen zu Berlin. Studien zur Geschichte der westasiatischen Knüpfteppiche.' *Jahrbuch der preussischen Kunstsammlungen*, vol. XIII. Berlin, 1892. pp.26–49, 108–37.

[26] Wilhelm von Bode, *Vorderasiatische Knüpfteppiche aus älterer Zeit*, Leipzig, 1902.

[27] Wilhelm von Bode and Ernst Kühnel, *Antique Rugs from the Near East*, 4th edn, London, 1970.

[28] Kurt Erdmann, *Oriental Carpets: an account of their history*, London, 1960.

[29] Vienna, K. K. Osterreichisches Handelsmuseum, *Oriental Carpets*, 1892–6.

[30] Vienna, K. K. Oesterreichisches Museum für Kunst und Industrie, *Ancient Oriental Carpets*, 1906–08.

[31] F. R. Martin, *A History of Oriental Carpets Before 1800*, Vienna, 1908.

[32] Friedrich Sarre and Hermann Trenkwald, *Old Oriental Carpets*, Vienna, 1926 and 1929.

[33] Martin, *op. cit.*, p.28.

[34] Bode/Kühnel, 4th edn., p.68.

[35] Erdmann, *op. cit.*, p.47.

[36] K. K. Öst. Handelsmuseum, *op. cit.* Notes on no.5, no.47, nos. 21 and 22.

[37] *Orientalische Teppiche*, para. 6.

[38] A. F. Kendrick and C. E. C. Tattersall, *Hand-woven Carpets, Oriental and European*, London 1922, vol. I, p.43.

[39] Sarre and Trenkwald, *op. cit.*, vol. II, p.23.

[40] Maurice S. Dimand, *The Ballard Collection of Oriental Rugs in the City Art Museum of St. Louis*, St. Louis, 1935, n.p.

[41] Arthur Urbane Dilley, *Oriental Rugs and Carpets: A Comprehensive Study*, revised edn., New York, 1959, ch.6.

[42] The Art Club of Chicago, *Catalogue of a Loan Exhibition of Early Oriental Carpets*, 1926, p.18.

[43] Sarre and Trenkwald, *op. cit.*, vol. I, p.12.

[44] For colour repros. *v.* Oktay Aslanapa, *Turkish Art and Architecture*, London, 1971, pls.12–17.

[45] Sarre and Trenkwald, *op. cit.*, vol. II, p.8.

[46] Bode/Kühnel, 3rd edn., New York, 1922, p.41.

[47] Bode/Kühnel, 4th edn., p.25.

[48] Dilley, *op. cit.*, p.146.

[49] Rudolf M. Riefstahl, 'Primitive Rugs of the "Konya" Type in the Mosque of Beyshehir'. *The Art Bulletin*, vol. XIII, 1931, p.191.

[50] *Ibid.*, pp.192–3.

[51] Kurt Erdmann, 'Zur Frage der ältesten orientalischen Teppiche.' *Cicerone*, XXII, 1930, pp.152–156.

[52] Bode/Kühnel, 3rd edn., p.41.

[53] Kendrick and Tattersall, *op. cit.*, p.43.

[54] Erdmann, *Oriental Carpets*, pp.31–32.

[55] *Ibid.*, p.13.

[56] Bode/Kühnel, 4th edn., p.18.

[57] *Islamic Carpets*, New York, 1965, p.295.

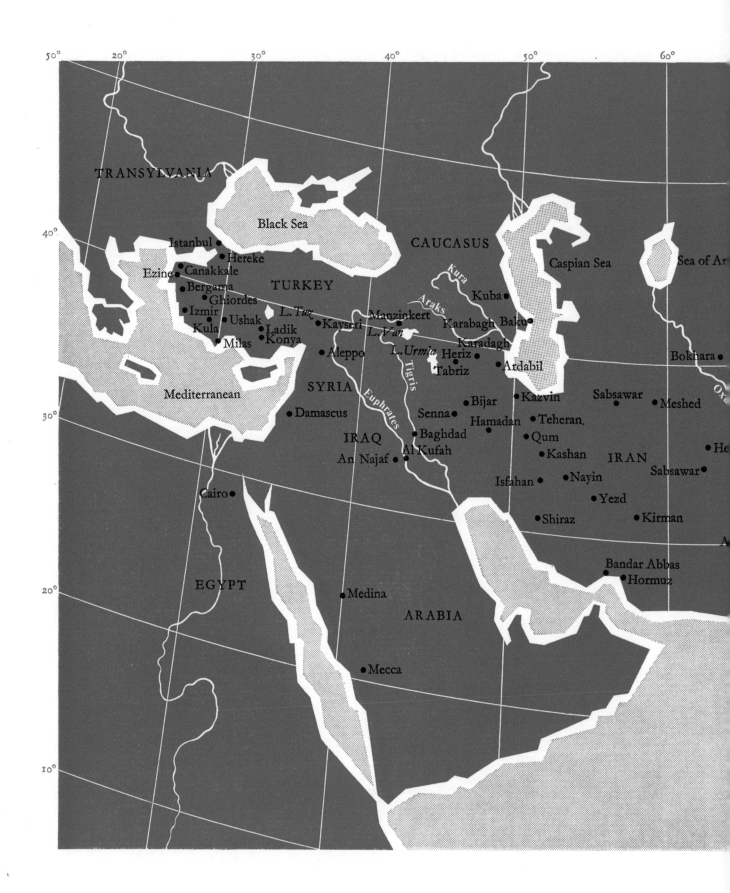

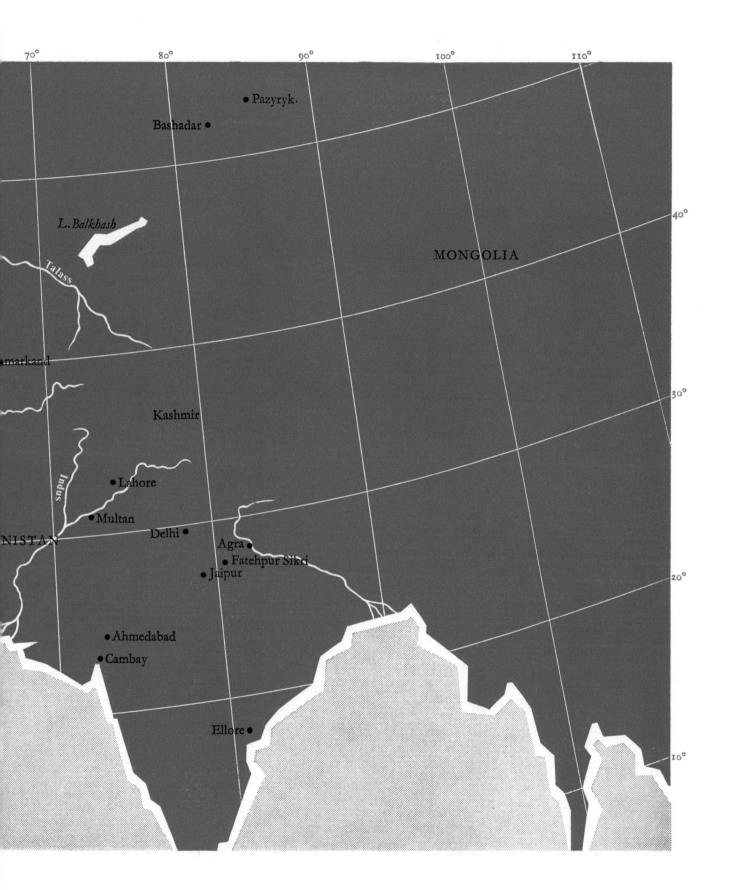

On the making of carpets
May H. Beattie

It is now recognized that carpet weaving is a craft of far greater antiquity than was at one time supposed. Richly coloured, supple rugs with velvety pile were already being woven in the first millennium B.C., and their structure is exactly the same as that found in modern carpets.

The remarkable persistence of the craft is not surprising as the carpet holds a unique place in the domestic life of the Orient. It is far more than a floor covering in the Occidental sense, for this single item may replace a great variety of articles such as tables, chairs, beds, coverlids, pictures, altar-cloths, cradles, stretchers, shrouds, and palls.

Origins

Originally sheep-rearing people who lacked sufficient furs for their needs, but who had wool available from their flocks, may have contrived the carpet as a substitute for an animal pelt. When patterns were introduced uniform clipping of the shaggy pile would follow in order to show up the designs more precisely. We do not know what types of looms were used for the weaving of the Bashadar fragment from about the end of the 6th century B.C., or the almost complete Pazyryk carpet from over a century later, but obviously the craft is traditional and the technique and probably also types of equipment persist, as shown by a primitive warp-weighted loom which was seen in use in Meshed early this century.

Structure

The foundation of a carpet consists of warp and weft. The former extends from end to end of the carpet and eventually, when cut, forms the fringes. During weaving the warp yarn must be kept under even tension. This is a function of the loom. The weft which binds the warps together is passed from side to side as if threaded over and under alternate warps by means of a needle. In fact, this effect, as in cloth weaving, is achieved much more simply and quickly by so arranging the warps that alternate threads are separated into an upper and a lower plane. The weft is slipped through the resulting space, or 'shed', and is returned after the warps have been reversed by one or other of a variety of shedding devices. In kileems, which have no pile, the number of wefts per linear inch exceeds the number of warps. This results in a flat-woven weft-faced fabric resembling a European tapestry; and the yarn, instead of passing right across the rug, is returned as required to form the pattern (no.35). When a supplementary weft is used for the pattern it lies between the passes of foundation weft. The method of progression is usually to lead the yarn forward over two or four warps and back under one or two. Successive rows may be parallel or countered. This form of brocading, known as Soumak work, is used in the design of the Dragon rug (no. 40). In the case of pile rugs the so-called knots lie between the foundation wefts. They are normally tied to every pair of warps, and when each row is completed the weft or wefts are passed. Side and end finishes vary. Sides may have a flat selvedge or be overcast in various ways, all of which is done in the course of weaving. Yarn may be bi-coloured and tassels added. Ends vary from simple fringes to complex cross-weaving or ornate shell, or other supplementary, decoration. To produce a rich effect the ordinary cotton fringes are sometimes replaced by silk ones which

are worked into the foundation of the rug.

Equipment

Looms vary in size from the modern but rarely seen miniature learner's loom, to the great looms of India, one of which had beams 48 feet wide and could take a carpet 100 feet in length. They may be modified in different ways but what determines local preference is not always evident.

The horizontal loom, which can either be pegged into the ground or stretched by means of side supports, is an obvious convenience for nomads as it can be dismantled easily, rolled up and packed onto an animal for transportation to the next site.

Vertical, or near vertical, looms have frames with either fixed or rotating beams. The Persian village loom consists of a simple rectangular framework at which the weaver works, and her bench is raised at intervals to a suitable height as the work proceeds. This loom is quite convenient provided that the length of the finished rug is less than the distance between the upper and lower beams. If it is longer, the warp has to be released and the woven part of the carpet brought down and re-attached to the lower beam, sometimes by nailing. Even today rugs of extremely fine quality are woven on these simple frames, which makes one wonder if cottage weavers of several centuries ago, working at the instigation of merchants who provided materials more expensive than the weavers themselves could afford, were not responsible for some at least of the smaller so-called 'court' rugs.

The Tabriz loom, known in Turkey as the Bunyan or 'flat' loom, provides more scope because a rug almost twice the length of the distance between the beams can be woven. The warp is applied direct to the loom by two men who pass the yarn continuously up and down around the beams. Tension is controlled by wedges or jacks and when required the edge of the work can be pulled down to a level convenient to the weavers, the finished portion of the work being forced below the lower beam and up behind it. This is the type of loom preferred not only by the merchants of Tabriz, but also by those controlling modern commercial carpet weaving in Turkey.

The traditional village loom of Turkey, the type on which the Anatolian rugs in the exhibition were almost certainly woven, is, however, the roller-beam loom, which is also used in Kirman, in some other districts of Persia, in India, and further east. The warp is wound onto the upper beam and, as weaving proceeds, the finished part of the work is rolled, periodically, onto the lower beam while more yarn is unrolled from the upper one. Tension is controlled by a sturdy lever inserted into one of the holes in the warp beam and then lashed into place. The length of the carpet can be almost as long as the warp. In Turkey strings of cushion covers or rugs in series are woven on such looms, the parts being separated when they are cut down from the loom. Rugs may often be woven side by side on a loom of sufficient width. In Persia and India I have seen the weft yarn being passed right across all the rugs which, when the work was finished, were separated from each other by cutting. The raw edges were then firmly overcast, but the practice is obviously undesirable. In Turkey each rug on the loom was worked independently, the edges being properly finished as the work progressed.

The spindle is a tool of great antiquity, used alike by men and women. The wheel also has been known in the Orient for many centuries. Both are still used by spinsters for preparing rug yarn, if it is not bought ready-spun direct from a factory, and one can see women turning their little wheels in the household court-yards or twirling their spindles as they walk to market or sit in the doorways in the cool of the evening. Much of the yarn in antique Egyptian rugs has a twist which is opposite in direction to that found in most other types, possibly because of a different method of using the spindle.

Small pieces of equipment such as yarn-winders, comb-beaters used to press or beat the wefts into place, and rug-stretchers for maintaining an even width of rug during weaving, do not vary greatly, but in Tabriz additional equipment is used. A flat hook with a blade on one side is customary for knotting and cutting the yarn, and a long flat needle, like a pliable steel ruler, is used to pass the weft. When trimming is done on the loom the scissors may be simple or gauged according to the length of pile required, but large shears are usual if the trimming is to be done after removal of the carpet from the loom.

Materials
In the case of luxurious 'court' carpets materials of the finest quality are obviously needed and would be obtained whether they were available locally or not. The foundation of such rugs was often of silk, because the strength of the fibres in relation to their diameter makes it suitable for the weaving of fine carpets. In more ordinary rugs the materials would depend on what was available locally and on the economic conditions prevailing at the time. One expects woollen foundations in the rugs of pastoral people but cotton will be used if it is readily available and cheaper than wool. This is seen where, in recent years, cotton has been introduced into rug weaving areas and now replaces wool in the foundations of local rugs. The same types of yarn used in antique carpets continue to be used today. Wool is by far the most satisfactory pile yarn as it is resilient and takes dyes well. Quality is of first importance. The wool of Persia is renowned for its lustre and even an Anatolian carpet weaver will occasionally admit, somewhat grudgingly, that it is superior to that of Turkey. The fine undercoat of the Tibetan goat, which was used in Kashmir shawls, makes a remarkably beautiful pile. Other fibres such as silk, cotton (plain or mercerized), ramie, coarse hairs, and rayon have all been used in carpets to a greater or less extent.

Dyeing
Where weaving is largely a domestic craft, as in Anatolia, the yarn used in older rugs would, for the most part, be dyed on the premises and much time and trouble would go to the collection of materials and preparation of the dyes. A portable 'filing cabinet' was sometimes used. It took the form of a coat or jacket with many pockets into which the various plants and other raw materials were consigned as they were collected. These garments were scarce enough early this century, and now, no doubt, any that survive have been put to other uses following the intro-duction of more easily obtainable synthetic dyes. In Persia, according to 19th century writers, dyeing was usually the prerogative of the village dyer and the

traditions were handed down from generation to generation as cherished secrets in families often of Jewish stock. An organic chemist could explain in simple terms the chemical reactions involved in dyeing but besides the obvious reactions the quality of the wool and water and the intensity of the sunlight seem to have contributed in less obvious ways to the beauty of colour in antique rugs, and the understanding and control of such factors was the point at which the craft of the dyer became an art. The effect of substances used in dyeing in some districts causes brittleness of the yarn fibres, notably when dark brown, red, and a certain green are used. The yarn so dyed wears away more quickly than that dyed with other colours and leaves part of the design standing out in relief.

The greatest disaster which ever befell the Oriental rug was Sir William Perkin's synthesis of mauveine in 1856. This revolutionized the dyeing industry in both West and East. No one can blame a village woman for going to the bazaar for synthetic dyes which are easy to get, easy to use and inexpensive. The range of shades in the new dyes was greater, the colours more brilliant, the results more uniform, and it was of little consequence to the weaver that some of the dyes were also fugitive. One only has to look at the faded repairs in museum carpets acquired in this unfortunate period – about thirty years on either side of 1900 – to realize the damage which these dyes did. Although present day dyes are largely synthetic, so far they are fairly stable. Contrary to popular belief the dyes in antique rugs often fade but the resulting colours may be more attractive than those which result from the fading of synthetic dyes.

Designs

Besides equipment and materials, designs are needed. The weaver may use a simple motif learned in childhood at her mother's side, but the charm of the rug she weaves depends on her choice of motif and her skill in the use of colours; or she may copy a design from the back of an existing rug where the pattern is more obvious than on the front. While such methods no doubt explain the amazing persistence of certain designs over a century or two, this constant repetition does seem to be a characteristic of weavers of Turkish stock. Through inherent inventiveness a weaver may create a simple new design, or she may counterpose or modify familiar motifs to avert the boredom of endless repetition, and, if left to her own devices, the designs will be single plane repeats. Among villagers such methods are to be expected as designing is costly and weavers are poor. In the case of great carpets of high quality, however, the designs must have been drawn in the fashionable style of the moment by experts and transferred to paper, the full size of the carpet if necessary, by copyists. Analysis of highly complex designs shows that they must have been built up from a series of simple, curvilinear patterns, which were superimposed, one upon the other, with such skill that the balance of the finished design was unimpaired. In more modest symmetrical designs a cartoon of only a quarter of the design need be prepared. When coloured it is cut into sections, pasted onto cardboard and varnished to protect it from wear and tear. Considerable numbers of such cartoons can still be seen in some of the premises of long-established merchants. In Ushak the women are justly proud of their ability to weave a carpet from a small free-hand design without it being enlarged onto

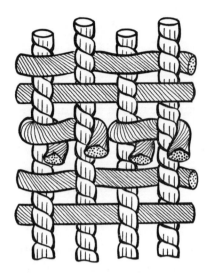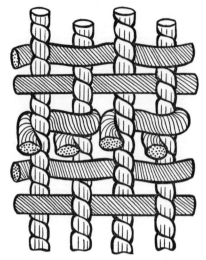

Asymmetrical or open knot
(Persian or Senna) open-on-the-right

Asymmetrical or open knot
(Persian or Senna) open-on-the-left

squared-paper. Villagers in the Heriz district of Persia have a similar skill but their designs when woven are rectilinear although that of the model may be curvilinear. Apart from cartoons a small woven sample, known in Turkey as a 'nümüne' and in Persia as a 'wagireh' may be supplied to a weaver by the merchant for whom she works. This is still done but those used last century are now becoming collectors' treasures.

Surviving rugs provide a faint echo of great designs of the past, but many must be lost entirely, and one regrets that more travellers (unlike the one who mentioned the animal rugs of Kirman) did not leave even a brief description of the rugs they extolled in such glowing terms.

Warps and Wefts

Warps must be firmly spun and plied to give sufficient strength to bear the weight of the finished rug, whereas the weft yarn of pile rugs is loosely spun and often unplied, which makes it suitable for packing down on the knots to hold them in place. Very fine rugs are woven on silk foundations and in some Indian rugs the warps are arranged in stripes of different colours but not necessarily of the same width, as the purpose seems to have been to aid the weaver in executing a complicated design in a rug of fine quality. Even today in commercial rugs it is quite usual to see a dyed warp thread at intervals to keep the weaver on the right line, or a line drawn across the warps as a guide to keeping the rows straight. In certain antique Indian rugs the unevenness of the edge of the work was so marked that additional short lengths of weft had to be introduced in the course of weaving to correct the irregularities.

As foundation yarns are not obvious on the surface of a rug they provide an opportunity for using up dark yarn which is unsuitable for dyeing. In many cases, however, the weft yarn is dyed to harmonize with the field. In Dragon rugs of the Caucasus, and kindred pieces, a thick cabled weft can often be seen at irregular intervals on the back of the rug and seems to be a 'stint' mark indicating how much work has been done in a given time, whereas in East Persian rugs a piece of yarn

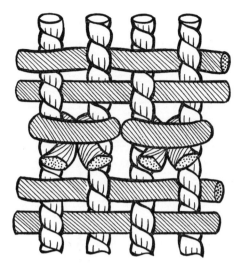 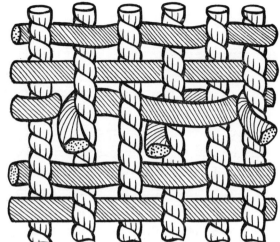

Symmetrical or closed knot
(Turkish or Ghiordes)

Paired or jufti or false knot
an asymmetrical or open form

looped into the work and left hanging at the back an inch or so from the edge seems to serve a similar purpose. In provincial rugs the number of passes of weft varies and the more there are the longer will be the pile, the flatter will it lie and the less durable will the rug be. To avoid moving every time the weft is passed a weaver, especially if she works alone, will return the weft at a point within easy reach of where she sits, reducing the number of warps taken in in each row. After several inches of weaving are completed the adjoining section is worked. This results in diagonal lines, visible on the back of the rug, where the wefts meet. These lines are seen most often in certain Ottoman and Indian rugs.

One difference between antique rugs and those from the 'revival' period in the 19th century is that many of the great antique rugs are woven with three passes of weft after each row of knots, whereas in late rugs two passes are much more usual. Just when this, and the greater use of the symmetrical Turkish knot in rugs of Northwest Persia, began, is not known.

Knots

A good Oriental weaver can tie at least 10,000 knots in an eight-hour day, which is about four times the speed of some of the carpet weavers of Western Europe. Counts vary from four or five to the square inch to over 2,000. A rug with a high knot count should wear much better than one which is coarsely woven, but this does not mean that it is aesthetically more desirable. The richness of colour and the charm of good traditional abstract designs in coarsely woven Anatolian and Caucasian rugs, often not older than the 19th century, have far greater appeal for many people, particularly in the West, than the beautifully woven but rather anaemic looking rugs with a high knot count which became fashionable last century and are still woven in great numbers. Today, and probably in the past, rugs of exceptional quality are woven only to order, but four or five lower grades are produced for ordinary trade purposes. Various types of knots are, or have been, used in different parts of the rug-weaving world, and unusual methods of tying are still practised by Spanish, Berber, and Tibetan weavers; and from time to time one also finds curiously tied knots in rugs where those of more usual type would be

expected. It has been customary to refer to the two most commonly used knots by proper names which are both irrelevant and misleading and it is high time that they were replaced by descriptive rather than geographical terms.

Where exactly the knots were first used will never be known but the so-called Persian or Senna knot was the one used by the weavers of the Bashadar fragment. The terms 'asymmetrical' or 'open' knot could be used to describe this type and they have no geographical implications. The yarn is passed between two adjoining warps, looped round one, passed back over it and under the second warp so that the ends of the yarn lie on either side of, and are kept open by, the second warp. It is usually tied with the ends coming up on either side of the left warp thread (open-on-the-left) but the form open-on-the-right is also used.

The so-called Turkish or Ghiordes knot may equally well be described as the 'symmetrical' or 'closed' knot. This was the one used by the weavers of the Pazyryk carpet. The yarn is passed between two warps, looped under one, passed back over both and brought to the surface again between the two warps, so that the two ends of the pile yarn lie together enclosed by the collar of the knot.

The open knot is usual in finely woven carpets in curvilinear designs, the closed knot more often in robust, richly coloured village rugs. To generalize briefly and broadly, for there are many exceptions in these matters, the asymmetrical knot open-on-the-left is found in Egyptian rugs, in Turkish 'Court' rugs, in most of the great antique rugs of Persia, and in those of India, in many of the somewhat later rugs of Persia, Western and Eastern Turkestan, and China, and in the commercially produced late rugs of Turkey. The asymmetrical knot open-on-the-right is quite usual in Turkman rugs as well as that open-on-the-left.

The symmetrical or closed knot is preferred by weavers of traditional Turkish village rugs, by those of the Caucasus, by many of the villagers of Western Persia (including those of Senna), and by some Turkman weavers, particularly Yomuds, of Northeastern Persia and the U.S.S.R.

The open and closed knots are sometimes found in one rug, used quite indiscriminately, and, in certain Turkman rugs, and in those from further east, the rows may be neatly finished at one or both ends with the closed knot, although the rest of the rug is woven in an open knot.

Another knot found in many antique rugs is the jufti (paired) or false knot, which in asymmetrical form is tied in various ways over two pairs of warps. The symmetrical form is relatively rare. It is unfortunate that the use of this knot is increasing as rugs so woven lack sufficient pile yarn and in consequence wear poorly.

It is customary to weave pile carpets with the knots on one side only but fragments of antique rugs exist which show that a built-in underlay was achieved by tying knots also on the back of the rug. This was done at intervals of several rows of the surface knots and the yarn was left long and so formed an admirable pad as additional protection against the cold of the floor. The practice is continued, particularly in Anatolia, where such pieces are known as 'two-faced' rugs. Some are extremely finely woven with different designs on the two surfaces and are examples of technical virtuosity rather than rugs for practical purposes.

Weavers

When all the equipment, materials and designs are assembled the weavers begin their time-consuming work. For centuries Oriental carpets have been mentioned in documents but the references are brief and concern provenance rather than weavers or methods of weaving. Both the Mughal Emperor Akbar and Shāh 'Abbās of Persia established carpet workshops, and some at least of the glittering silk and gold rugs came from looms in the royal precincts just off the great maidan in Iṣfahān. We are not told how these carpets were woven but no doubt the methods were analagous to those used by Persian weavers who settled in Eastern India in the 16th century. In 1679 their descendants were still working in Ellore. The looms they used were vertical, the warps were cotton, a master weaver who directed the boy-weavers, 'called' the pattern from a paper cartoon, and the rough ends of the knots were trimmed with scissors. The description could apply to carpet weaving in many places today. At this time also boys were employed in carpet weaving in Egypt and China. Indeed when the Emperor visited Ning Hsia in 1697 he was not only presented with carpets but was sufficiently interested to order the weavers to demonstrate how the work was done. Unfortunately the details were not recorded, but the 'foot carpets' presented to the Emperor were described as being coarser than those of Turkey, as indeed many Chinese rugs are.

In the few early descriptions women are not mentioned as carpet weavers, although among nomads and in Anatolia in particular carpet weaving is largely woman's work; but in a Moslem country 300 years ago one would hardly expect a foreigner of the opposite sex to have access to the premises where women were working. Apart from domestic weaving the further East one goes the more does carpet weaving seem to become the prerogative of men.

This splendid exhibition provides an opportunity to compare and contrast not only colour and design but also some of the less obvious yet important features of carpets, such as qualities and types of yarns, regional colour ranges and characteristics of side and end finishes, all of which combine to produce the rich and overwhelming beauty of the Oriental carpet.

AD	AH	Egypt and Syria	Turkey
			1077–1307 Seljuqs of Rūm Capital at Konya
1100	500	1168–1250 Ayyūbids 1169–1193 Saladin	
1200	600	1254–1517 Mamlūks 1291 Crusaders finally expelled	1204 Capture of Constantinople by 4th Crusade 1260 Commercial treaty between Venice and Sultan of Konya
1300	700		1300–1924 Ottoman Sultans 1326–1365 Capital at Bursa 1365–1453 Capital at Adrianople
1400	800		1402 Tīmūr defeats Ottomans at Battle of Ankara 1453 Capture of Constantinople by Ottomans; thenceforth capital
1500	900	1517 Ottoman conquest 1517–1805 Ottoman Sultans of Turkey	1520–1566 Sulaymān the Magnificent 1571 Defeat of Ottomans at Battle of Lepanto
1600	1000		1603–1617 Aḥmad I
1700	1100		
		1798 Bonaparte's campaign in Egypt	
1800	1200	1805–1848 Muhammad 'Alī 1869 Inauguration of Suez Canal	

Persia and Mesopotamia	India	Europe
1221 Chingiz Khan, founder of Mongol Empire, invades Persia 1256–1335 Mongol rule 1258 Capture of Baghdad by Hulegu founder of the Mongol dynasty of the Il-Khanids		1237–42 Mongol drive into Europe 1254 First voyage of Marco Polo to China
1369–1405 Capital at Samarqand 1378–1469 'Black Sheep' Turkmān in N.W. c. 1380 Establishment of Tīmūrid Empire		1333–1391 Height of Arabic Civilisation in Granada
1469–1502 'White Sheep' Turkmān in N.W. 1471 Alliance of Venetians with 'White Sheep' Turkmān		1480–1556 Lorenzo Lotto 1491–1547 Henry VIII of England 1492 Capture of Granada by Ferdinand and Isabella 1492 Columbus discovers America 1497–1543 Holbein the Younger 1498 Vasco da Gama's journey via the Cape to Calicut
1502–1732 Ṣafavids 1501–1524 Shāh Ismā'īl 1524–1576 Shāh Tahmāsp 1588–1629 Shāh 'Abbas the Great 1514 Ottomans defeat Persians at Chaldiran 1502–1549 Capital at Tabriz 1549–1598 Capital at Kazwin 1598–1722 Capital at Isfahān	1525 Bābur founds Mughal Empire 1526–1858 Mughal Emperors 1530–1556 Humāyūn (refugee in Persia 1540–1555) 1555–1605 Akbar	1527–1598 Philip II of Spain 1529 Ottomans besiege Vienna 1530–1584 Ivan the Terrible 1533–1603 Elizabeth I of England 1588 Defeat of Spanish Armada
	1600 Charter to the East India Company 1605–1628 Jihāngīr 1612–English factory established at Surat 1628–1658 Shāh Jihān 1659–1707 Awrangzīb 1661 Acquisition of Bombay by Charles II	1683 Ottomans defeated before Vienna
1722 Afghan invasions 1736–1795 Afshārids 1737–1739 Nādir Shāh invades India 1750–1794 Zands 1779–1924 Qājārs		

Catalogue
Joseph V. McMullan

Editorial note: The essays by May Beattie and David Sylvester have been written for this catalogue; the entries have been adapted from the descriptions in Joseph V. McMullan's catalogue of his collection, *Islamic Carpets* (New York, 1965). Two of the rugs in the exhibition, however, were not included there, and are published here for the first time (Plates XXXVIII and XLI). The remaining plates are printed, by permission of the Near Eastern Research Center, from the blocks made for *Islamic Carpets*, in which every item is illustrated, from photographs taken by Otto Nelson.

For convenience of reference the numbering in this catalogue remains that of *Islamic Carpets*; hence there are gaps in its sequence. The previously unpublished pieces are numbered 97a and 105a to indicate their notional position in *Islamic Carpets*.

When no other ownership designation appears in the entries the carpet remains in Mr. McMullan's possession.

A ndmber of the rugs included in the catalogue are not exhibited owing to pressure of space.

ERRATA
Plates III and IV: the catalogue numbers are reversed.
Plates XV and XVI: the catalogue and the plate numbers are reversed.

Mamlūk

This and the following two small, rare and sophisticated groups from three different areas occupy a special position as they exhibit only relatively minor clues of ancestry, and have almost no descendants.

An important feature common to these three types, and to Persian rugs of classical design, is that they are made from complete cartoons which always establish a balanced field pattern. This completeness is particularly emphasized in the borders where all the corner devices are especially designed to fill the corner areas in such a fashion as to secure a continuous pattern.

The elaborate geometric carpets of the Mamlūks of Egypt were probably well developed in the 15th century, existing examples surviving from the 16th and 17th centuries. They are marvels of complex geometric design containing only small floral devices. It should be noted that the geometric outlines of their pattern elements go beyond the usual basic figures such as triangles, squares, oblongs, trapezoids, and octagons. Space is filled to a large extent with delicate floral sprays, derived from the papyrus shrub, rolled leaves, and small tree forms resembling the cypress. A later type, although related in colour and technique, is greatly simplified with designs carried in panels of uniform size.

The geometric Mamlūk rugs have a certain relationship with cut loop pile rugs produced by the Copts, before the Arab conquest (M. S. Dimand, 'An early cut pile rug from Egypt', *Metropolitan Museum Studies*, vol. II, 1930, pp.239–52).

The Textile Museum in Washington has by far the largest collection of Mamlūk rugs which was published by Dr Ernst Kühnel, with technical assistance from Miss Louisa Bellinger, in 1955 (*Catalogue of Cairene rugs and others technically related*, Washington, 1955).

I

PLATE XIX
L.6ft.4in. w.4ft.6in.

There is little distinction between field and border and between major and minor pattern elements in Mamlūk rug designs. All elements seem to interpenetrate each other forming a tightly packed geometric design of a great variety of individual forms. Medallions, rosettes, cartouches, stars and arrow-head shaped units, all greatly varying in size and individual outline, create a pattern of unparalleled complexity. In the 'field', floral shrubs of the papyrus type and rolled leaves are used to fill every inch of the given space. The extraordinary elaboration of these patterns is unified by the use of only two main colours, a deep burgundy red and a light green.

New York, Metropolitan Museum of Art. Given 1971

2

L.8ft.1in. w.3ft.7in.

This fragment is very similar in design and general execution to no.1, though somewhat simpler in composition. In this piece the border, which unfortunately is missing in no.1, but which is typical of many of these carpets, has been preserved. There are two main borders, both filled with identical designs: a long cartouche alternating with an indented circular medallion.

Washington, D.C., Textile Museum Collection

3

PLATE XX
L.6ft. w.4ft.2in.

In addition to the rugs of the early Mamlūk period with a highly complex pattern (nos.1 and 2) a much simpler group appears in Egypt at the end of the 16th century. The design of these rugs differs greatly from those of the earlier type.

In this rug the field is divided into nine oblongs which in turn are filled with octagons in the centre of each of which appears a slightly oval star medallion, surrounded by floral sprays and small rosettes. The border also shows a change: diamond-shaped cartouches alternate with oblong panels from which spring palmette sprays. In these rugs we no longer have the great imaginative power of the earlier examples, but still the essence of the particular spirit of Egyptian rug design remains.

New York, Metropolitan Museum of Art. Given 1969

The second of these isolated groups consists of floral carpets frequently termed 'Turkish Court Manufactury', but also variously called Ottoman, Cairene, and Ottoman-Cairene. The style originated about 1550 during the reign of Sulaymān the Magnificent, continued through the 17th century under Sultan Aḥmad, and finally degenerated in the 18th century. Some 18th century rugs called 'Smyrna' use similar palmettes, but beyond that they are of different composition, colour, and wool.

About 1550 the court of Sulaymān the Magnificent gave birth to a new school of pottery and tile production with centres at Iznīk and Kutāhiya, and a school of sumptuous brocade weaving and embroidery with production centres in Brusa and Scutari (Üsküdār). Not to be outdone the rug designers and weavers created a new and delicate style which has become known as that of the 'Turkish Court Manufactury'.

For the first time in Turkey there appeared a feeling of ecclecticism, as the carpet designs show a definite connexion with the motives on the textiles and even more so with those on the tiles. The robust and forthright character previously known, and still carried out elsewhere in Turkey through the 18th century, was succeeded at the court centres by a delicate, almost feminine approach.

Probably the leading feature is the universal appearance of curled leafy fronds of the most delicate outlines. As companions, palmettes and rosettes, drawn with exquisite skill, complete the field designs. The arabesque is still known and used to advantage, particularly in medallions, some of which are of round, others of ogival form. A dominant central medallion, such as is used in the Ushaks and the rugs of Northwestern Persia, is not used. The silk foundation, the basic colours, and the wool itself, are clearly closely related to those used in the Mamlūk rugs. There is, however, no connexion with the designs of those rugs. It is still not clear whether these new designs were introduced into Egypt after the Turkish conquest or whether Egyptian weavers were brought to Turkey, that is, in other words, whether these rugs were made in Egypt under the new Turkish rule or whether they were initially made in Turkey by Egyptian weavers. It is to be hoped that information in Turkish archives which is gradually being made available, will eventually bring us the answer to this question.

4

PLATE XXI
L.6ft. w.3ft.7in.

Only very few rugs of this particular type have survived. A central theme of palmettes, varying in scale, is carried on a thin graceful trellis from which spring feathery, leafy fronds and arched sprays of small floral rosettes. The arches of the prayer niche are filled with curved arabesques; the lower corner pieces, with Chinese cloud bands. A border of palmettes and fronds complements the field.

New York, Metropolitan Museum of Art

5

L.5ft. w.5ft.5in.

Three almost identical fragments, all about 5 × 5 feet, still survive from what was originally a large carpet. The other two fragments are today in the Victoria and Albert Museum and in the Musée des Arts Décoratifs in Paris. In addition, Mr Charles Grant Ellis, Research Associate of the Textile Museum in Washington, has tracked down a number of small pieces that seem all to come from the same carpet.

The design of this fragment shows a field of gracefully curved serrated leaves, palmettes and rosettes, similar to those in no.4. In the field pointed, scalloped, ogival medallions in repeat appear as the main pattern element. They contain floral quatrefoils sharply outlined. Finely drawn palmettes and gracefully curved leaves complete the design. The secondary repeat of smaller scale contains a cloud band with two small trefoils, identical to those of the larger medallions.

New York, Metropolitan Museum of Art. Given 1972

6

PLATE XXII
L.6ft.6¾in. w.4ft.4in.

A so-called 'thunder-and-lightning' symbol covers the entire field of this rug. Against this background appear a single, scalloped central medallion and four corner pieces. The borders are of special interest. The main border has a dual meandering scroll, one beset with rosettes, the other with palmette blossoms. An unusual feature (see also nos.4 and 7) is to be seen in the centre of each border section: a special palmette, pointing inward in the centre of the long sides, and outward at the narrow sides of the rug, is placed on axis defining the centre of each side of the rug.

New York, Metropolitan Museum of Art. Given 1971

Mughal

The last of these groups is composed of carpets from the courts of the Mughals of India, many produced in Lahore, Pakistan. Their main feature is a naturalistic treatment following the general style of decoration developed during the reigns of the emperors Jihāngīr and Shāh Jihān.

The Mughal dynasty originated with the Emperor Bābur (1526–1530) who claimed descent from both Chingiz-Khan and Tamerlane (Tīmūr). He was succeeded by a fascinating group of men, the Emperors Humāyūn (1530–1556), Akbar the Great (1556–1605), Jihāngīr (1605–1628), and Shāh Jihān (1628–1657), probably best known as the builder of the Taj Mahall, the mausoleum for his beloved Persian wife, the Empress Mumtāz Mahall. The decline of the dynasty was marked by the reign of the Emperor Awrangzīb (1658–1707).

It is notable that Humāyūn spent considerable time as a refugee at the court of Shāh Tahmāsp in Tabriz and that from this time on, with the marriage of Persian women to many Mughal emperors and nobles, the art of Persia exerted a strong influence on that of the Mughal dynasty. Documentary evidence exists that during the reign of Akbar a considerable number of Persian rugs were imported to the Mughal court. Despite this Persian influence, the Mughals developed an individual style of their own in which the floral forms are drawn far more realistically than in the Persian rugs.

The collection includes only one of this floral type, a woollen prayer rug (no.7). Only two examples seem to have survived; the other was in the Engel-Gros Collection.

A second piece, a fragment, displaying a fantastic group of animals devouring one another (no.8), represents a group of highly unusual and particularly original Mughal rugs.

Only the Metropolitan Museum of Art in New York and the Victoria and Albert Museum in London have representative collections of Mughal carpets in the West.

7

PLATE VI
L.5ft.1in. w.3ft.4½in.

The field of this extraordinary rug is dominated by a single large flower, probably a chrysanthemum, filling almost the entire field from the bottom to the arched top. A highly realistic effect is achieved by rendering both leaves and flowers in almost full-face position giving the weaver the possibility to represent them in great detail. Below, on either side of the main flower, appear smaller flowers, probably tulips. Interlacing leaf stems provide the transition from the field to the spandrels of the arch above. These spandrels are filled with a chrysanthemum scroll on a fairly large scale, but in colours contrasting to those of the chrysanthemum in the field. In addition two of the blossoms on either side are drawn in profile view. The border design is based on a meandering floral scroll. But the floral rosettes of this scroll are conventionalized and can no longer be identified botanically, with the exception perhaps of the four poppies in the corners and four more in the centres of the longitudinal as well as the lateral borders.

New York, Metropolitan Museum of Art

8

L.2ft.6½in. w.1ft.9½in.

Quite a number of fragmentary pieces of this remarkable animal carpet have survived, none of which can however be joined to any of the others.

No other carpet known presents such an utterly fantastic grouping of animal forms. There is in this fragment, for instance, a bird with one body and six heads. One beast has a long, swordlike beak, rudimentary wings, a tail around which a serpent is coiled, and no feet. In another segment an imaginary creature is shown devouring a rabbit. An animal of the fox family, with well-developed forelegs, rudimentary hind legs and without a tail, seems to be attacking an enemy not represented. Scattered through the field are detached floral devices.

Various attempts have been made to interpret the meaning of this fantastic design, none of which can be called conclusive. Such rugs have been dated by various writers as early as the 16th century, but a 17th century date seems to be more likely.

New York, Metropolitan Museum of Art. Given 1971

Persian

With the fall of the White Sheep Turkmans in 1502 a new and native Persian dynasty came into power in Iran, establishing Tabrīz, in Northwest Persia, as its capital. The first Shāh of this dynasty, Ismā'īl, spent most of his life in warfare, and had a relatively short rule after gaining power.

His son, Shāh Tahmāsp, had an extraordinarily long rule from 1524 to 1576. He greatly encouraged the arts and he was an accomplished artist himself.

The well-known Turkish abstract patterns that dominated all rug design up to the very end of the 15th century were replaced by a medallion style, which was created not by the weavers but rather by the painters and illuminators of the court school, who had now assumed a more prominent position than ever before. The large characteristic central medallions served to give the rugs a monumental character. Some of them are of supreme simplicity and austerity, others are more elaborate, introducing a great variety of decorative motives. Both types are represented in the collection. The most famous of all, the Ardabīl carpets, woven as a pair in 1539–40, are represented by a small border fragment from one of them, consisting of part of a cartouche and a roundel (no.9). A corner fragment of the more austere type was purchased in New York some years ago, and was found to be the end of a rug in the Victoria and Albert Museum (no.10).

Additional types developed during the time of Shāh Tahmāsp were animal carpets and hunting carpets showing mounted horsemen in pursuit of game.

A remarkable fragment of the animal type, with one design superimposed over the other, is in the collection (no.14). Finally, rugs almost entirely floral, ancestors of the well known 17th-century 'Iṣfahāns', and some silk rugs apparently produced in Kāshān, complete the extraordinary development of this form of art at the court of Shāh Tahmāsp.

9

Top: L.10½in. w.9in. Bottom: L.18in. w.14in.

These are two fragments from the border design of one of the two Ardabīl rugs of 1539–40 which are undoubtedly the most famous of all existing carpets. They have been described in great detail in many publications. It is well known that both carpets had suffered some damage and that parts of one were sacrificed to complete the other, which is today in the Victoria and Albert Museum. During the process of this work a few small pieces, mainly from the borders, were not used and came on the market. The incomplete, though still splendid, companion piece is now in the Los Angeles County Museum. Its field is fairly complete but all borders are missing.

This border fragment has a complete eight-lobed medallion, filled with balanced arabesques and a floral scroll, and two sections of a cartouche, decorated with a large Chinese cloud band motif.

Washington, D.C., Textile Museum Collection

10

L.7ft.7in. w.5ft.1in.

This fragment is of particular importance. It fits with a superb carpet of the early 16th century in the Victoria and Albert Museum of which both ends had been cut off (*Survey of Persian Art*, vol. VI, 1939, pl.1112). The discovery of this corner piece made a reconstruction of the entire pattern possible. It establishes the complete original composition of the London rug and shows the design of the corner pieces which differs from that of the central medallion. *Note*: The carpet in the Victoria and Albert Museum hangs on the staircase leading from Room 33 to Room 107 with the fragment exhibited here immediately below.

London, Victoria and Albert Museum

11

PLATE VII
L.28ft.2in. w.10ft.7½in.

No Persian carpet at any known period nor from any other area exhibits the severe austerity of this particular type from the Northwest.

The deeply indented stellate central medallion is the base from which springs at each end first an oblong cartouche and finally a medallion pendant. These dominate the scroll system of arabesque stems and blossoms arranged in a method easily traced and easily followed, contributing to the basic austerity. The field is relieved by four-lobed corner pieces of a design different from the central medallion, consisting of two asymmetrical cloud bands and small blossoms. The border design is equally austere, displaying interlocking, rigidly drawn meanders; one system contains nothing but small blossoms, the other is similar but has large palmettes. *Note*: The rug has been photographed from the back as the pile is so worn down in parts as to obscure the design.

New York, Metropolitan Museum of Art. Given 1964

12

L.32ft.2in. w.14ft.2in.

This is one of four Northwest Persian rugs that seem all to have been made in the same workshop.

A large complex central medallion almost touches the sides of the field with the traditional cartouche and large pendant palmette attached at both ends. The basic design conforms to standard patterns of oval arabesques but is distinguished by the large number of cloud bands, practically all asymmetric, which add a great deal of liveliness and animation to the extraordinary field.

Chicago, Art Institute

13

PLATE I
L.3ft.11in. w.3ft.6in.

A few 16th-century Persian rugs with designs of the highest sophistication, complexity and nervous energy have survived. Probably the most noteworthy are the so-called 'Emperor Carpets', one of which is in Vienna (F. Sarre and H. Trenkwald, *Old Oriental Carpets*, 2 vols., trans. by F. A. Kendrick, Vienna 1926-9, vol. I, pls.6 and 7), its mate in the Metropolitan Museum in New York (Acc. no.43.121.1). This is a fragment of still another such piece.

Basic expression in the field is secured by placing one series of forked arabesques over another. Either system in itself is a complete and satisfactory design. However, the blending of two such arabesque designs is an outstanding achievement. But the designer was not satisfied with the dual floral system bearing a series of palmettes and rosettes of varying scale, but chose to introduce asymmetrical cloud bands as well, along with flying birds. In strong contrast to the apparent freedom of the field pattern are the large-scaled geometrical units displayed in the border. Here we find a multilobed medallion containing what appears to be either a cheetah or a leopard attacking a gazelle. Adjacent is half of an oblong cartouche whose principal decoration is an elongated, balanced cloud band. Moving along the border is a chain of balanced, interlocking cartouches, ornamented in the centre with arabesques and on the flanks with huge half palmettes. All the elements described above create a field of odd-shaped areas ornamented principally with birds perched upon a simple scheme of vines and blossoms.

New York, Metropolitan Museum of Art. Given 1970

14

PLATE II
L.24ft.1in. w.9ft.10in.

In this rug we have the 16th-century ancestor of the Iṣfahāns of the 17th and 18th centuries, frequently incorrectly dated into the 16th century.

Included in the Chicago Exhibition of 1926 (no.14) it has been described in detail by Arthur U. Pope. Our description follows largely his masterful analysis.

'The field is ornamented by a rich and brilliant array of huge palmettes, numerous styles of lotus flowers, pairs of phoenix and many cloud bands, with asymmetrical loops placed at various angles throughout. The main floral motives and dainty star-like interstitial blossoms are set on two orders of even, delicate spirals on conflicting circuits. The entire design moves in stately measure symmetrically about an invisible centre.'

Dr Pope concludes his discussion as follows: 'Not all of the so-called "Iṣpahāns" are on a red ground with a green border. While that style was always popular and became stereotyped by the European demand, the older quieter harmonies of blue and gold, such as we find dominant in the Ardabīl carpet and in some of the pieces from Northwest Persia, were favoured by the early designers. The perfection of this carpet, which is evident

when compared with the commoner types, consists not merely in the quietly satisfying colours and perfect drawing, but in the conception which reveals an unerring knowledge of the vital moving qualities of lines, so that they contagiously swing a sympathetic observer into their own easy and graceful motion.' (Chicago Exhibition, p.53.)

New York, Metropolitan Museum of Art. Given 1959

15

L.7ft.8¾in. w.5ft.3in.

The pattern of this rug, following a well-established tradition of floral and animal design, has all the indications of a hunting scene, only that the hunters are missing.

Four trees radiate from a central eight-lobed unit which may represent a pool. The field is filled with a variety of floral forms and animals of the royal hunt, leopards, gazelles, and 'kilins'. The magnificent double-scroll of the border complements the palmette design of the field on a larger scale, and provides a strong frame, giving the impression that the animals are confined to the royal hunting ground.

Cambridge, Mass., Fogg Art Museum, Harvard University

There was a short interval of minor rulers after the death of Shāh Tahmāsp; finally a truly remarkable sovereign appeared, known as 'Shāh 'Abbās the Great.

He moved his capital to Iṣfahān in 1598 largely rebuilding the old city. His great mosque at the Maidān-i Shāh, the mosque of Sheikh Lütfullah opposite the Ali Qapu, part of the Shāh's palace, the bridges over the Zinda-rūd and the great avenue of Chahar Bagh all testify to the magnificent achievement in art and architecture of his period, which lead to the expression: 'Iṣfahān is half the world'.

But architecture and architectural decoration did not take all of his time. Under his patronage a great school of painting flourished, and magnificent rugs were woven on the court looms for the royal palace and other new buildings of the capital.

The first and most famous type is the Vase carpet, of progressive floral design which springs from a vase; similar rugs use the floral trellis only. A sumptuous group with silk pile, the so-called 'Polonaise', used for export and to some extent as royal gifts, were woven in both pile and tapestry (kileem) techniques. The most comprehensive collection of such rugs is today in the Metropolitan Museum of Art, New York (John D. Rockefeller, Jr. Collection). They feature both floral and animal

patterns, but are much simpler in composition than their predecessors of Shāh Tahmāsp's time. The third group attributed to Shāh 'Abbās is quite rare, and not too well known. It is an arabesque type, represented today almost entirely by fragments. Never has such bold interlacing appeared in rug design before or since. An all-over pattern of large palmettes proved so popular that it was copied extensively, and persisted in the Caucasus well into the 19th century. It is popularly known as the 'Shāh 'Abbās design'.

Although probably not originating from the court school in Iṣfahān, but created in a North Persian centre, are a number of types that were also first made during the reign of Shāh 'Abbās. These are the so-called Tree and Garden carpets.

16

PLATE IV
L.11ft.11in. w.5ft.10in.

This rug, published first by Jacoby (H. Jacoby, *Eine Sammlung orientalischer Teppiche*, Berlin, 1923, pl.2), was also shown in the Chicago Exhibition of 1926 (no.20); we follow in our description Dr Pope's text.

'The field is resplendently decorated with palmettes, rosettes, lotus flowers, and vases set on a double order of stems that outline irregular ogival lattices, alternating with sprays of fruit blossoms and masses of flowers, including thistles, Persian roses, asters, coreopsis, evening primroses, poppies, primulus, iris, and a willow tree. There are numerous small *tchi* forms.'

Dr Pope concludes the discussion: 'Although this carpet is incomplete, it must nevertheless rank as one of the finest of the Vase carpets known. It still preserves something of the dignity and scale of the earlier pieces now refined and enriched without becoming lost in the intricate maze that so delighted the later designers. Such accuracy and delicacy of contour, such consistency of perfect drawing, such firmness and restraint are scarcely found in any carpet. The growing influence of the painters with their increasingly naturalistic and pictorial effects is clearly shown here. Without losing the decorative character the patterns have acquired botanical accuracy. The entire pattern is arranged with a freedom of invention and sophisticated asymmetries which, despite their boldness, are perfectly harmonized and controlled by the major plan, here unfortunately fractured by a missing section. This freedom, if attempted by a designer less wise and experienced, would certainly have yielded confusion, but here we have a deeply satisfying richness and a quiet peace.' (Chicago Exhibition, p.65).

A companion piece is in the Victoria and Albert Museum. See: *Survey of Persian Art*, vol. VI, 1939, pl.1227.

Cambridge, Mass., Fogg Art Museum, Harvard University

17

PLATE III
L.6ft.9in. w.4ft.8in.

Variants of the vase pattern occasionally occur, here with the introduction of a dominant new note in composition, the stellate central medallion, enclosing arabesque sprays and buds with corner pieces to correspond. The border design is derived from no.16, though it is simpler in outline. This rug was included in the Chicago Exhibition of 1926 (no.19) and was described by A. U. Pope. Our description again largely follows Dr Pope's text.

In the field a rich assortment of decorative but naturalistic flowers, campanula, narcissus poeticus, iris, willow shrub, rose, calendula, carnation, aster, lily and fruit blossoms, is arranged around a small but vigorous central eight-pointed star medallion ornamented with energetic interlacing arabesques and numerous small *tchi* forms, characteristic of this type. In the corners are quadrants of the same medallion.

Dr Pope concludes his discussion of the rug as follows: 'Although the vases and huge palmettes are missing, this carpet is a worthy member of the great group of vase carpets. The flower patterns are identical with the flowers of many of the larger pieces as well as of well known fragments, and the scattered *tchi* forms are a characteristic mark of these weavings. To have attempted in such small compass the huge flower forms would have betrayed a lack of taste and understanding. But for all its small dimensions, and it is the only small rug of the kind known, it has maintained the virility and clarity of the best of the type and to this have been added a freshness and charm of colour that bring a joyous quality into the style somewhat lacking in the solemn early carpets and most appropriate to the smaller and more intimate size.' (Chicago Exhibition, p.63.)

New York, Metropolitan Museum of Art. Given 1970

18

L.13ft.2in. w.5ft.10in.

All the sprays and shrubs characteristic of the type, a Vase carpet variant, are here, but substituted for the vases are a central medallion and corner pieces.

Although the outline of the original ogival medallion is still in position, its field is, for some unknown reason, a replacement. It can be assumed that the colour and design are similar to those of the original, but unless the original is discovered, its actual appearance will remain unknown. A spirited border of forked arabesques and palmettes, flanked by trefoil guard borders, completes the composition.

Washington, D.C., Textile Museum Collection

19

PLATE V
L.8ft.10in. w.4ft.

Now and then a carpet has been found, shaped to fit a given area. Such rugs are fairly common in Mughal India, and do occasionally occur in Ottoman-Egyptian types, but they are rare in Persia. In fact, this is the only rug of this kind from Persia that has come to my attention. Although the rug is incomplete, the side borders, springing at approximately 45° angles, suggest that the rug was originally octagonal or hexagonal. We do have the full length, and it is probably safe to assume that the medallions at the right represent the original central axis of the pattern. If this be true, it would follow that the length and width of the complete piece were almost equal. As the rug is woven in a technique similar to that of the Vase carpets, it is safe to assume that it was made in the same area. The design, featuring indented quatrefoil medallions in repeat, connected by large serrated leaf forms with a variety of floral stems scattered through the field, is quite unusual. It can be related to a large carpet in the Victoria and Albert Museum (*Guide to the Collection of Carpets*, London, 1915, pl. VI).

New York, Metropolitan Museum of Art. Given 1970

21

L.4ft.6in. w.4ft.5½in.

One of the glories of the Shāh 'Abbās school is a group of rugs wherein the forked arabesque is the dominant feature, so clearly displayed in the design of this piece (one of two fragments from the same carpet in the collection). On closer examination we can find a secondary scroll system from which spring practically all of the floral elements with the exception of the elaborate palmette forms carried by the major arabesque system.

A closely related fragment was published by Arthur Upham Pope (Chicago Exhibition, 1926, no.21). It seems that complete rugs of this type have not survived, which would indicate that they were made in very small numbers. That the arabesque style of this type has survived in later carpets is demonstrated by no.22 in this exhibition which was made for a Kurdish chieftain in A.D.1794. In addition to this late 18th-century example, excellent 19th-century rugs called Bijars were produced practically to the turn of the 20th century. With designs based on the arabesque system, these later carpets are also made on a solid double warp. We can therefore conclude that the three well-known design types developed at the Iṣfahān court during the period of Shāh 'Abbās were made not far from Iṣfahān.

New York, Metropolitan Museum of Art. Given 1970

22

L.14ft.4¾in. w.4ft.7¾in.

This rug is a splendid echo of the Arabesque and Vase carpets brought to perfection during the time of Shāh 'Abbās the Great. The only element missing is the vase itself. A powerful system of arabesques is the framework connected in many places by a variety of superbly drawn palmettes, crisp and clean in every outline. With the exception of the palmettes, the semi-naturalistic flower and shrubbery of the field pattern all grow in one direction, which of course is characteristic of the early Vase carpets. At the very top a small ivory cartouche appears with an inscription which contains the name of Alī Riza Khan, and the date A.H.1209 (A.D.1794). It also appears to mention the Kurdish town Gerous, near Bijar. It is surprising to find such a rug, standing fully in the great tradition of 17th century arabesque patterns, woven as late as the end of the 18th century. However, to quote Dr. Pope: 'this carpet is important far beyond its years.' It should be noted that in all probability this Kurdish chieftain had, through inheritance or gift, an original carpet of the Shāh 'Abbās arabesque type and chose to attempt a weaving of equally superior design.

The carpet has been studied by scholars both in the United States and in Europe. They have all unanimously agreed that, were it not for the inscription, they would not have hesitated to date it into the 17th century.

New York, Metropolitan Museum of Art. Given 1970

23

L.3ft.7¼in. w.3ft.5¾in.

There is a rather rare group of rugs generally known as 'Portuguese' due to the fact that European ships and figures in Portuguese dress are included in their field designs.

The main feature of these 'Portuguese' rugs is an enormous central motif made up from a series of superimposed medallions with large-scaled leafy outlines. In this fragment, a part of this central design has been preserved, showing five successive border sections of such superimposed medallions.

These rugs have been considered to have been made in Southern Persia or India.

Washington, D.C., Textile Museum Collection

25

L.8ft.10¼in. w.6ft.2½in.

Although dating not earlier than 1800, or perhaps even later, the composition of this rug is a lineal descendant from such rare 16th century pieces as no.13, and from a large number of 17th and early 18th century rugs produced in Persia, imitated in India, and commonly called Iṣfahāns.

As time passed the fundamental pattern of rosette and lancette leaf carried earlier in large scale, became smaller and smaller. Some 19th century rugs, such as the so-

called Feraghans and Khurasans, reduce it to such minuteness that the entire field is tightly filled with scarcely any ground left undecorated.

This example still displays proper recognition of a sound ratio between the field and the design which it bears.

Close examination will disclose a number of small figures, most of which are shaped like a cloud band or a Greek Omega and scattered at random through the field, a sign of unsupervised work.

26

PLATE VIII
L.21ft.7in. w.7ft.6in.

Tree carpets based on a formal garden scheme have been preserved in very small numbers; only four or five pieces still exist.

The basic design of this rug is essentially quite simple. The field is organized by alternate rows of smaller multi-lobed medallions and larger reciprocal cartouches. The medallions alternate in width and colour and, from the wider ones, four trees of two species grow, filling most of the field. Both the medallions and the cartouches are decorated with palmette patterns. The border pattern is unusually simple, consisting of separate units, each of which displays a repeat design of diamond-shaped rosettes from which spring very heavy, forked arabesques. It seems that carpets of this type might have come from Northern Persia rather than the Northwest, since the border design is less elegant than in those of the 16th century Northwest Persian rugs from which it was derived.

New York, Metropolitan Museum of Art. Given 1960

27

PLATE X
L.22ft.10in. w.8ft.10in.

Kurdistan has not usually been given its due as a region which has produced rugs of considerable excellence of design and rich brilliant colours, probably from early times on, well into the 19th century. Technically they range from the solid, heavy, double-warped Bijars of the 19th century to the flexible rug of this type, and the kileems, or flat-woven rugs of great delicacy. The design displayed in this example, clearly derived from a 17th century model, proved popular both in Eastern Persia and in the Caucasus. It continues well into the 18th century and can still be found in Caucasian rugs of the 19th century. The design is based on an alternating succession of two large lateral palmettes surrounded by small palmette blossoms, and a complex palmette arrangement composed of a central round floral medallion, four large palmette forms of two different designs facing this rosette, and four diamond-shaped cartouches, filled with rosettes, on the diagonal axis. A small-scale trellis system, as a secondary pattern, fills most of the background of the field.

New York, Metropolitan Museum of Art. Given 1968

29

PLATE IX
L.22ft. w.8ft.

In this rug all major pattern elements are derived directly from the design of a Persian garden. There is a main stream down the centre and lateral streams flowing from it on either side containing stylized fish. Three garden plots in the centre of the main stream indicate areas where shaded pavilions would usually be placed. Shade is provided by Chinar trees (Sycamore or Oriental Plane). Shrubbery of various kinds is indicated throughout the field and, as is usual in almost all garden rugs, a decorative floral border is provided which gives definition to the entire composition. The general colour scheme, technique and character of the wool tells us that this carpet, though classed with the Persian group, is actually a product of the Kurds. Some earlier formal garden carpets exist strictly of Persian manufacture. The finest of all is in the Jaipur Museum in India and was published in an excellent article by Maurice Dimand (*Ars Islamica*, VII, 1940, pp.92–96).

Cambridge, Mass., Fogg Art Museum, Harvard University

A rare series of rugs usually of extremely fine weave were originally thought to have come from India. It is, in fact, true that there are certain similarities between their design and certain velvets and cottons of Indian manufacture. But now this group is generally attributed to South Persia at the time of the Zand dynasty, which had established itself in Shīrāz, but collapsed after the conquest of the city by the Qājārs in the late 18th century. Resemblance to some of the Indian work seems more plausible when we realize that during this period Persia was in a state of anarchy with practically no communication between North and South, which caused South Persia to seek trade connexions with India.

The best known design type is the prayer rug which invariably shows at the base a vase from which springs an exuberant growth of palmettes and semi-naturalistic flowers covering the entire field. Spandrels in contrasting colours display similar flowers but usually include a diamond-shaped outline enclosing a palmette. Borders show forms similar to those in the field in repeat but with tighter discipline.

In contrast to the exuberance of the basic field pattern, half of a cypress tree is found on either side.

Other rugs are of an all-over pattern almost invariably with the flowers drawn in a somewhat naturalistic style; occasionally a small medallion might be inserted in the field and medallion sections in the corners. The surface of all these rugs has a peculiar feeling almost like that of raw silk; it seems,

however, that the pile is actually made of the fine underhair of the goat.

30

There are three South Persian prayer rugs in the collection all following basically the same idea of design; an enormous bouquet of flowers filling all of the field 'grows' out of a small vase placed at bottom centre. Cypress trees flank the field, and an arch appears above.

In this particular rug the floral elements of the field are designed in a strangely geometrical fashion, the majority of stems being drawn in straight lines, forming a strong contrast to the curvilinear floral patterns of both the base and the arch. The border design consists of a straight line trellis, forming octagonal sections, filled with floral shrubs alternating in pairs, and joined by alternating palmettes and rosettes.

The weave of this rug is exceedingly fine with about 700 knots to the square inch, a true *tour de force* of technique, creating a surface appearance similar to that of velvet.

The rug was given to the collection by Mrs Mc-Mullan.

New York, Metropolitan Museum of Art. Given 1970

31

L.5ft.8in. w.3ft.6in.

This rug is basically identical with no.30, but certain differences can clearly be noted. All pattern elements are drawn to a larger scale, the vase is standing on a clearly outlined footed shallow dish, the flower bouquet is curvilinear in design, less tightly packed and of a stronger stem system; the colour of the field is light, setting off well the flower motifs. The decoration of the spandrels of the arch consists of a loosely drawn floral scroll with thin stems creating the impression of a floral spray rather than that of an organized scroll system. The cypress trees to the right and left are very gracefully drawn accentuating the typical leaf form of the trees; the tree trunks are higher and elaborately ornamented.

Cambridge, Mass., Fogg Art Museum, Harvard University

32

L.6ft.4in. w.4ft.2in.

A third South Persian prayer rug bears the familiar stamp, but again with certain differences.

The vase, raised higher in the field, is bulbous at the bottom, rather than cone-shaped. The blossoms of the bouquet are largely carried in straight lines, as in no.30, but arranged in an entirely different manner. A large beaded palmette dominates the upper field. The greatest difference lies in the main border design, which consists of a curved meander, bearing sprays of small blossoms repeating one type seen in the field. All guard stripes are identical with no.30. Published in colour in *Survey of Persian Art*, vol. VI, 1939, pl.1275.

Chicago, Art Institute

33

L.8ft.3½in. w.4ft.5in.

The field pattern is based on a continuous succession of rectangles created by floral stems beset with small flowers and connected by small floral rosettes. Superimposed is a second system of a thin-lined floral trellis creating a succession of diamond-shaped medallions, clasped by a group of larger floral rosettes which appear in the centres of the oblongs. All of these geometrical forms are filled with flowering shrubs of different varieties.

New York, Metropolitan Museum of Art. Given 1967

Persia produced beautiful rugs in the 19th century, particularly those known under the trade names of Feraghan, Jushagan, Sarabend, Hamadan, Khurasan, Heriz, etc., plus certain tribal rugs such as those of the Kashkai, Bachtiari, and Afshari which are of excellent decorative value. They have, however, survived in such quantities and are so well known through frequent publication that they have not been included in this collection. Nevertheless, a small group of rugs from Persian Kurdistan is of sufficient interest, as they are rare and quite original.

35

L.5ft.3in. w.4ft.

The pattern of this tapestry-woven prayer rug is composed of a continuous succession of a small stylized flower with a diamond-shaped blossom. Every shrub is identical in contour, but colour changes at two intervals in both field and spandrels not only give life to the design, but also carry the eye from the base to the apex of the niche. The inner border, a diamond-shaped chain, provides an echo to the terminals of the shrubbery in the field. In contrast, an outer border consists entirely of detached hexagons, which contain leaf forms as delicate as those in the field. The whole is well set off and defined by minute reciprocal trefoils.

New York, Metropolitan Museum of Art. Given 1970

36

L.5ft. w.3ft.8¾in.

The entire field of the rug is filled with horizontal rows of shrubbery. Variety is attained by subtle changes in design and colour. The spandrels of the scalloped arch are decorated with a geometrical diamond-trellis filled with small flowering plants, possibly carnations. The border design is complex and crowded. It is made up of small floral sprays which have little or no connexion with any of the floral ornaments in the field. Although small in scale, the two reciprocal trefoil minor borders set off well both the field and the border design.

New York, Metropolitan Museum of Art. Given 1970

37

L.3ft.1½in. w.3ft.2½in.

Flat woven, and thin as a handkerchief, this saddle cover must have been made for an important chieftain and been used on state occasions only as constant use on a saddle would have worn it out very quickly. The little leaf devices scattered through the field are in bright tones of gold, creating a metallic effect. The central pattern, taken as a unit, is very difficult to identify and has baffled various scholars who have examined the piece. There is a certain resemblance to a garden pattern but the predominantly architectural features of the design would rather suggest the representation of a palace. The possibility that the representation of a mosque was intended can be discarded in spite of the fact that the central niche recalls that of the prayer-niche representations on prayer rugs, as it would be most unlikely that a mosque would appear on a saddle rug. It is remarkable, in any event, that almost the entire field was given to the main motif and no secondary pattern elements are introduced which would distract from it. Even the borders are kept narrow and unobtrusive in pattern, corresponding, however, in colour, to the main motif, and creating in this way a strong frame for the light field of this remarkable piece.

New York, Metropolitan Museum of Art. Given 1971

38

L.1ft.9¼in. w.1ft.11½in.

Occasionally a small saddle bag appears which contains in a small space such power of design as to make it a true masterpiece, even though the details may be drawn quite crudely.

The design of this rug from Persian Kurdistan is quite simple, but at the same time of perfect balance of accents and extraordinarily powerful expression. From a small central medallion spring laterally highly stylized flowers and vertically equally stylized palmettes. It is surrounded by four decorative motifs that resemble boats but are probably to be identified as birds, which, in keeping with the general abstraction of the design, have been reduced to almost unrecognizable forms of purely decorative value. Above these 'birds', in the four corners of the small field, appear palmettes of a different variety than those used in the centre. They are each composed of four half-palmette leaves drawn in profile. The design of the main border, although based on a floral meander, is reduced to a purely geometrical form.

Caucasian

No rug from the Caucasus bears the hallmark of so-called 'court-weaving', that is, the corners of the borders are not carefully drawn to secure continuity of pattern; but the monumental scale of design and the large size of the early pieces puts them among the most exciting rugs ever made and assures them of a place in the classic tradition.

The first and best known are the 'dragon' rugs. They present what has been deemed the most energetic form of decoration ever placed within the confines of a woven fabric.

They are followed by the rare trellis rugs, such as the 'Niğde' carpet in this collection (no.41), and by a group in a large, assured, and bold scale generally known as 'Kubas'.

A third early type seems to be patterned on the great Persian hunting carpets of the 16th century, but is drawn with an extraordinary sense for abstraction (no.46). A fourth style repeats a wide palette of crisply drawn palmettes and rosettes (no.44) and a frank imitation of a Persian medallion carpet reminds us of the close connexion, at this period, between Persia and the Caucasus.

In the Caucasus, just as in Turkey, a great variety of relatively simple but very beautiful types were made in the 18th and 19th centuries.

The 18th century style is represented by three different designs (nos.47–49) that relate to classical Persian and Turkman traditions.

The large 19th century group represents a reasonable survey of the principal types of the period. They include three types of techniques, knotted pile rugs, rugs of the Soumak (tapestry) type, and embroideries.

39

PLATE XII
L.10ft.8in. w.5ft.7½in.

In the entire field of textile design it would be difficult to find anything that matches the extraordinary display of controlled power exhibited in the so-called 'dragon' rugs of the Caucasus. The archaic quality of these designs caused scholars to place the first few examples that came to light as early as the 15th and even the 14th century.

It seems, however, that no existing piece is earlier than the 17th century, although a 16th century date could be contemplated for the Berlin 'Graf' carpet (K. Erdmann, *Oriental Carpets*, trans. by C. Grant Ellis, London 1960, fig.96) which unfortunately was very badly damaged in the last war.

This rug contains within the elaborate lozenge frame lattice which forms irregular cartouches (some resembling the outline of the cypress tree) highly stylized figures representing dragons; hence the name 'dragon' carpets for this type.

At the base of the field four stylized but still recognizable birds, probably ducks, are shown; on the lattice framework appear three different types of bird-forms,

all without heads, terminating in blossoms. The tails are indicated but they also end in blossom forms. Two panels of the central vertical axis are filled with pairs of deer that flee in terror. Their peculiar design is highly reminiscent of the Scythian animal style. In fact, all the animal- and bird-figures in this rug seem to have been derived from Scythian forms which would indicate a continuous tradition of design over a period of more than 3000 years.

New York, Metropolitan Museum of Art

40

PLATE XVIII
L.7ft.3½in. w.5ft.1½in.

Even though different in general design, there can be no doubt that the pattern of this flat woven rug was derived directly from the tradition of the 'dragon' rugs of the 16th and 17th centuries (see no.39). In fact, the surface is almost entirely covered with continuous rows of highly stylized, enormous, dragon figures, alternating in colour. The patterns on the bodies of these fantastic animals, although largely floral in nature, seem to indicate the presence of scales, which are particularly emphasized in the two white dragon-figures in the first row. Groups of other animals, probably stags on a minute scale, are scattered all through the field. A curious feature is the presence of three small human figures.

New York, Metropolitan Museum of Art. Given 1971

41

PLATE XIV
L.24ft.8in. w.10ft.

This rug has become famous as the 'Niğde' carpet. Although certainly produced in the Caucasus, it was found in the mosque of Niğde in central Turkey.

In contrast to the other important rug types that have been produced in the same area, the 'dragon' rugs and the so-called 'Kubas', the design of this carpet is highly unusual. It is based on a continuously alternating system of diamond shaped medallions on a huge scale. One row of these diamond panels is filled with lancette leaves, palmettes, and cloud bands; the alternate row with large cruciform figures is filled with palmettes and surrounded by half-palmette and lancette leaves. Large palmette blossoms appear at the tips of the diamond points and in the centre of each side of these panels. Alternating in the background colour, the diamond panels create an almost unparalleled sumptuous effect. The border design follows a common Caucasian motif consisting of an alternate row of hexagonal cartouches, filled with stylized floral forms, and small floral rosettes.

New York, Metropolitan Museum of Art. Given 1956

42

PLATE XIII
L.21ft.5in. w.6ft.

Next to the 'dragon' rugs, the most energetic rug designs that have been produced in the Caucasus are the monumental Kubas of which this is an exceptionally large and powerful example.

It may escape the eye at first that a centre is indicated, composed of a relatively small deeply serrated hooked palmette, surrounded by four small flower rosettes. The central axis springing from this point consists of two huge units of octagonal outline enclosing a deeply serrated floral medallion, and of floral stellate medallions of even larger scale. This second unit is repeated on either side of the centre. As usual with early rugs from the Caucasus the border is quite narrow. Its principal feature is a succession of cypress trees that all point in the same direction.

New York, Metropolitan Museum of Art. Given 1970

43

L.7ft.1½in. w.3ft.

Even though probably made only at the turn of the 19th century the scale as well as the general colour scheme and the technique of earlier rugs are fully maintained in this piece. The basic pattern, still large and vigorous, has, however, lost some of the sense for space that characterized the earlier designs.

The border design, consisting of open palmettes and serrated leaves, has been known since the 16th century. It is frequently mistermed 'wine-cup border'.

The inscription in the upper right hand corner has still not been fully deciphered. It contains possibly the name of the owner (Mahmud Khan Alfan Muhammad?) and a date (which is, however, written the wrong way round and does not make much sense; it could be read 1038, which would correspond to A.D.1628, a date that would appear altogether too early).

44

PLATE XI
L.9ft.3in. w.5ft.10½in.

Although this rug comes from the Caucasus, the design elements are derived from Persia. The grace of the Persian style is transformed into a highly stylized design consisting of an extraordinary variety of palmettes in various scales alternating with small rosettes, all drawn with the greatest skill. The Persian connexion is particularly apparent in the main border which is a somewhat stiff rendition of the well-known alternating diamond-rosette and leaf-scroll, seen frequently in Northwest Persian medallion rugs of the 16th and 17th centuries.

New York, Metropolitan Museum of Art. Given 1971

45

L.9ft.2in. w.6ft.2in.

Occasionally a Caucasian rug appears which is frankly copied from a Persian original.

The main field supports a variety of stylized floral devices having lost, however, most of the flowing quality which was probably present in the Persian original. The main border, similar in drawing to the border of no.44, is also adapted from the well-known Northwest Persian designs.

Washington, D.C., Textile Museum Collection

46

L.12ft.2in. w.6ft.

A hunting carpet is so defined through the presence of men on horseback, as distinct from an animal carpet, which contains birds and beasts only. Although the basic design is definitely derived from the great Persian hunting carpets of the 16th century, the figures here are drawn with such crudeness that they might almost be imagined the work of a child. How such primitivism found its way into a basically sophisticated design is difficult to explain. There has been no inclination on the part of the weaver to place recognizable horsemen on any of the steeds, although the ability to draw a human figure is demonstrated in at least two places, where figures are so placed as to appear seated atop a tree. Scattered through the field in addition to these trees on a rather large scale is a variety of beasts together with flowers strewn at random wherever it seemed to strike the weaver's fancy. In utter contrast to the drawing of the field, and contributing to the extraordinary effect of this piece, we find the main border, as well as the companion guard borders, drawn with considerable skill and control.

New York, Metropolitan Museum of Art. Given 1971

47

L.9ft.7in. w.4ft.3in.

Although basically a simple progressive repeat pattern, the design of this rug was obviously inspired by the garden theme which still underlay so many rug designs in the 18th and 19th centuries.

Quite unusual is the treatment of the main border which consists of a simple monochrome central stripe set off by two narrow bands with running triangles in alternate colours.

New York, Metropolitan Museum of Art. Given 1972

48

PLATE XVI
L.12ft.7in. w.5ft.6½in.

This pattern again suggests a terrace garden.

An interesting note is the presence of numerous detached designs, placed at random at the whim of the weaver. Four birds, stylized almost beyond recognition, can be seen below the central octagon in the second and third series from the bottom.

The balanced serrated leaf-volutes of the field still appear constantly in the 'skirts' of 19th century Yomut Turkman prayer rugs; the border design as carried out here is also a common feature of the larger Yomut carpets.

As the colours and technique of this rug bear no resemblance to Turkman work, it appears that the design was fashioned after Turkman models of the 18th century which have not survived, but was not made within Turkman territory but rather in the Caucasus.

New York, Metropolitan Museum of Art. Given 1972

49

L.7ft.4in. w.6ft.

One of the most popular types of rugs produced in the Caucasus, known as Kazaks, ranges from relatively small pieces, five feet in length, to a normal maximum length of nine feet. The knotting is never fine, nor need it be as the pile is usually high and shaggy. Because of its length, the pile invariably slants at a considerable angle which creates a brilliant effect when strong light falls with the direction of the pile. If light hits the surface against the pile, the absorption is so great that a deep and rich effect is produced in contrast to the brilliance just noted. Even though this effect of light is true of all rugs, even those of short pile, it is particularly true of long pile rugs such as the Kazaks.

It is quite likely that the basic pattern element outlined in white is again a water basin of a formal garden. The balance of the field is served with single rows of eight petalled rosettes, adjacent to the inside border. The rosettes enclosed in the border cartouches echo those of the field.

This particular Kazak has an importance beyond the normal as it is dated 1212 A.H., equivalent to A.D.1797. Similar designs are frequently encountered in Kazaks and can also be found in Turkish rugs, presumably dated around 1800. This is one of the earliest Kazaks which can be precisely dated, which is not only of documentary value for the development of the Kazak type, but at the same time demonstrates that the type of design used here was already well developed in the 18th century.

New York, Metropolitan Museum of Art. Given 1971

50

L.7ft.3in. w.6ft.

This design appearing here still in almost pure form in the 19th century has been in continuous use at least, to

our knowledge, from the 15th century, as is documented by rugs of this type represented in Tīmūrid miniatures and European paintings of the 15th century.

The basic pattern is very simple: oblong panels enclose stepped octagons. These in turn bear geometric rosettes and tendrils. The borders are quite narrow but they carry the powerful field with no difficulty.

New York, Metropolitan Museum of Art. Given 1971

52

PLATE XV
L.3ft.11in. w.3ft.4in.

The pendant cartouche so well known in Northwest Persian rugs of the 16th century finds an interesting 19th century survival in this small rug from the Caucasus. The squarish central medallion, however, seems to have been derived from a garden design. A common border of serrated leaves and open palmettes is drawn with unusual skill and sense of space. All is set off by the well-known reciprocal trefoils in the minor borders.

Cambridge, Mass., Fogg Art Museum, Harvard University

53

PLATE XVII
L.8ft.9in. w.5ft.3in.

It is quite unusual to find in a village or nomadic rug a field pattern worked out with such precision.

The blue central figure, enclosing a white rosette, resembles the swastika. Six other units, all close to the edge, have lost one volute. There is a constant suggestion of movement in all these figures emphasized by diagonal leaf forms; finally detached rosettes, identical with those contained in the swastika forms, are placed directly on the field. The arrangement is exceedingly attractive, powerful, yet graceful, with strong colour contrasts. The highly stylized border on a white background provides a perfect foil.

This rug need not bow to many for excellence of rhythm, controlled spacing and balance. Yet freedom of thought on the part of the weaver can readily be discerned in the large number of small floral devices dropped in here and there at the weaver's whim.

54

L.12ft.10in. w.5ft.

Stepped voluted medallions in repeat fill all of the long and narrow field of this Chichi, named after one of the larger Caucasian tribes. Variety is secured through constant colour changes and the insertion of a leaf palmette at intervals along the sides. Trefoils form the transition from the field to the borders, and are balanced by a similar border on the outside. The main border of star-rosettes, buds and stem-forms, so heavy as to resemble bars, is characteristic of the Chichi design and rarely appears anywhere else.

55

L.5ft.1½in. w.3ft.3½in.

In this Chichi a golden field supports eight rows of stellate octagons flanked by angular leaves. They alternate with nine rows formed of a plaquette, a shrub with a diamond-shaped flower, and an angular palmette. None of the design elements touches the other.

New York, Metropolitan Museum of Art. Given 1971

56

L.10ft. w.4ft.10in.

A row of deeply indented stars containing octagons forms the main design element of this Soumak. Scattered all over the field appear a great variety of small rosettes, swastikas, diamond checkerboard devices, and many other such minor motifs. A 'latch-hook' runs along the edge of the field. The designs of the narrow complementary borders are both familiar; one is based on an S, or serpent form, the other on a form similar to the Greek wave or running dog, but both are actually derived from purely floral motifs.

New York, Metropolitan Museum of Art

57

L.1ft.9in. w.1ft.9in.

Sheer geometry almost conceals the floral origin of this pattern, as there is not a single curved line in the entire design of this Sumak saddle-bag.

Deeply stepped stellate medallions containing octagons form the main element of the design. A secondary motif is a continuous connected pattern created by the voids left by the star medallions.

New York, Metropolitan Museum of Art

58

L.1ft.8in. w.1ft.5in.

The design of this small Soumak mat must be considered an extraordinary achievement as it produces with very limited means, and within an exceedingly small space, a highly powerful effect.

The field is almost entirely filled by the polygonal central medallion (from which emanate two arrow shapes both above and below and trefoil tendrils at the sides), and powerful, angular corner pieces. A trefoil tendril motif set on the diagonal around a hexagonal central figure fills most of the medallion, and similar trefoils appear in the corner pieces.

New York, Metropolitan Museum of Art

59

L.6ft.5in. w.5ft.2in.

Tiny hollow rosettes, drawn on exactly the same scale, judicious spacing and changes of colour, demonstrate how effective, and to some degree even powerful, patterns can be created. The whole scheme evolves into a series of diamond-shaped lozenges one within the other.

It will be noted that as a general rule these embroidered rugs were woven on narrow looms and frequently sewn together, in the fashion seen here. Obviously the use of such rugs would be somewhat limited, as their durability does not compare with that of the heavy knotted rugs. They were generally used as sleeping mats, bedding and couch covers.

Not too many of these older embroidered pieces still survive as no particular value was given to them by importers and so they remained at home and were usually worn out.

New York, Metropolitan Museum of Art

60

L.6ft. w.5ft.8½in.

This embroidered rug possesses much of the native charm associated with samplers, a popular production of school girls in the American West.

A simple floral shrub, drawn in profile and in lateral rows, alternates with rows of geometric items and buds in much smaller scale, on a natural white ground.

62

L.5ft.1in. w.2ft.3in.

Familiar forms such as the 'latch-hook' diamond rosette, small cartouche, S-form and small detached rosette, create a characteristic Caucasian pattern.

The piece is of more than average interest, however, as it is complete and in excellent condition. A few of the tassels at the ends have been worn, but the loops at the centre and the 'lock-strings' are intact, making it still possible securely to fasten the bags on a camel, horse or donkey back.

New York, Metropolitan Museum of Art

63

L.3ft.11in. w.1ft.8in.

Palas is a term ascribed to a special ribbed type of embroidery, a technique which probably travelled westward from Central Asia. The technique is rare in the Caucasus, but relatively common in Turkestan. These ribs can readily be detected in the field, where they furnish a positive and attractive accent to the design elements.

New York, Metropolitan Museum of Art

64

L.6ft.5in. w.4ft.7in.

A remarkable ability to create large scale within a small space is here manifest.

Two opposed rows of 'arrowheads', in sharp colour contrast, run all along the outer edge of a diamond medallion which fills the entire field with the exception of the triangular corners. At about the half-way mark, these corners too are sharply accented by a single row of similar arrowhead-motifs looking outward.

The basic foundation of the piece is a natural black, probably of goat hair, which creates an effect not often seen.

New York, Metropolitan Museum of Art

66

L.4ft.5in. w.2ft.11in.

This rug is dated 1272 A.H., equivalent to A.D.1856.

The entire field of white is covered with rows of flowers, probably carnations, all facing in the same direction, with slight colour changes. Occasional small devices are introduced from time to time at the whim of the weaver.

New York, Metropolitan Museum of Art

Of the Turkish rugs of the earliest periods, only fragments and incomplete pieces survive. Among them the rugs from Konya and Beyshehir in the Museums of Istanbul and Konya, dating almost certainly from the Seljuq period, are the most important.

A series of fragments, found in Egypt, and published by C. J. Lamm, similar fragments in the Benaki Museum in Athens, Berlin and Stockholm are all that remains from the period before the 16th century. Additional clues to rug patterns of that period (14th and 15th centuries) can be found in Tīmūrid miniature paintings particularly of the Herat school.

We can say with some certainty that in the 16th century there was extensive rug production on a commercial scale, both for local consumption and export, in the vicinity of Ushak. Rugs from that area have become known by various type names, facilitating identification. Among them are the Star-Ushaks, Medallion-Ushaks, both of which show influence of Ṣafavid Persian design, 'Holbeins' and 'Lottos' which continue the classical 15th century Turkish tradition, and the 'bird' rugs, probably an original creation of the period.

In addition a group of small prayer-rugs appeared at the end of the 16th century that continued well into the 17th century.

67

PLATE XXIII
L.14ft.7in. w.7ft.7in.

This Star-Ushak is of unusually beautiful and brilliant intense, clear and vibrant colour.

In the field, large, eight-pointed, indented stars in repeat alternate with four-sided indented diamonds, all enclosing several types of arabesques drawn with great feeling for space. The rest of the field seems to be filled with a loose floral spray. Closer examination reveals, however, an exceedingly fine trellis that connects all floral elements into a continuous, secondary pattern covering the entire field. The constantly shifting play of colour in the floral motifs throughout the rug follows no set system, adding a unique charm; it does not occur in any other piece of this type known to me.

New York, Metropolitan Museum of Art. Given 1958

68

PLATE XXIV
L.9ft.6¼in. w.4ft.10½in.

This is a fragment of a rare Ushak type, dating from the 16th century. Other rugs of this type are in the City Art Museum of Saint Louis, the Victoria and Albert Museum and the collection of Ricardo Spiritus Sanctus in Lisbon.

The typical floral trellis forms the background against which the main pattern is set. Of the main pattern only

one unit is preserved consisting of diamond-shaped medallions and complex stellate forms composed of four spade-shaped compartments set against the diagonal sides of a central octagon. It is quite curious that this octagon, even though filled with an arabesque pattern and set off from the field, still has the field colour and not the deep blue that is used for the other figures. This alternate of diamonds and stars is, however, not the complete pattern as it may at first appear, but there is a second repeat motif consisting of larger diamond-shaped medallions and squares, connected with the tips of the stellate forms by thin stems with a knot motif in the centre. The complete pattern would then appear to consist of alternate and staggered rows of stellate and large diamond medallions and small diamond and square cartouches.

New York, Metropolitan Museum of Art. Given 1972

69

L.7ft.1in. w.6ft.3in.

Occasionally a late rug turns up from an outlying village continuing in a cruder way the classic Ushak tradition. At present only few classic pieces of the late 16th or early 17th century exist, displaying the type of medallion shown here. As the prototypes are quite rare (see no.68), the appearance of the basic design in this village or nomadic piece is of more than average interest.

In the centre is a figure that recalls the principal pattern unit of no.68, a central octagon with four spade-shaped cartouches set on the diagonals, although here the octagon has been considerably distorted.

New York, Metropolitan Museum of Art. Given 1972

70

L.10ft. w.4ft.3in.

The basic design of this carpet is an alternate repeat of two major motifs; in between these main pattern elements we find small detached octagons filled with star-rosettes. The entire pattern is set against a brilliant red ground. The border design is developed from Kufic writing. In earlier examples, the actual letter forms are still preserved while in later examples, such as this, the design becomes balanced and purely decorative. For purposes of easy identification, rugs of this design have become known as 'Holbeins', as they appear in a number of paintings by the 16th century German master.

New York, Metropolitan Museum of Art. Given 1961

71

REPRODUCED ON COVER
L.1ft.1in. w.2ft.3in.

Belonging to the same family as the 'Holbein' rugs, the pattern of this fragment from a masterfully designed carpet is of an entirely different nature. The type is usually identified as a 'Lotto' design, again after the 16th century Venetian master, Lorenzo Lotto.

Instead of the 'Holbein' octagons, we find here an open design of continuously alternating rows of octagonal and cross-shaped forms created entirely from palmette leaves in yellow, set against the red of the ground.

In harmony with the 'Holbeins', the 'Lotto' rugs use the same Kufic border design. In this fragment the earlier type of Kufic border is used following still closely the forms of actual Arabic writing. It is from such forms that the purely linear decorative pattern of the later 'Holbein' rugs is derived.

New York, Metropolitan Museum of Art. Given 1972

72

L.7ft.8¼in. w.4ft.8¼in.

Another example of the 'Lotto' type, this rug displays in the field the coat-of-arms of the Doria and Centurione, commemorating a marriage between these two great Genoese families. It is therefore of considerable historic interest as it demonstrates the close ties between Genoa and the Turkish weaving centres while the Genoese merchants were established in Istanbul.

Several rugs of this type have survived.

New York, Metropolitan Museum of Art. Given 1962

74

L.6ft.5½in. w.4ft.5in.

The 'Lotto' type appears to have reached a degenerate end by the middle of the 18th century, of which this rug can be considered a typical example. The drawing has become careless, which can be particularly observed in the lateral palmettes. The rug has, however, one feature of distinction; the field, invariably on a red ground, is here carried out in blue. As far as we know, this is the only example where this change of colour has taken place.

New York, Metropolitan Museum of Art. Given 1972

75

PLATE XXV
L.5ft.10in. w.4ft.7½in.

This is an extremely rare variant of the 'Lotto' group. Only one other rug of this type, formerly in the Heinrich Wulff Collection in Copenhagen (published in *A Collection of Oriental Carpets and Rugs belonging to Heinrich Wulff*, Copenhagen, 1934, pl.10), has come to light.

The leaf forms providing the main decorative element of the design are related to those of the 'Lotto' type; however, they are now enclosed within prominently drawn octagonal medallions each containing four of these leaves with the tips pointing inward. The leaves actually spring from the small squares enclosing a small star forming the secondary pattern element. A sense of movement is provided by floral buds springing from the diagonal sides of the octagons. The border design is

loosely drawn, consisting of a rather disjointed and highly stylized palmette and rosette scroll.

New York, Metropolitan Museum of Art. Given 1972

76
PLATE XXVI
L.14ft.7in. w.7ft.7in.

In contrast to the usual brilliant red and blue colours of the Anatolian rugs, this type known as 'bird' rugs uses white as the dominant colour, both in field and border. Against this brilliant white ground a continuous pattern based on a system of highly abstract leaf forms resembling birds (hence the name of these rugs) radiating around floral rosettes, is placed. The square units formed by the horizontal and vertical rows of these leaves and rosettes are filled with floral motifs composed of palmettes and floral rosettes. In spite of the static character of all pattern elements, a sense of movement is created which probably lead to the interpretation of the leaves of the main pattern elements as birds flying around the blossoms into which they seem to sink their beaks. The design of the main border consists of a succession of reciprocal half-medallions of diamond shape.

New York, Metropolitan Museum of Art. Given 1963

78
L.6ft.10in. w.5ft.3in.

Another 'bird' rug uses again a large scale for the traditional field pattern as we have seen it in no.76, but the border design of this piece has been changed to consist of formalized cloudbands and a reduced version of a palmette scroll.

Chicago, Art Institute. Gift in memory of Margaret O. Gentles, 1972

79
L.9ft.10in. w.5ft.11in.

The main interest of this rug lies in the adaptation of a border design to the field.

Consisting of a continuous floral trellis with palmette blossoms and a heavier arabesque system, the design in its expansion over the entire width of a field loses nothing of its interest and creates an effect of strikingly controlled movement. The border design of the rug is developed from the same pattern elements, which appear in contrast to the field on a red ground.

New York, Metropolitan Museum of Art. Given 1972

80
PLATE XXVII
L.8ft.5½in. w.4ft.7in.

This highly unusual rug possibly comes from the vicinity of Ushak although it does not follow the typical patterns created at that weaving centre.

The extraordinarily powerful design, consisting of a small hexagonal central medallion and a massive cartouche-figure with two pointed ends in the field, and a complex border pattern based on highly abstract floral forms, is really without parallel.

Dr Riefstahl, while publishing a rug of the so-called Ladik type (*Art Bulletin*, vol. XIII, 1931, p.201, fig.22), draws attention to the similarity of some later Anatolian rugs to Seljuq designs. This rug does, in fact, recall equally the powerful simplicity of Seljuq art and even though not earlier than the 17th century, it preserves a concept of design no longer found in rugs of later centuries.

New York, Metropolitan Museum of Art

81
L.8ft.4in. w.5ft.8¼in.

Ushak seems to have been a major weaving centre since the 15th century. Rugs of various types were produced there well into the 19th century. Among them, the two most prominent types are the so-called Star- and the Medallion-Ushaks.

This rug is a typical example of the medallion design which was created in reaction to the Persian medallion patterns that were brought to Anatolia in the 16th century. It is, however, a late example of the type dating from the 18th century, as can be seen by the way the central medallion is drawn, anticipating the later village rugs that have been made in great quantity and variety using in the most imaginative fashion elements of these 'classical' designs for their own vigorous, entirely unconventional patterns.

New York, Metropolitan Museum of Art. Given 1972

83
PLATE XXVIII
L.5ft.½in. w.3ft.6in.

This rug, derived from the classical prayer rug and still using its niche design, only in a duplicated version, and highly abstract mosque lamp hanging from the centre of an arch, is a typical example of the adaptation of a classical 16th-century design to the new tastes and ways of expression of the 17th century.

The border is filled with a cloud band and floral scroll pattern of great beauty and movement. The inside border-stripe is left plain while the curiously elongated floral scroll of the outer guard-stripe gives a special feeling of vigour and movement.

New York, Metropolitan Museum of Art

84

PLATE XXIX
L.6ft.5in. W.4ft.10½in.

Rugs such as no.83 must have been very popular in Europe in the 16th and 17th centuries as they appear on tables in many paintings of that period. This would indicate that they were produced in great numbers, very likely under special supervision, for export to the European market. It is therefore of considerable interest to find a piece of highly individual design.

In this piece the hexagonal central medallion has been replaced by a star-shaped one filled with palmette blossoms. Floral stems crowned by star rosettes extend from the centre to the two ends of the field; four identical rosettes ornament the field. In the border design, the Chinese cloud band of the earlier standard type has been retained, but it has become heavier in outline and of a curiously squat form in the top and bottom borders. The pattern of the inner guard-stripe has been changed, containing now floral forms almost suggesting swastikas.

This rug is, of course, crude in detail and lacks the balance of the earlier types, but it has in its original handling of the traditional motifs a special charm of its own.

The entire history of rugs possesses no more intriguing group than a series, popularly known as 'Transylvanians'. A number of small Protestant churches, located in the Transylvanian mountain area of Hungary, housed a large number of rugs. When first discovered, little or no study had been directed to them, but, as with the so-called Polonaise rugs, the myth of European origin was soon abandoned, and they are now known to be Turkish. The old, but incorrect, term still serves as an easy means of identification. The 'Transylvanians' then, in their size, general composition, and certain design features can trace descent from the Ushak prayer rugs of about 1600 such as no.83 in this exhibition.

They deviate, however, in many ways; new borders are introduced, and instead of the universally red background of the various Ushak types, the colours are far more variable. In addition to reds, backgrounds of yellow, ecru, and white are frequently observed, together with a variety of patterns in both field and spandrels.

85

PLATE XXXI
L.5ft.7in. W.4ft.1⅛in.

In the use of angular arabesque designs in the spandrels of the double-niche, and in the particularly articulated outline of these two arches, the pattern of this rug closely resembles that of no.83. The field is, in contrast, filled with a floral arabesque design, and two large vase-shaped mosque lamps, each of different design, are placed below the centre of each arch. This unusual feature finds a parallel in the same use of two different mosque lamps in the famous Ardabīl rug of 1539–40 in the Victoria and Albert Museum. The strongest difference between this rug and no.83 lies in the different colour scheme and the entirely different border design, based on an alternating succession of elongated cartouches and star medallions in the main border, and reciprocal trefoils in both the inner and the outer guard-stripes. A narrower intermediary guard-stripe separates the powerful trefoil design from that of the field.

86

L.5ft.8¼in. W.4ft.1½in.

This is still another rendition of the double-niche pattern seen in the preceding rugs. The way the pattern is handled here again in a different manner, demonstrates the limitless imagination of the weavers of these rugs that would find over and over again a new variation on the same basic theme.

A sense of movement is created in the design of the field through the central floral motif that leads the eye from one arch to that opposite it. Two detached floral branches fill the rest of the field with a curved movement. Highly simplified but powerful lancette leaf and flower-rosette elements fill the spandrels of the arches which are accentuated by a colour much darker and more intense than any other in the entire design.

New York, Metropolitan Museum of Art

87

PLATE XXXII
L.5ft.3½in. W.3ft.11in.

This is still another rug of the double-niche type, but an especially striking effect is achieved through the introduction of an elongated diamond medallion as the dominating motif in the centre of the field. A four-pointed star in the centre of this medallion terminates at both ends in a straight stem bearing a palmette blossom and two highly stylized flowers possibly derived from the tulip. The spandrels and main border are practically identical with those of no.86.

New York, Metropolitan Museum of Art

89

PLATE XXX
L.5ft.10½in. w.3ft.10in.

This rug, although clearly belonging to the same design-group as nos.85 to 87 seems to be unique in its particular rendering of the individual forms of the pattern. The central medallion recalls that in no.83. Two leaf forms in the spandrels, which are much more curvilinear than those in nos.86 and 87, enclose a sharply indented rosette. A single detached serrated leafy volute, familiar from other rug patterns, also appears. A new form of cartouche, enclosing balanced tulip sprays bounded by stems and leaves, now forms the main border element.

New York, Metropolitan Museum of Art

90

L.5ft.2½in. w.3ft.9¾in.

Turkish prayer rugs such as this have always been favourites with collectors as they combine in a particularly successful way architectural and floral decoration.

Six slender columns support a triple arch and a gallery, resembling the decorative pinnacles of many Muslim buildings, from which a row of flowers grows straight up. The main border design consists of a continuous row of floral cartouches, flanked by smaller octagons enclosing stars.

The rug was given to the collection by Mrs McMullan.

New York, Metropolitan Museum of Art

91

L.5ft.6½in. w.3ft.9¼in.

Essentially a companion piece to no.90.

The relatively rare white ground throughout places all the elements of design in sharp relief in contrast to the coloured ground usually encountered. A second difference lies in the pattern of the arches. It seems likely that an attempt is made to simulate ceramic tiles frequently used in architectural decoration.

New York, Metropolitan Museum of Art

92

PLATE XXXIII
L.6ft.8¼in. w.5ft.6in.

This rug is dated four times A.H.1182 (A.D.1768). The weaver, obviously not supervised in her work, has used only the triple arch of the design seen in nos.90 and 91, creating a balanced pattern similar in idea to the double-niche patterns of nos.83–87. The rug was almost certainly woven in a village somewhat remote from the main area from which most of the so-called 'Transylvanians' come.

New York, Metropolitan Museum of Art

93

L.5ft.¼in. w.3ft.6¾in.

In still another version of the triple arch design, the weaver of this rug, in reversing the selection of that of no.92, has eliminated the arches of the original pattern (see nos.90 and 91) and carried the central four columns all the way across the field. Elongated floral shrubs appear in the three larger spaces in the centre and at the right and left while a succession of six abstract ornamental motifs are placed between the columns that resemble to a degree the abstract mosque lamp shape in no.83.

New York, Metropolitan Museum of Art

95

L.8ft.1¾in. w.5ft.8½in.

In the 18th century commercial looms sprang up in the Turkish hinterland, their production coming into the Western market through the port of Smyrna. In texture the rugs of these looms are quite thick and heavy. In design, however, they follow classical models – the series of large openwork palmettes in the field being obviously based upon palmettes which appear in the sumptuous Turkish carpets of the late 16th and early 17th centuries, familiarly known as 'Turkish Court Manufactory'. The border too is a borrowed one, the pointed cartouches are characteristic features of many so-called 'Transylvanian' rugs, woven towards the end of the 17th and first half of the 18th century.

Known as 'Smyrnas', rugs of this type seem to have been produced solely in the 18th century, probably in an area not far from Izmīr (Smyrna) as their export seems to have been handled exclusively by that port.

Rugs of the following types were made in the 18th and 19th centuries in many different parts of Turkey. If at one time it was known where they came from, such knowledge has long since been lost. These are the truly indigenous rugs of the Turks, each representing a highly developed individual interpretation of an age-old tradition as established in village and family life.

There are rugs that have become known as 'Holbein-variants' (Bode), rugs that follow the formal garden design, others that continue the 15th century tradition of the dual medallion, or repeat octagonal patterns, both often represented in 15th-century European paintings, and still others that follow a variety of different traditions creating individual patterns.

This group warrants particular attention and study as these are among the most important and rare rugs of the entire collection. Many of them are, in fact, as the present stand of our knowledge goes, unique pieces.

96

PLATE XXXV
L.5ft.2½in. w.4ft.4in.

A few small rugs of great charm have come down to us which one could well call 'Holbein-variants'. They do show certain pattern elements reflecting earlier designs but feature a dominant central medallion in contrast to the overall pattern of the 'Holbeins' and 'Lottos'. The central medallion is square in form enclosing an octagon which in turn supports a stepped medallion surrounding an eight-pointed star. In contrast this rigid rectangle is placed upon a diamond-shape of exuberant floral form. In the four corners of the field four relatively large octagonal medallions are placed, filled with stars and arabesques, producing an ideal balance with the central medallion. The main border is relatively narrow and simple, but the two guard-borders with four-lobed flowers in repeat successfully sustain the powerful pattern of the field.

97

L.5ft.7½in. w.4ft.10in.

The field pattern of this second 'Holbein-variant' closely resembles that of no.96, except that corner pieces have been introduced, taking the place of the four corner octagons of no.96. The border design, however, is entirely different, consisting now of unconnected, reciprocal, highly stylized palmette blossoms.

New York, Metropolitan Museum of Art. Given 1972

97a

PLATE XXXVIII
L.6ft.2in. w.5ft.10in.

This is a very close but hilarious descendant of no.97 and a more remote relative of nos.98 and 96. The design is basically faithful to that of no.97, though the diagonal rows of rosettes are doubled, an enlarged rosette appears at the top and bottom of the field, and there is considerable elaboration of the corner pieces. But there is no comparison between the sloppy drawing in this rug and the sophistication of its model, while the use, or misuse, of colour, particularly blue in the central medallion, is strange indeed, without system or sense. Again green is used in the corner pieces at one end only. It is all a refreshing reminder that the independent human spirit can, and does, produce wonderful effects impossible to the trained and sophistical mind.

New York, Metropolitan Museum of Art

98

PLATE XXXIV

L.5ft.7½in. w.5ft.1¼in.

Here we have a survival of the garden theme. The large central panel of this design almost certainly depicts a pool with eight stylized water fowl arranged around a small oblong enclosing a star, probably representing a fountain. Similar stars surrounding the water fowl are probably used to represent pond lilies, lotus, or other water flowers. In the four smaller panels, which can be interpreted as smaller pools, a larger star appears, this time with only four small birds stylized to an even higher degree than the birds in the central panel.

New York, Metropolitan Museum of Art

99

L.6ft. w.4ft.7in.

This design seems again to derive from the earlier formal garden patterns (compare no.29).

The linear system with the attached diamond-shaped panels, making up the major element of the design, and the large sections of octagons to the right and left can be interpreted as water channels and pools. Floral elements both in the water pools and in the surrounding 'land' complete the impression of a typical Islamic garden.

New York, Metropolitan Museum of Art

100

L.6ft.7¾in. w.5ft.1¾in.

In this rug the garden design has been combined with an architectural feature of a double-niche or arch either derived from prayer rugs or from stylized renderings of water courses and pools (compare with no.102). The centre of the field is occupied by a diamond-shaped medallion and four medallion sections that resemble the usual corner pieces of earlier medallion rugs. The rest of the field is filled with stylized trees and flowers in relatively large scale. In contrast to the well proportioned and balanced field design, the border pattern appears careless and almost crude.

101

L.8ft.10in. w.5ft.3in.

The design of this rug, although greatly reduced in detail and abstract in general rendering, recalls once again those of the garden rug variations. The central stellate medallion is surrounded by a few distinctly drawn floral forms; the dominant feature of the field resembles the outline of a large central pool, such as appears in no.102, but with the octagonal end-basins turned inward. In fact, the abstraction is so far advanced that only a vague echo of the original design remains. Although somewhat difficult to recognize at first, the border design, with the exception of a few floral devices, is based on a very heavily rendered version of the Chinese cloud band which was obviously much less understood by the weaver than the design of the field.

New York, Metropolitan Museum of Art

102

L.7ft.8¾in. w.4ft.3in.

Even though classified as Turkish, both the technique and the colour scheme identify this rug as a product of the Kurds of the Turkish part of Kurdistan.

The design is again based on the outlines of a formal garden which appears, as usual, to be represented in bird's-eye view. The main motif of the field seems to represent an enormous water pool with a large central fountain and four small fountains, two of which appear in the polygonally shaped basins at either end.

New York, Metropolitan Museum of Art

103

PLATE XLII
L.6ft.3½in. w.4ft.11in.

Rugs of this type, using a dual medallion as the main element of design, appear frequently in 15th-century paintings of both the Venetian and the Flemish schools. This pattern tradition survived into the 18th and even into the 19th century in Turkish village rugs of which this is an exceptionally powerful example.

The two octagons that fill almost all of the field enclose a small octagon in the centre from which radiate rectangular panels in a star-like fashion, filled with 'latch-hook' patterns. The central octagon contains a star-and-knot design commonly found in 'Holbein' rugs of the 16th century and used already in the 15th century. The balance of the field features rows of detached octagons with stars and rosette volutes in the corners which give a sense of movement to the otherwise compact and somewhat static design. The border pattern, although originally based on floral forms, is entirely broken up into geometric units.

New York, Metropolitan Museum of Art

105a

PLATE XLI
L.6ft.6in. w.4ft.9in.

Like no.103 and two other rugs in the collection (*Islamic Carpets*, nos.104 and 105), this rug is of the dual medallion style.

Each panel is centred by the familiar octagon enclosing an eight pointed star. Four more of the same forms terminating in a very small rosette complete the decoration of each panel. A sharp outline is afforded by the white backgrounds of the rug which is really its field colour. A series of detached forms is the decoration in this area. It is difficult to describe what they are; the sides are simple serrated forms each terminating in a very simple single 'latch hook'. In the outside field we see detached octagons with a stepped internal design which gives a definite echo to the deeply stepped outline of the dual medallions. Another connexion between medallion and field is established through the use of identical star forms. The main border is very familiar as it is used so extensively: an 'S' shaped leaf form and a

very simple medallion alternating. The guard borders and supplementary guard borders on no.103 are almost identical with those on no.105a.

New York, Metropolitan Museum of Art

106

L.7ft. w.4ft.5in.

Only a thin, slightly undulating, outline of a pointed arch in the upper half of the field indicates that we have in this kileem a prayer rug. A distinction between field (below the arch) and sprandrels is also made by the use of two different floral motifs. Those in the spandrels give a fine sense of movement and vigour to the otherwise subdued pattern. Stronger in accent are the large, somewhat less stylized floral shrubs, probably carnations, in the border.

New York, Metropolitan Museum of Art

108

PLATE XXXVI
L.6ft.9¾in. w.5ft.3in.

An extraordinarily powerful central medallion dominates the design of this rug. This medallion is of exceptionally large scale filling almost one third of the entire field; its effect is greatly increased by eight sharp indentations. In a central somewhat irregularly drawn octagon appear two eight-pointed stars, one enclosed within the other. To balance this exceedingly large and strong medallion design is a task indeed. Nevertheless, the attempt is made in the field with two large five-pointed highly stylized palmettes at the ends and with four smaller ones flanking them. An echo of the sharp indents in the central medallion is found in the four corner pieces which, together with the field figures, succeed in holding the central medallion in balance.

It should be noticed that the main border is quite similar to the design in the corners of the field. The weaver was undoubtedly conscious of the necessity of creating suitable echoes to the central medallion.

New York, Metropolitan Museum of Art

109

PLATE XL
L.5ft.5in. w.4ft.8½in.

The charm of this rug, which recalls to a degree the design of Turkish velvet pillow covers, lies in its extreme simplicity of decorative elements. A hexagonal medallion enclosing a diamond-shaped cartouche carries on a short stem a pair of palmettes reaching to both ends of the field. The sharp indentation of the corner pieces is reminiscent of similar forms found in other rugs, such as no.83.

New York, Metropolitan Museum of Art

110

L.7ft.4in. w.5ft.¾in.

Although many of the design elements of this rug are familiar, their particular use and their peculiar colour seem to be unique.

The most remarkable feature is the expansion of the border areas and the extraordinary reduction of the field. In fact the width of the field is about equal to the width of the twelve border-stripes that surround it. Gradually widening from the inside to the outside there are four main borders, and eight narrow guard-stripes often reduced to a simple line. The third border is decorated with a continuous diamond-lattice filled with floral rosettes, a pattern derived from ancient Anatolian field designs. It appears as a border motif also in a rug represented in Holbein's portrait of the Venetian ambassadors in the National Gallery in London. The design of the field, in contrast, is quite simple and composed of motifs common to many Turkish village rugs of the period. The only unusual feature is perhaps the use of what appears to be a small mat or rug, complete with field and border, as the central motif.

A similar rug has been published by Albrecht Hopf (*Oriental Carpets and Rugs*, New York, 1962, no.32), which he dates about 1860, but I feel that these rugs are at least fifty years earlier.

New York, Metropolitan Museum of Art

111

PLATE XXXIX
L.6ft.11in. w.4ft.11in.

This rug again has a rather narrow field in relation to the width of the border. It is decorated with an intricate linear design, forming complex geometrical and highly stylized floral shapes. The chief elements of the main border pattern are probably derived from the Chinese cloud band, but they are so stylized that they could easily be mistaken for large open palmettes.

New York, Metropolitan Museum of Art

112

L.7ft.10½in. w.5ft.5in.

The design of this rug preserves a pattern concept that can be traced back in pictorial representation, particularly of the Italian school, to the 14th and 15th centuries. Only the Dragon and Phoenix Rug in Berlin (F. Sarre and H. Trenkwald, *Old Oriental Carpets*, 2 vols., trans. by F. A. Kendrick, Vienna, 1926–29, vol. II, pl.1) and the Marby Rug in Stockholm (*ibid.*, pl.2) are actual survivors of this type from that period. It seems that the pattern was not used much after the 15th century which makes this rug especially interesting, as it demonstrates the existence of a continuous tradition in the villages of Anatolia. The pattern is, in fact, organized exactly in the fashion of the early designs, that is in a continuous succession of square panels enclosing octagons, filled with animal groups. In this rug the animals, probably pairs of birds, have reached almost complete abstraction.

113

L.7ft.6in. w.5ft.4in.

Even though there seems to be no distinction between field and pattern, the design of this rug is based on the usual system of a continuous pattern running throughout a given field area.

Here the pattern consists, however, of units that do not appear in their complete outline, but continue horizontally, being cut by the border. This highly unusual design idea gives this rug its particular charm. The main design units are composed of a series of interconnected cartouches of an arched shape, resembling remotely a cloud band with stepped outlines. These units are dark blue. The field, coloured red, almost repeats the form of the main design units, an impression that is heightened through the fact that both these units and the field are covered with the same decorative motifs, small octagons filled with stars and small flower rosettes.

New York, Metropolitan Museum of Art

114

PLATE XXXVII
L.7ft.1¼in. w.5ft.2¼in.

Occasionally a rug appears which, although crude in execution, is so exciting in design as to find a definite place in almost any rug collection. Here we have in the centre of the field an octagonal medallion reminiscent of those of the 'Holbein' type. The rest of the field is filled entirely with detached rosettes in two scales. The inner border is decorated with a series of heart-shaped floral palmettes connected by a thin floral stem, with trefoils resembling carnations. The main border is again unusually wide in relation to the width of the field. The dominant pattern is a series of large, heraldic palmettes. About half of them are drawn skilfully and in balance. The other half, however, is distorted; no two of them are alike. Although quite crude in design they form a powerful pattern fully balancing that of the field.

New York, Metropolitan Museum of Art

115

L.7ft.3¼in. w.4ft.4¼in.

Nothing could be simpler than a rectangular tile pattern in endless repeat. It is treated here, however, with such skill and imagination that even the slightest danger of monotony is avoided. The triple-line frames that define each unit are interrupted in the centre by a minute white point, emphasizing the individual and separate quality of each 'tile'. The extraordinary play of colour, varying in ratio and tonality, enlivens the otherwise utterly repetitive pattern.

New York, Metropolitan Museum of Art

117

L.2ft.9½in. w.3ft.2½in.

Occasionally a small Turkish mat is found which contains an extraordinary amount of power within a very small space.

There is a large medallion in the centre – so large it almost touches the edge of the field on either side – which in addition has two pendant palmettes, enclosing simple leafy shrubbery, which in turn almost reaches the borders at each end of the field. The central medallion encloses a beautiful, eight-pointed, deeply indented star, from which spring eight stylized trees. Even though the central motive is already powerful and large in size, there is yet room in which comfortably to place corner pieces decorated with floral buds. It would seem that the limit of decoration had been reached; nevertheless, the field between the central medallion and the corner pieces supports still further motifs: four multiple rosettes, and four geometric rosettes in cartouche form.

New York, Metropolitan Museum of Art

118

L.9ft.2¼in. w.3ft.9in.

Four hexagonal medallions dominate the field. Tulips and carnations of large size and elegant design form the basic floral motif of both the medallion and the field pattern. Transition from medallion to the field is effectively produced by the 'latch-hooks' placed both in and outside the medallions.

A peculiarity of some Turkish rugs are the 'skirts' at both ends. Such additional end borders are still found in the nomadic rugs of Turkestan and may have been brought to Anatolia from there by the Turks.

New York, Metropolitan Museum of Art

119

L.4ft.2½in. w.3ft.7¼in.

Even though far removed from the early incomplete rug no.80 of this collection, the pattern of this small 19th-century piece resembles, in the central medallion and the arrowhead-shaped, bracketed finials, that of the much earlier piece.

The borders are comparatively insignificant and particularly inconspicuous, as the colour scheme is identical with that of the field.

New York, Metropolitan Museum of Art

As far as is known none of the existing Turkman rugs can be dated earlier than 1850 or 1860. But their designs preserve in the purest form traditions established at least as early as the Seljuq period. The presence of such patterns in Central Asia, from whence the Turks of Anatolia came, is documented for the 15th century by Tīmūrid miniature paintings of the Herat school. The Turkman nomads preserved their cultural identity into the 19th century by maintaining their tribal life and having little or no contact with the cities. This explains to a large degree their continuation, over a known four to five hundred year period, of design elements harking back possibly even to the pre-Islamic Turkish traditions of Central Asia.

At present about six principal groups are known; they are the Saryks, the Yomuts, the Afghans, the Ersaris, the Tekkes, and the Salors.

121

PLATE XLIV
L.7ft.1in. w.5ft.8½in.

The Saryks not only display rich and warm colours but are prone to use animal figures enclosed within the octagon. It will readily be seen that the animals of this rug are a complete abstraction, as each of them has two heads connected by a narrow body. The main border design consists of hexagonals at the sides and octagonals at the ends. All of them enclose geometric serrated rosettes. The 'skirts' have different patterns; one of them is decorated with flattened octagons, the other with balanced shrubbery.

Washington, D.C., Textile Museum Collection

122

PLATE XLIII
L.8ft.10in. w.5ft.8½in.

The design of this Yomut appears on a red ground rather than on the usual brownish red. It is distinguished also through the unusual appearance of a secondary pattern element of a diamond-shaped cartouche along the edge of the field. The main border is characteristic of Yomut work, with an angular meander bearing solid stylized palmettes on the side, in contrast to the skeletonized ones at the ends. It is interesting to note that the minor borders are given unusual importance. Each of them displays delicately drawn reciprocal shrubs, but the outside border is nearly twice as wide as the inside one.

New York, Metropolitan Museum of Art

123

PLATE XLVI

L.9ft.1½in. w.6ft.5in.

Occasionally a Yomut rug appears with an unusual variation of the standard pattern, such as is seen in this example. Two of the design elements are diamond-shaped, one with a 'latch-hook' outline, containing small shrubs; the other one has sharply accented 'latch-hooks' within and is bounded by 'latch-hooks' on the outside, which are drawn in the same scale as those in the other series. The third form is an elaborate, unbalanced medallion of a type not frequently seen, and based, it seems, on a palmette design.

New York, Metropolitan Museum of Art

124

PLATE XLV

L.10ft.5in. w.6ft.8½in.

This, one of the most resplendent of all Turkmans, presents a type which was first brought to the attention of the writer through Grote-Hasenbalg who illustrates a rug, practically a duplicate of this one, calling it an Afghan (W. Grote-Hasenbalg, *Der Orientteppich, seine Geschichte und seine Kultur*, 3 vols., Berlin, 1922, pl.46). In the description of the type he says: 'In the glow of the colours and sheen of the wool they surpass the finest Persian velvet'.

Only two pattern elements are used in the field, an indented octagon, which includes an eight-pointed star, surrounded by trefoil shrubs springing from the points of the star. Simple flowered octagons form the secondary repeat. The very narrow border is filled with a chain of small stepped medallions.

It was probably the trefoil motif, very common in Afghan rugs, and the unusual size of this piece, that persuaded Grote-Hasenbalg to attribute it to the Afghan group. But no Afghan rug has ever matched the brilliance in colour and smoothness of surface of this piece.

New York, Metropolitan Museum of Art

127

L.1ft.10¾in. w.2ft.2in.

Even though only a small fragment, it becomes clear from the size and the secure drawing of the pattern elements, that here survives part of a great Turkman rug. The two main motifs, indented octagons filled with stars and trefoils, and small octagons filled with cross-shaped stylized flowers and triangles, are not uncommon in Tekke Turkman and Afghan rug design but their particularly fine execution in detail, combined with a number of smaller field pattern motifs equally carefully designed and executed, make this fragment a testimony of a great artistic tradition at its height.

Washington, D.C., Textile Museum Collection

128

L.11¾in. w.2ft.4¾in.

Although usually classified as a Tekke Turkman, the actual tribal origin of this type of saddle bag still remains obscure. The basic pattern is a series of oblongs, each containing a serrated diamond device outlined in sharp white cotton, separated by floral channels. Two of the corner panels are silk. We have, therefore, a rug made of all three of the basic materials: wool, cotton, and silk. There is a lower border with checkered diamond devices, which complement and echo the larger diamonds in the field.

New York, Metropolitan Museum of Art

129

L.2ft.3in. w.1ft.3in.

It is unusual to find a Yomut pattern, this time on a small saddle bag, based upon a formal garden design. Here, however, within panelled outlines are enclosed tree forms so stylized as almost to defy identification. The trees bear devices which are possibly derived from birds. At the bottom, two forms of shrubs can be seen; similar but balanced figures are on the sides, and at the top appears a still further reduced version of the same form.

New York, Metropolitan Museum of Art

130

L.5ft. w.1ft.5in.

An unusual feature presented from time to time in rugs of the Ersari weave is the dominance of a central medallion in contrast to the usual repetitive patterns of the Turkmans. The medallion is made up from a succession of star forms, the innermost being enclosed in an octagon, the outermost being flattened out into an almost rectangular panel.

New York, Metropolitan Museum of Art

131

L.4ft.4in. w.1ft.9½in.

The Saryk Turkmans used in their rugs the warmest and richest colours of any of the tribes. The basic octagon of the design this time is so flattened that at first sight it appears to be a diamond-shape. Its outline is straight-sided with no indentation, a design peculiar to this tribe. The secondary pattern is a small octagon containing a simple four-petalled flower. Floral tendrils spring from all four sides.

New York, Metropolitan Museum of Art

Mongol

132

L.3ft.9½in. w.1ft.2in.

The Ersari tribe created a considerable variety of patterns of great originality, often, as in this example, using undyed cotton as an effective accent.

New York, Metropolitan Museum of Art

133

L.5ft.9in. w.1ft.11½in.

Turkman saddle bags are made in three major sizes and always in pairs. The smallest, usually square in shape, suitable for use on a donkey or as cushions, is called torba; an intermediate size suitable for many purposes, and the largest, used as a camelbag which can be filled with enough impedimenta to make a full load for even such a huge animal as the Bactrian, or Asian camel, are called juval.

Here is one of the larger types and by its design of diamond-shaped 'latch-hooked' repeats is unmistakably identified as a Yomut product. The easily monotonous pattern is considerably enlivened by the colour variation of the 'latch-hook' design that runs along the diamond cartouches and an interesting border pattern of stepped reciprocal half-cartouches.

Washington, D.C., Textile Museum Collection

134

L.7ft.3in. w.4ft.

The Yomut tribe produced a number of flat woven embroidered textiles which are not rugs in the ordinary sense of the word but were equally used as floor covers and tent decorations. It will be noted that the embroidery patterns of these textiles are quite different from those found in the pile carpets of this tribe. The ornament of this piece consists of a series of alternating horizontal bands. The widest of these bands is decorated with stepped chevrons of varying widths ornamented throughout with a simple trellis. The secondary elements consist of narrower bands, either plain or filled with an elongated checker pattern in three parts, individually coloured. A single band at the end contains repeated and highly stylized rosettes.

New York, Metropolitan Museum of Art

These saddle rugs are entirely separated in expression from the main stream of the nomadic cultures of which the Mongols were part. Their designs are to a small extent survivors from old Shamanistic animal worship, or, to a larger extent borrowed from Chinese models. They do, of course, belong to Chinese rather than Islamic culture for all that some Mongols became Muslims. The rugs are included here because they deserve to be better known.

It should be understood that there were no woollen pile carpets in China, that is to say at least not before the Mongol period in the 14th century. China is not a wool producing country. The Mongols, in contrast, produced the essential raw material for rugs from their flocks. China imported Mongol rugs regularly by caravan. It was only in recent centuries that carpets were made in China proper, some of imported Mongol wool, others from wool imported from Australia.

A technical note regarding the construction of the Mongol saddle rugs seems to be useful. They were all made in two pieces, joined at the middle. By making the two parts separately and starting the weaving from what was to be the outer edge, the senna (open) knotted pile on either side of the saddle cover in use slanted downwards, thereby shedding rain and dust and making a more comfortable contact with the thigh of the rider. Each saddle is provided with four studs or bosses. After the weaving is completed, four holes are cut into the saddle rug enabling it to be securely anchored when slipped over the bosses.

135

PLATE XLIX
L.4ft.1in. w.1ft.10½in.

This is possibly the oldest of the group. Its design is directly copied from a Chinese textile pattern. The nomadic weaver succeeded admirably in maintaining the curved lines of the original which is no mean achievement.

There is no outer border. Both the main border, of an evenly corroding brown, and the inside border, of an even more corrosive black, are undecorated. These borders are characteristic of Mongol rugs of the K'ang-hsi Chien-lung periods.

New York, Metropolitan Museum of Art

137

PLATE XLIX
L.4ft.8in. w.2ft.5½in.

The first impression of this pattern is that of a geometric maze or labyrinth; further examination discloses a large number of minute flowers well balanced and well distributed. No leaves or petals are indicated, just the

geometric stem system, and the flowers are all of uniform size and design. There are actually a total of ten borders in three different widths all without decoration. The simplicity of this design is most effective and highly original. It is one of the main characteristics of this group. Surely this specific design is based on the cracked-ice and plum blossom design so popular in K'ang-hsi blue and white porcelain?

New York, Metropolitan Museum of Art

138

PLATE XLVII
L.4ft.5½in. w.2ft.

The Chinese 'sacred mountain on waves' at each end of the field looks toward a pair of filleted swastikas, Chinese symbol of longevity. As a contrast to the usual plain border schemes this one displays in the main border some of the Eight Precious Things from Taoism: fan, bamboo tubes and rods, flute, flower basket, castanets. The Mongols were understanding of many religions. The whole is set off, as usual, with narrow borders bearing no ornament.

New York, Metropolitan Museum of Art

139

PLATE XLVII
L.4ft.8½in. w.2ft.2in.

The field design of this rug has been interpreted in three different ways. There is an unquestionable resemblance to the horns of the stag. If so, this may be a design derived from Shamanistic animal worship which was widespread in the Mongol area before the coming of Islam. A second possibility is that the design represents the irregular limbs of the hawthorn shrub, so frequently seen on the great Chinese hawthorn vases. A third possible interpretation is that this represents some kind of an animal pelt with its brown and yellow colouring.

Regardless of interpretation as such the design moves outward symmetrically from the centre with great vigour, in contrast to the great reserve in some of the other pieces. An interesting note is introduced through the use of small discs, some with a cruciform centre, symmetrically placed about the outside edge of the field. The plain coloured borders are handled with great decorative effect through use of diagonal lines at all the corners.

New York, Metropolitan Museum of Art

140

L.4ft.5¼in. w.2ft.3in.

The pattern of this rug is a complete rendition of a tiger skin with even the backbone indicated.

The main border has an intricate pattern in two shades of blue on white. Contrary to the common rule in saddle covers the inside border is decorated with the pearl seen often on the guard borders of Chinese rugs, but coming originally from Persia.

New York, Metropolitan Museum of Art

142

L.4ft. w.1ft.10in.

Three designs form the entire composition. In the field a trellis with a dot on the lower point of each lozenge gives an all-over effect of delicate imbrication. The main border is filled with the swastika diaper fret. If there was once an outside border it has now disappeared. The inside guard-stripe bears, as usual, no decoration; but a second stripe is beaded with small solid coloured rosettes, somewhat cruciform in outline. The leather patches are in flower and leaf shapes.

New York, Metropolitan Museum of Art

143

L.4ft.2in. w.1ft.11½in.

The field, in light tone, is almost devoid of ornament, which brings the beautifully shaped leather leaf into focus. Leather is used frequently in these saddle rugs for various purposes: first, to protect the rug from undue wear in certain areas due to pressure from the horseman's knees; secondly to patch any point which has been damaged for one reason or another; finally as binding.

The dark border is set with small medallions with flowers and doubled bats, the symbol of happiness. The arrangement of a light field and dark rich border adds a dramatic note.

New York, Metropolitan Museum of Art

144

PLATE XLVII
L.4ft.7½in. w.2ft.2½in.

The field of this saddle rug, narrower than usual, is decorated in the centre with a mysterious convention seen on many of these pieces, and sometimes more closely related to the auspicious Chinese 'as-you-will' (ju-i) form than in the angular version. There are also two large discs filled with peony flowers. The inside border is quite unusual; it is filled with reciprocal trefoils, and is wider than the main border of S- and T-frets. The outside border returns to the usual plain undecorated stripe.

New York, Metropolitan Museum of Art

145

L.4ft.5½in. w.2ft.1½in.

One of the most famous of all Chinese symbols, the Dog or Lion of Fo (Buddha) appears as the major theme in the field. Our lion or dog is a lioness with her cubs on her back, forming a decorative roundel. Regardless of any other meaning, the presence of parent and young is a symbol of fertility. The balance of the field is embellished with sprays of flowers and butterflies. The main border is quite unusual as the darker, thinner line of leafy sprays and flowers is intertwined with heavier, but lighter coloured forms which suggest foliage dragons. Decorated discs, two of them with longevity symbols, also appear in the border. An inner border of pearls, and an outer, undecorated border complete the assembly.

New York, Metropolitan Museum of Art

147

PLATE XLVIII
L.4ft.1½in. w.2ft.

With the exception of the frequently used design convention over the joined centre, one element alone is used for the pattern of both field and border. It is a well known favourite, the endless knot, Buddhist symbol of eternity. The innate artistic sense of the simple nomadic weaver is here realized most forcibly as one studies the contours of these 'knots'. The centre knots are three in number on either side, the middle one flattened, the outer ones about the same in width as in length. All of those beyond are also flattened. The border knots, if anything, are slightly longer than wide. Thus variety is introduced into a repeat pattern which otherwise would be mechanical.

New York, Metropolitan Museum of Art

148

PLATE XLVIII
L.4ft.4in. w.1ft.11½in.

The field pattern introduced here suggests the Chinese motif familiarly known as 'cash'. Whether or not this is true may be a moot question, but the pattern should receive special attention.

The first impression is that of diagonal lines crossing one another. But actually the pattern is based on a continuous system of interpenetrating octagons, each filled with a small diamond-shaped device surrounded by four petals. As these diamond shapes and the petals are darker in colour than the outlines of the octagons they dominate the initial visual effect.

It becomes clear that apparently simple all-over patterns have often a complexity which frequently at first glance escapes the eye.

New York, Metropolitan Museum of Art

149

PLATE XLVIII
L.4ft.2in. w.2ft.

For lack of a better term the field design can be called a balanced, or double key and swatiska fret diaper. In the widest portion of the field there are four Ts, one row a half length lower than the other. When observed from side to side, a series of lateral frets can be seen; T-ends now form the shafts of these laterals which pass across in a solid line, creating the impression of a trellis or lattice. Once again these repeat patterns should receive at least a second look.

Good Luck in infinity is indicated, possibly, by the endless knots in the border. There is really no inside border as such, as it is practically the edge of the field. The outside border is a solid undecorated band. The squeezing together of the designs at the central crossing seam seems to suggest that the saddle covers may well have been re-sewn to hide wear.

New York, Metropolitan Museum of Art

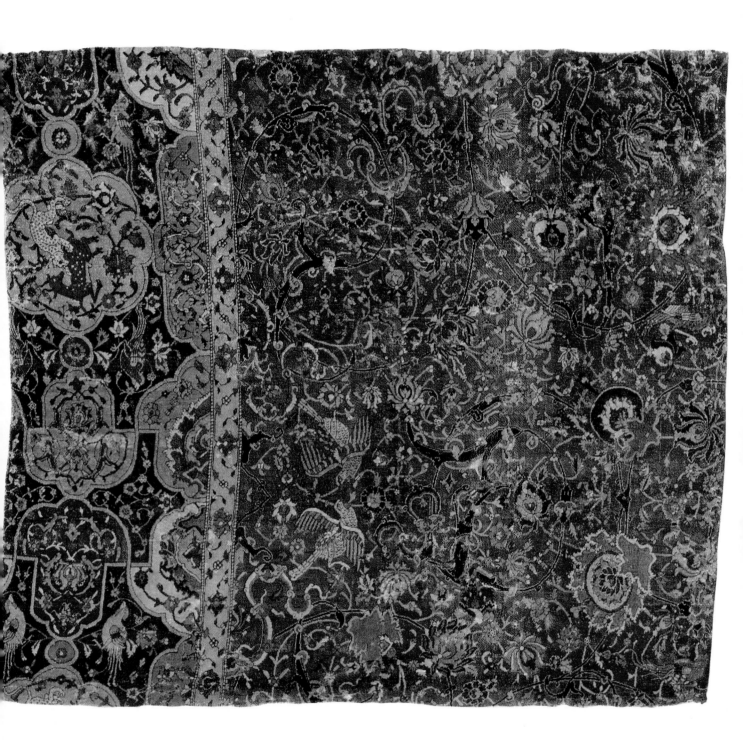

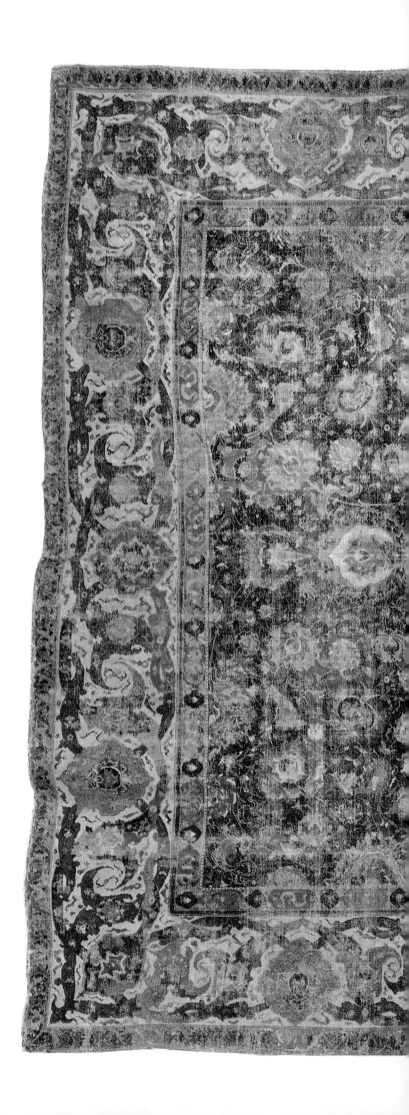

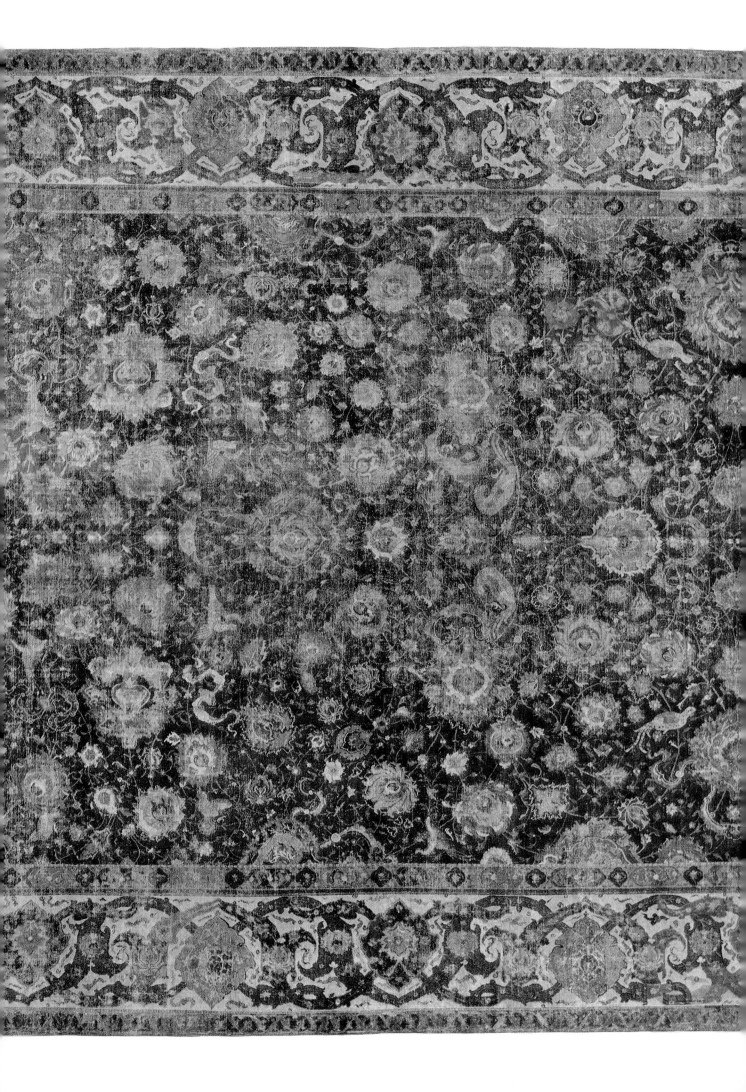

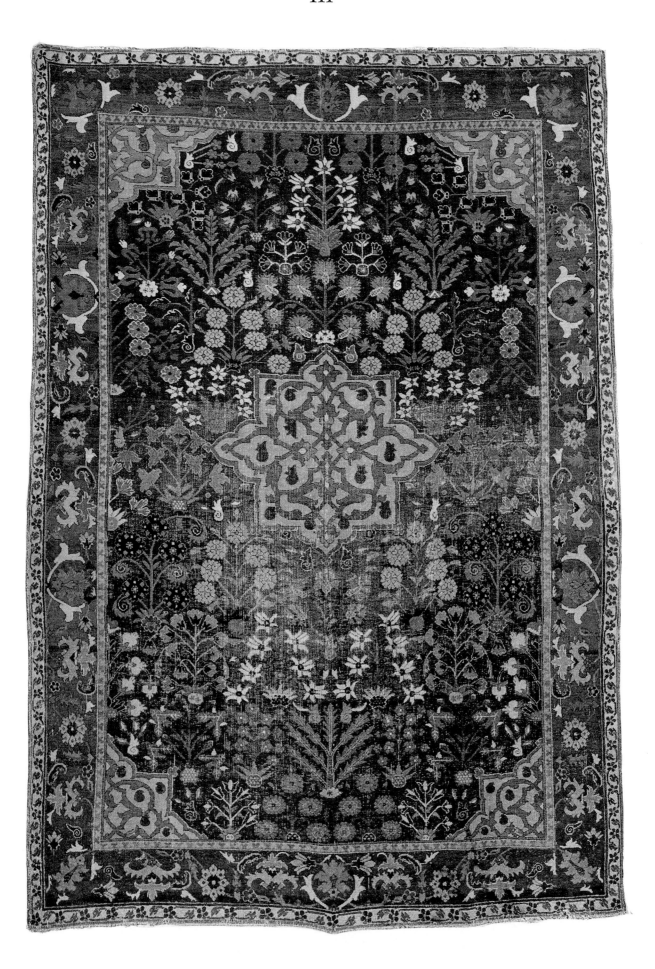

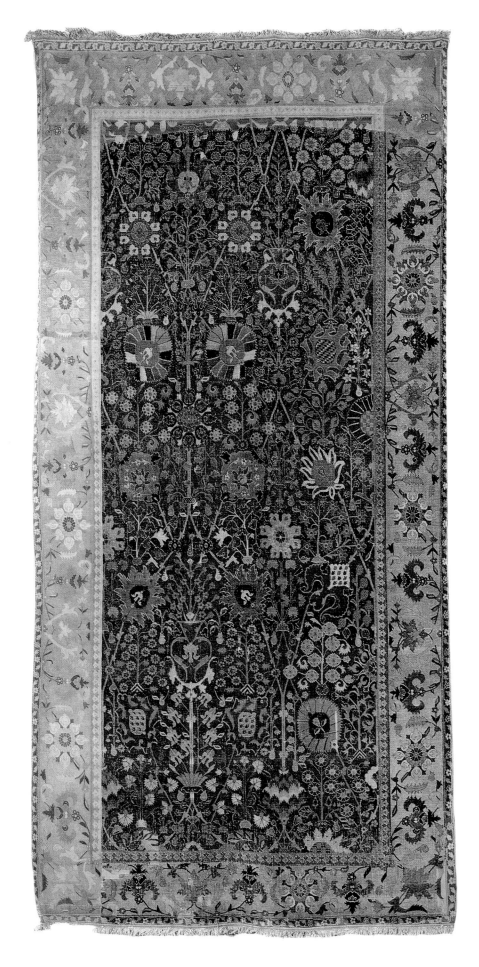

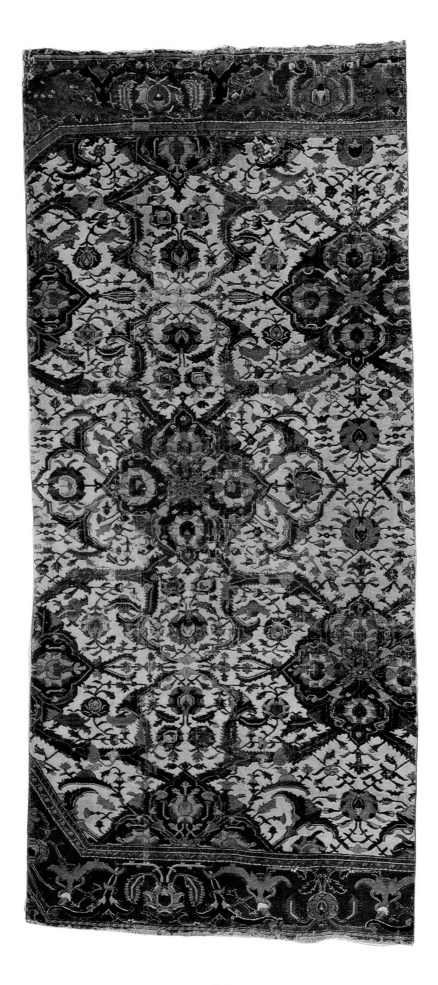

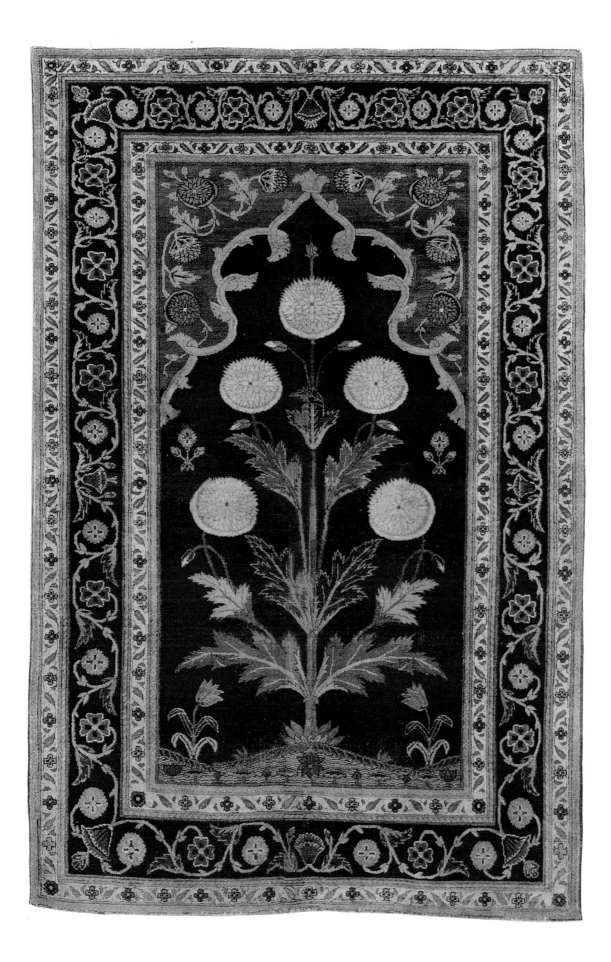

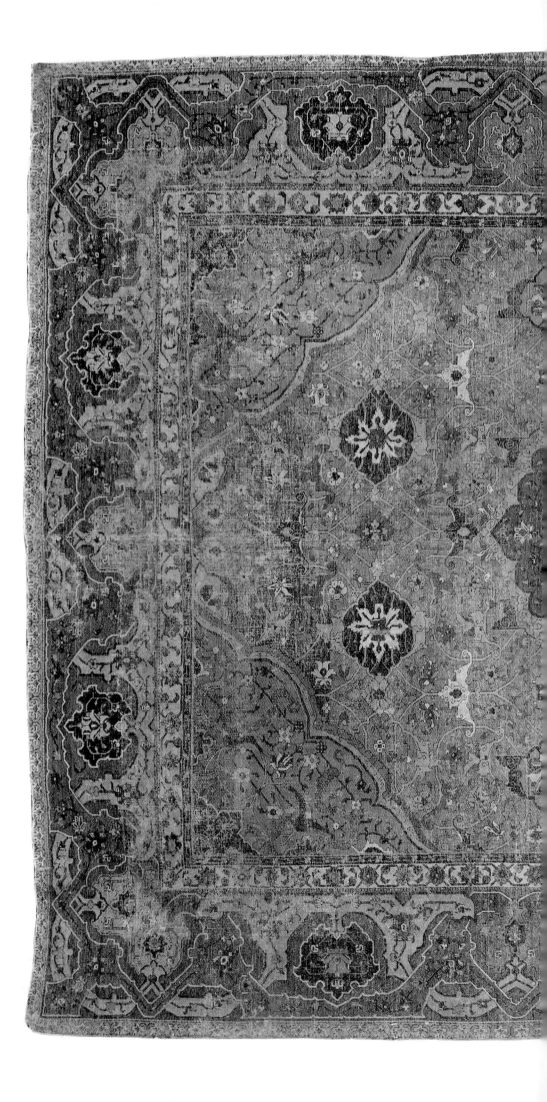

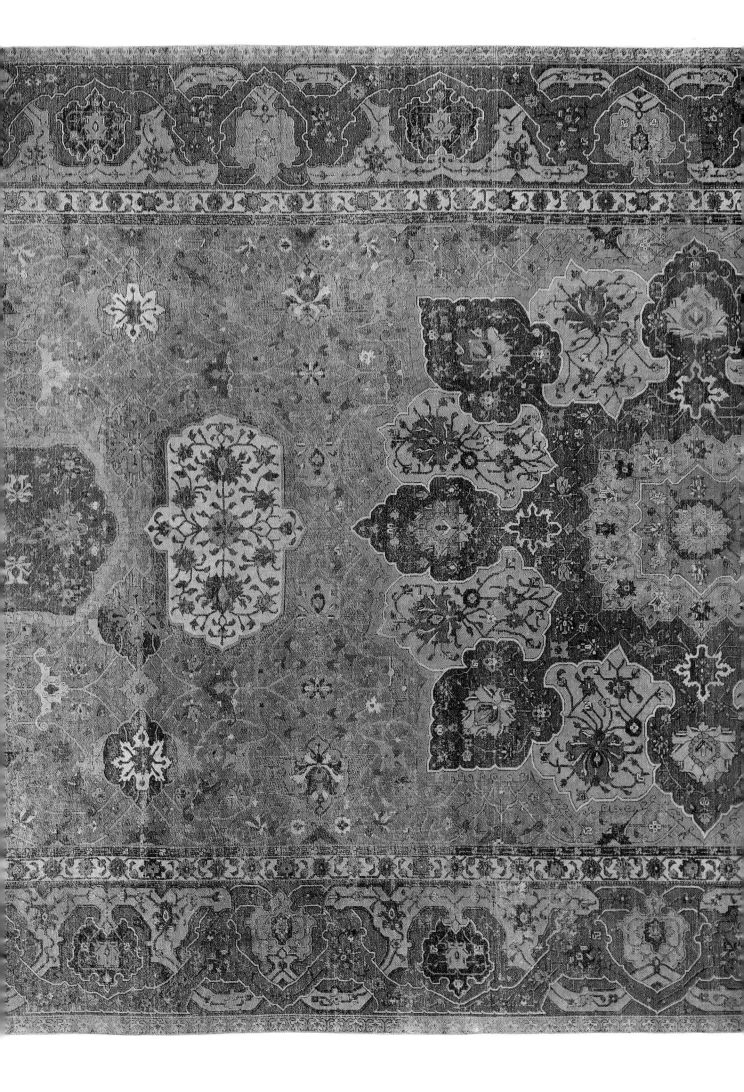

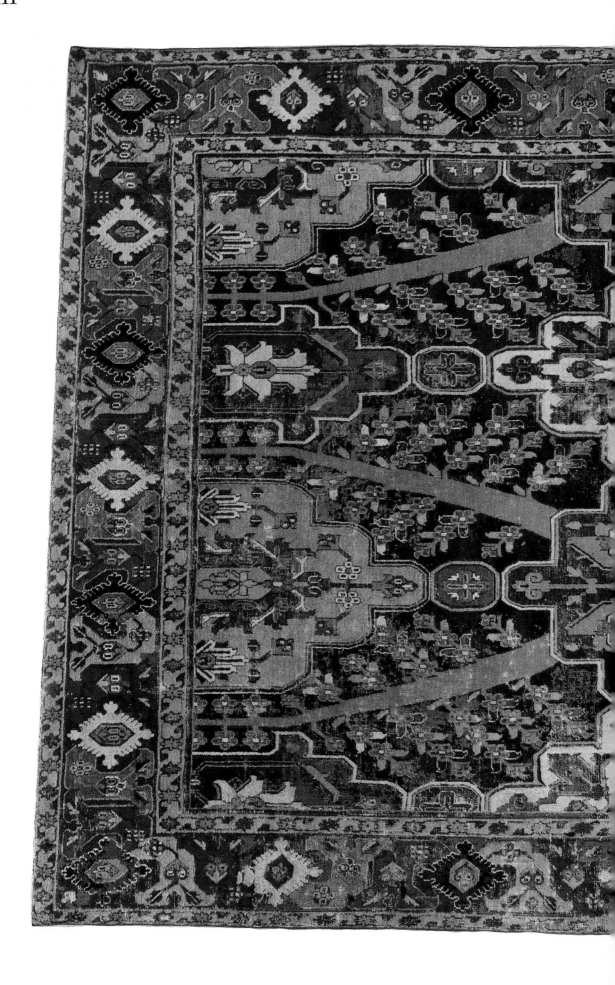

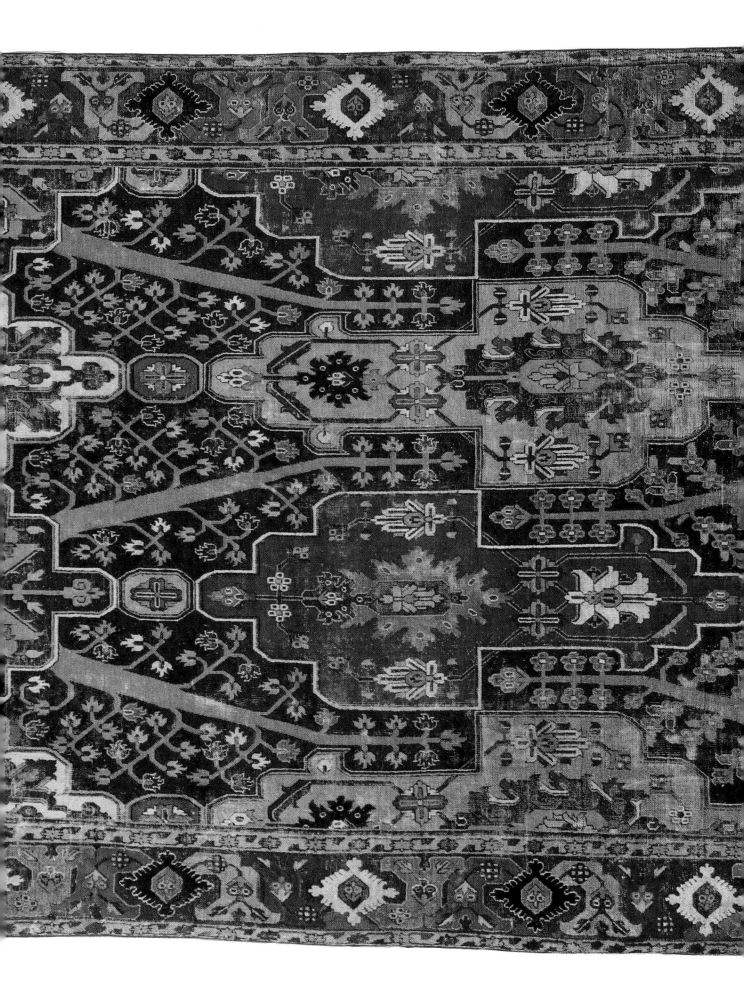

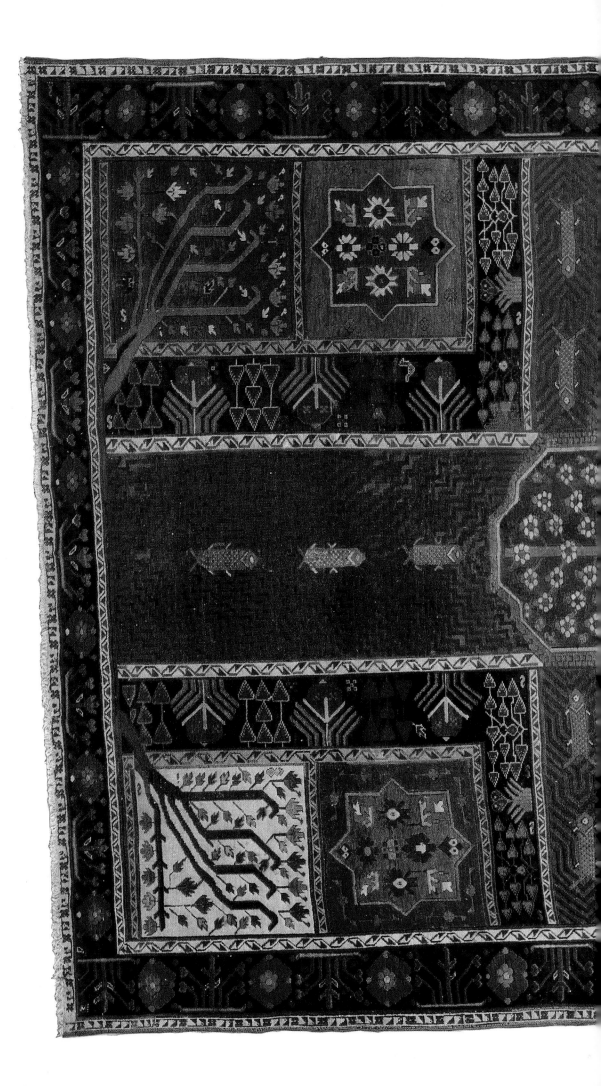

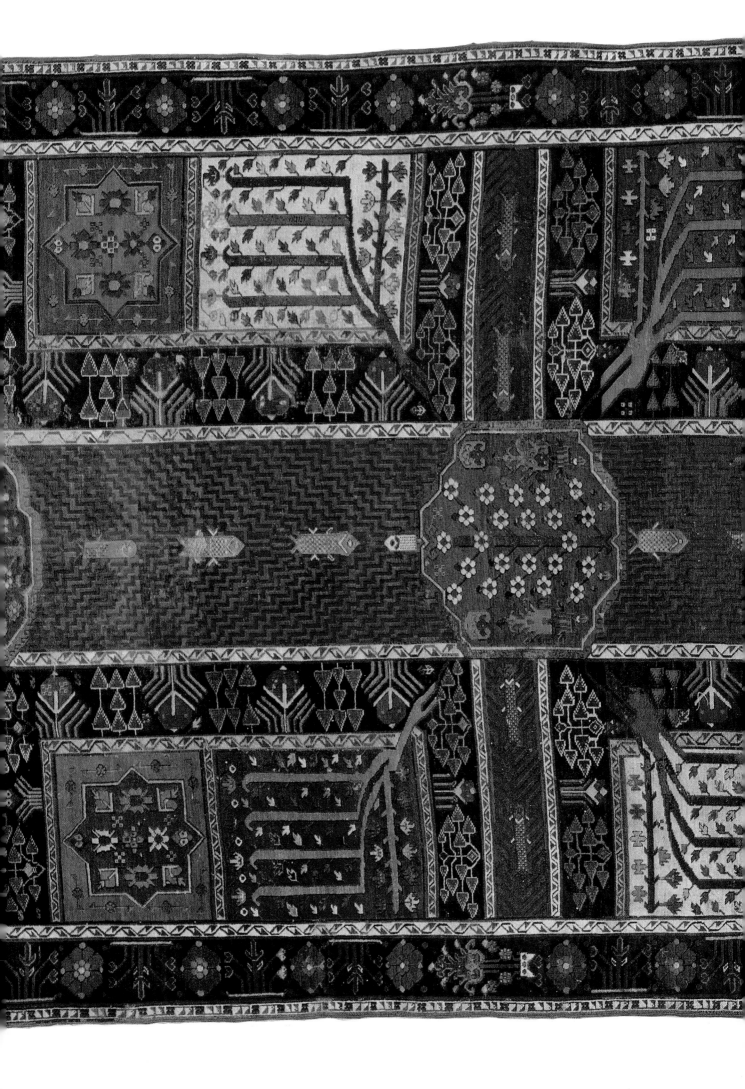

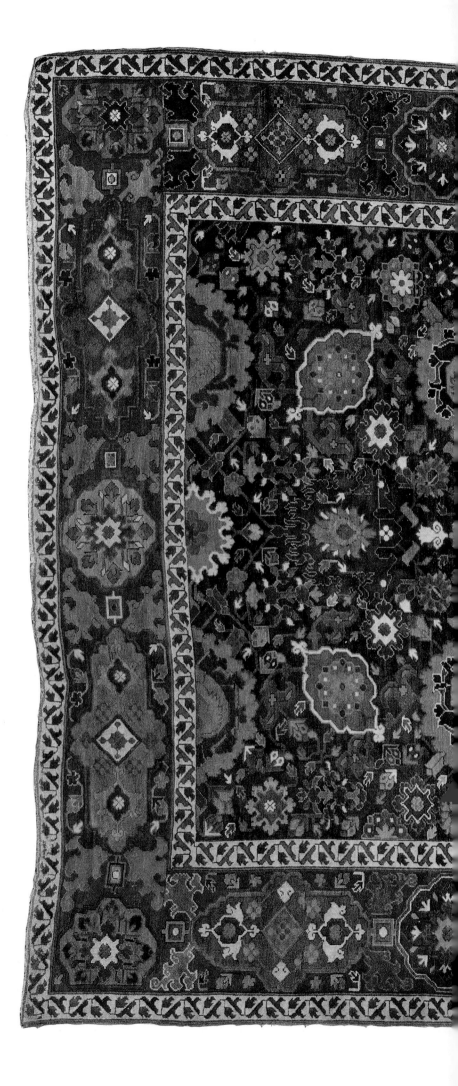

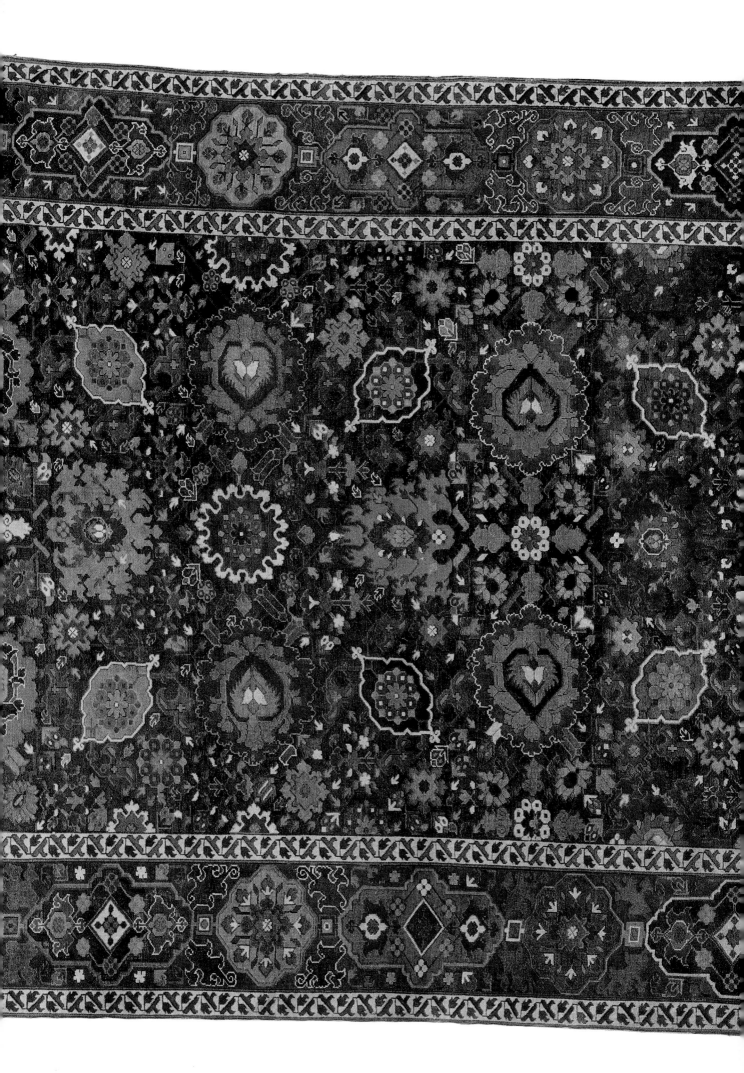

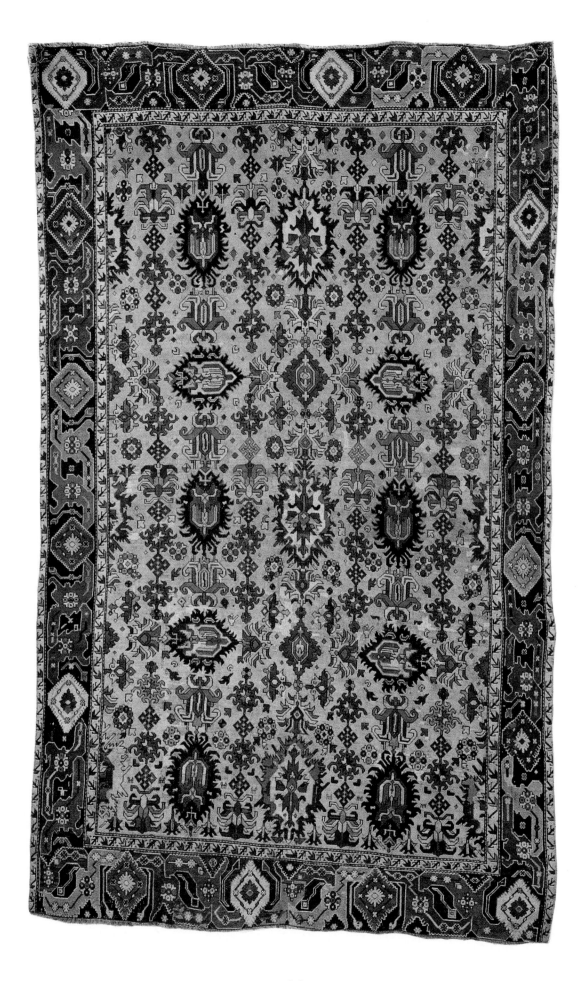

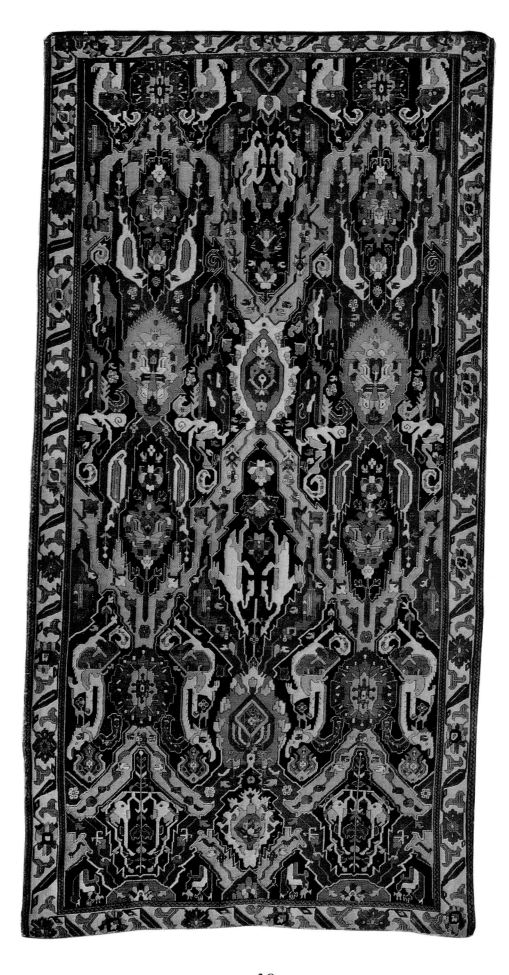

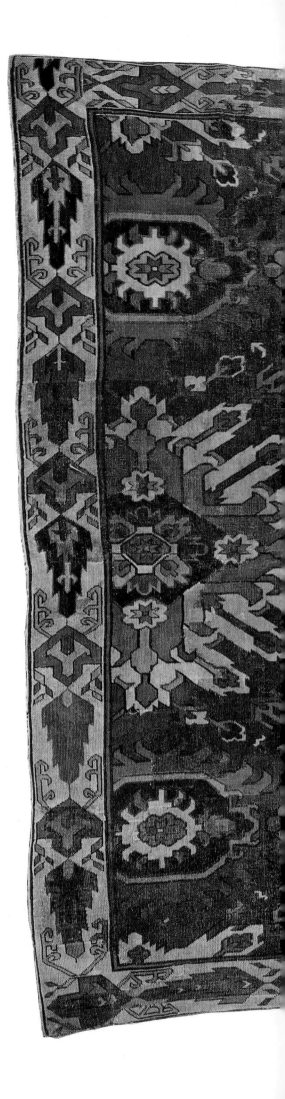

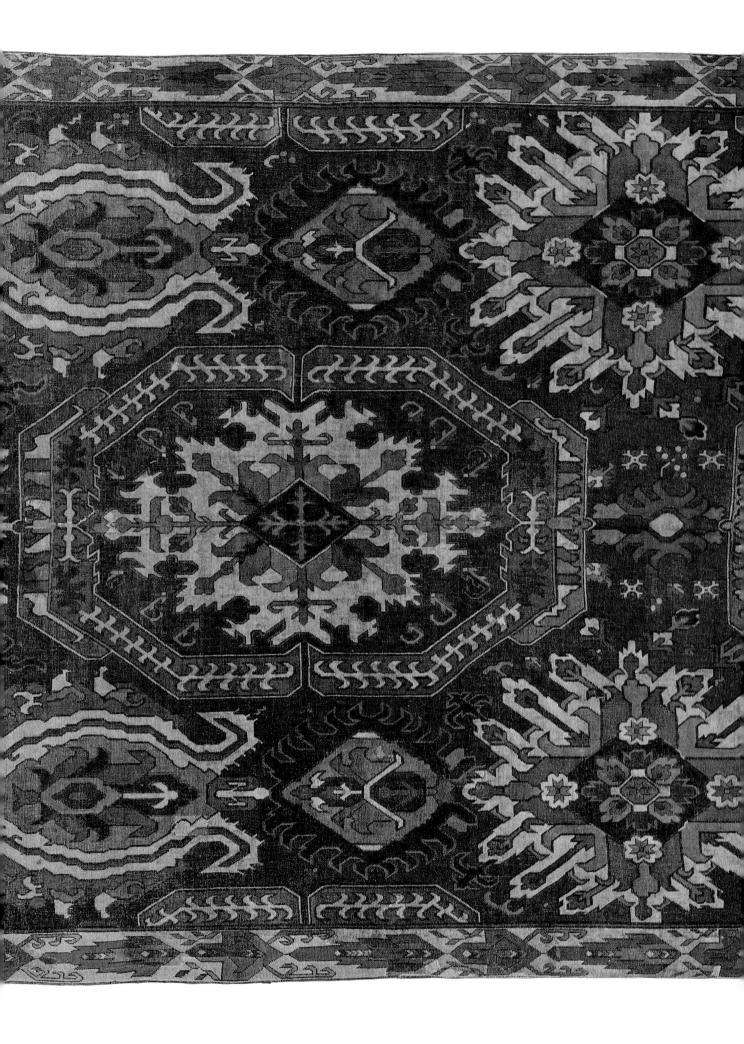

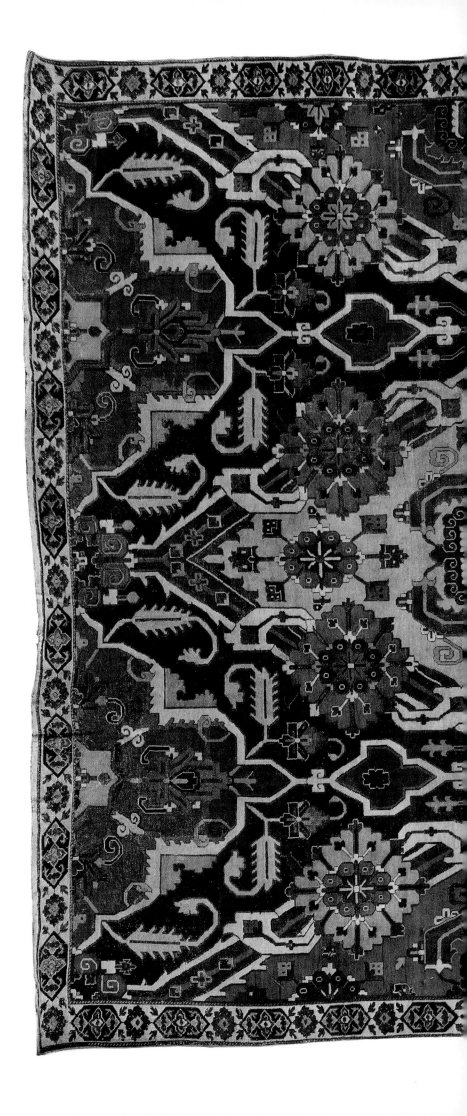

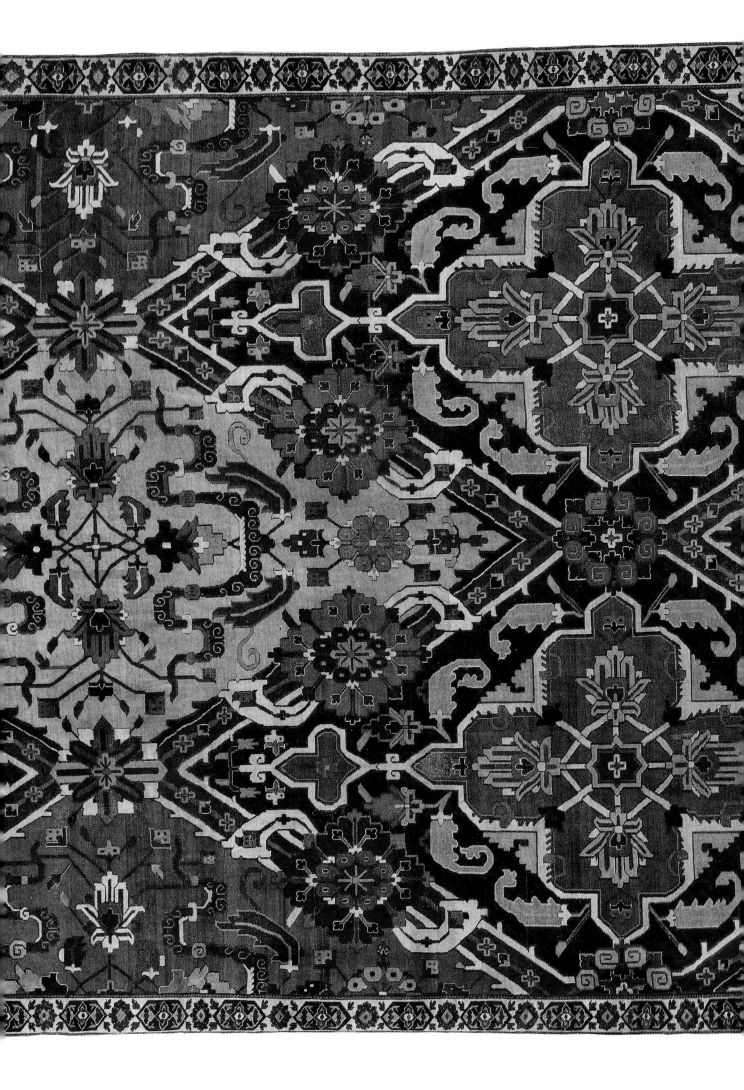

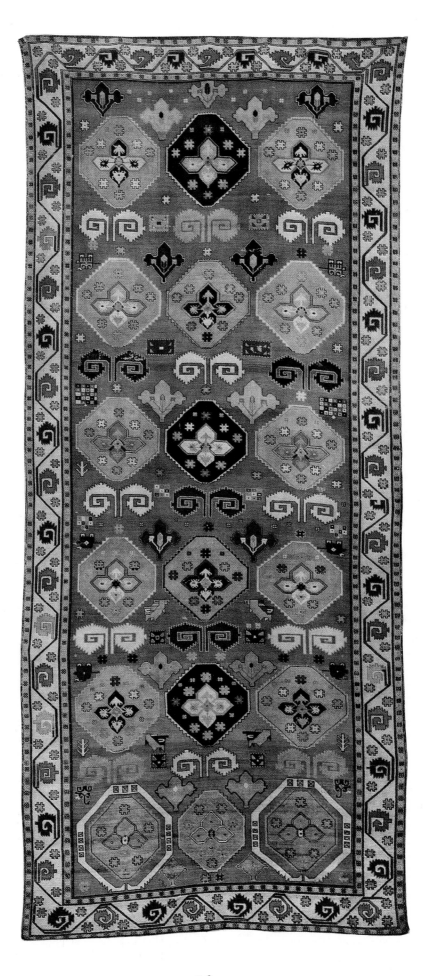

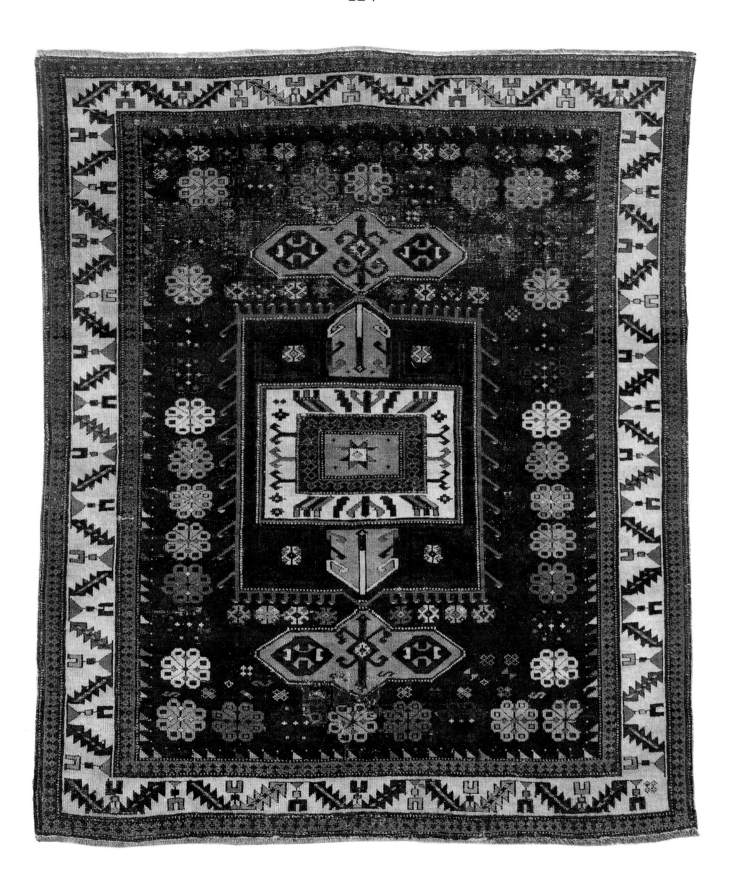

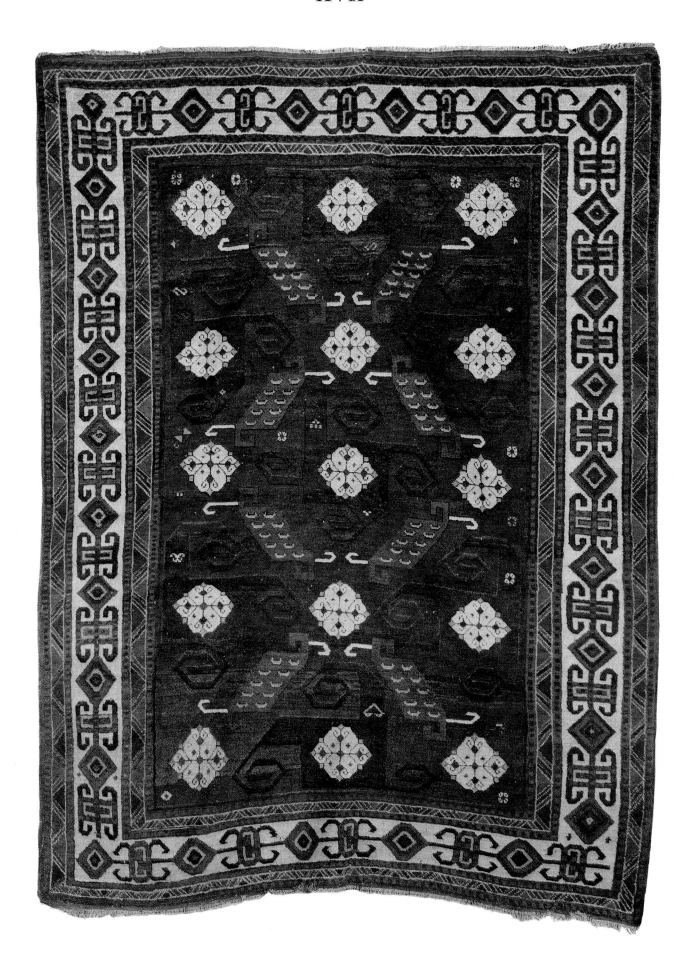

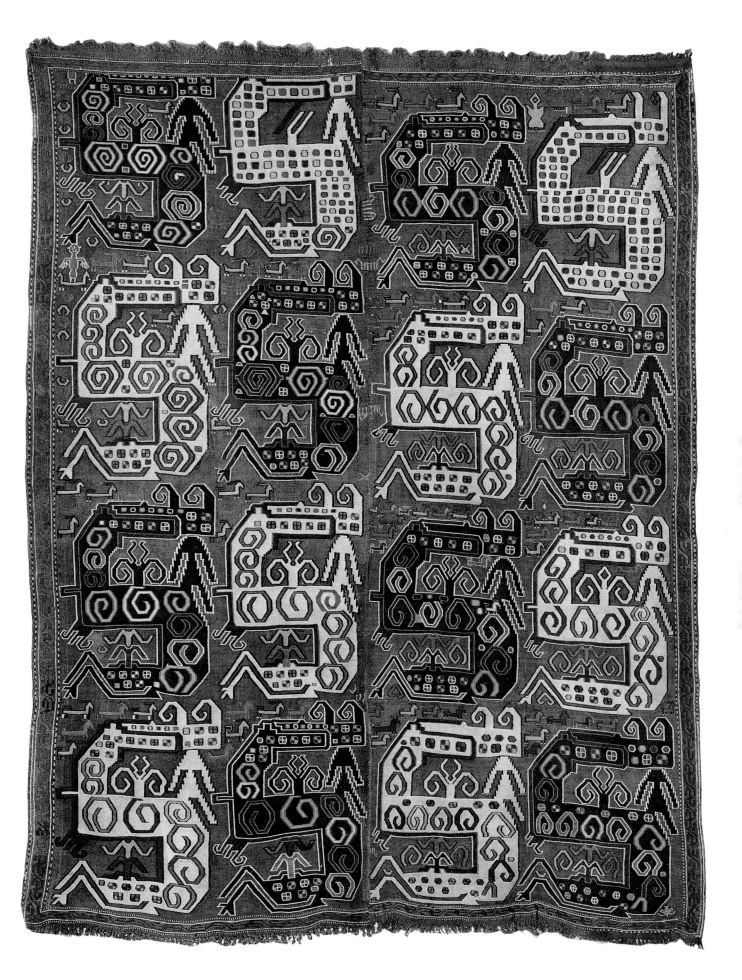

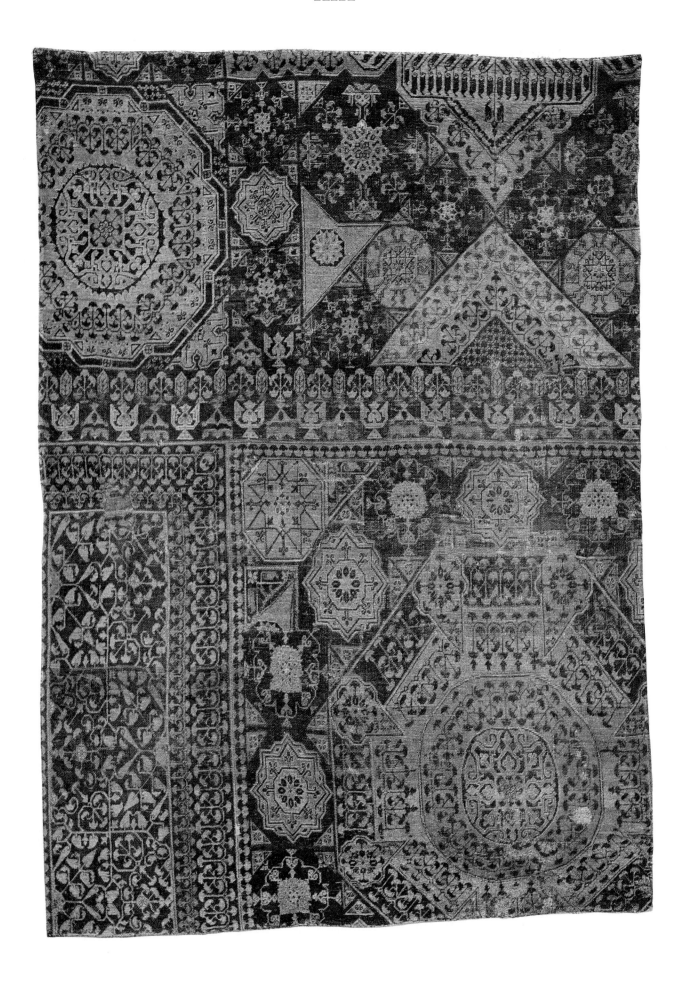

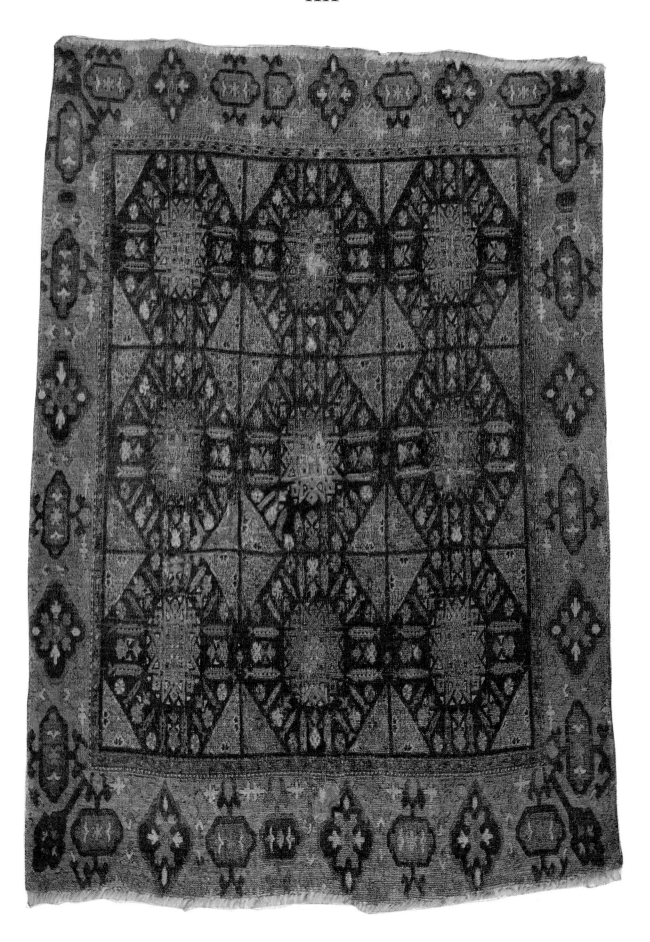

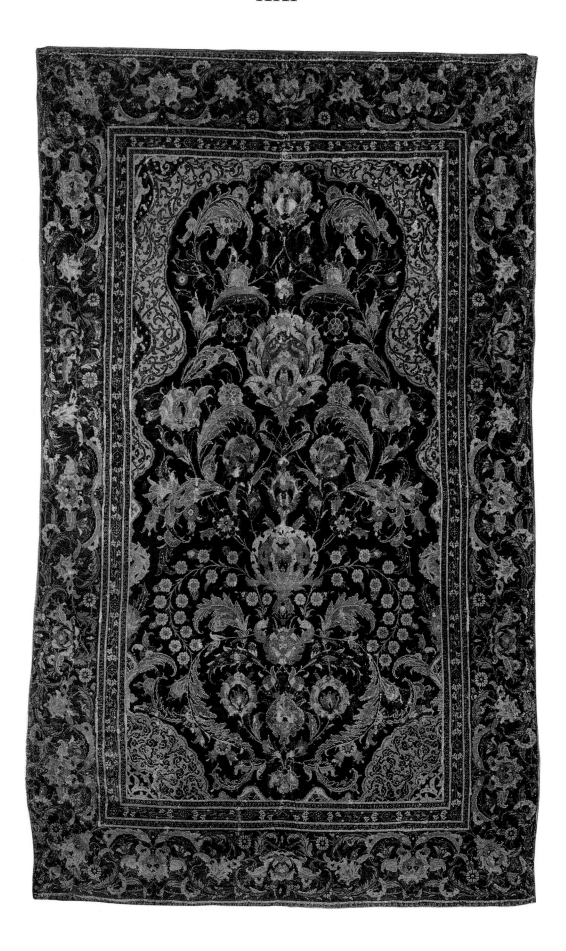

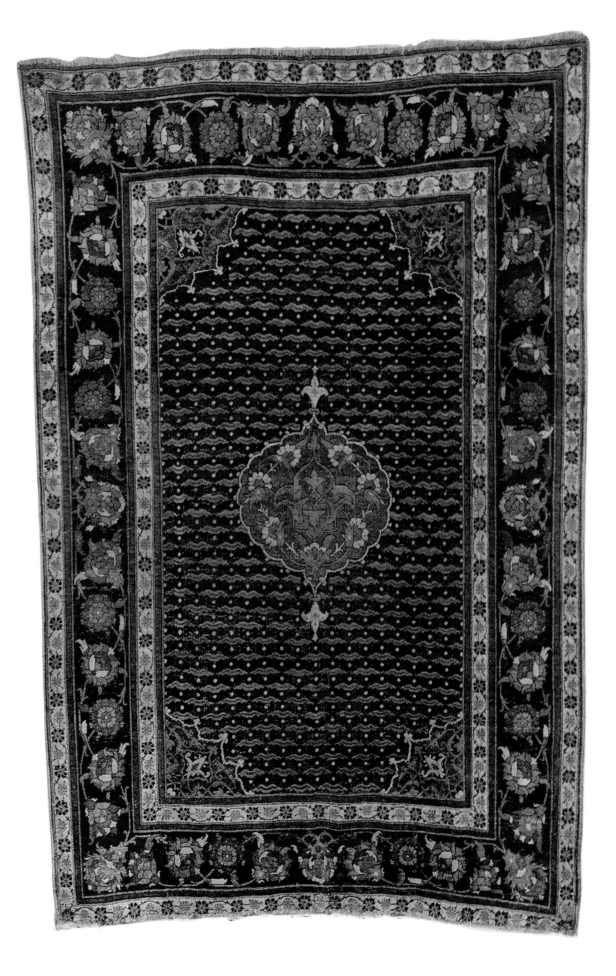

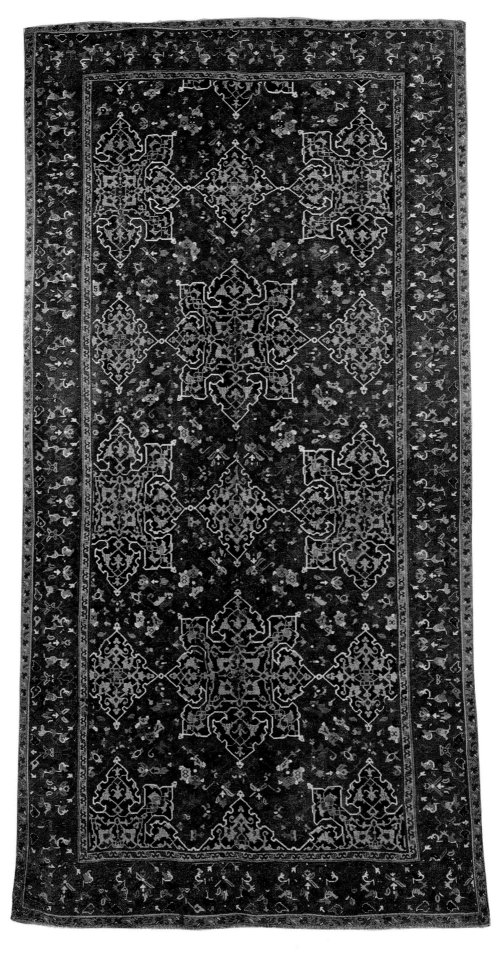

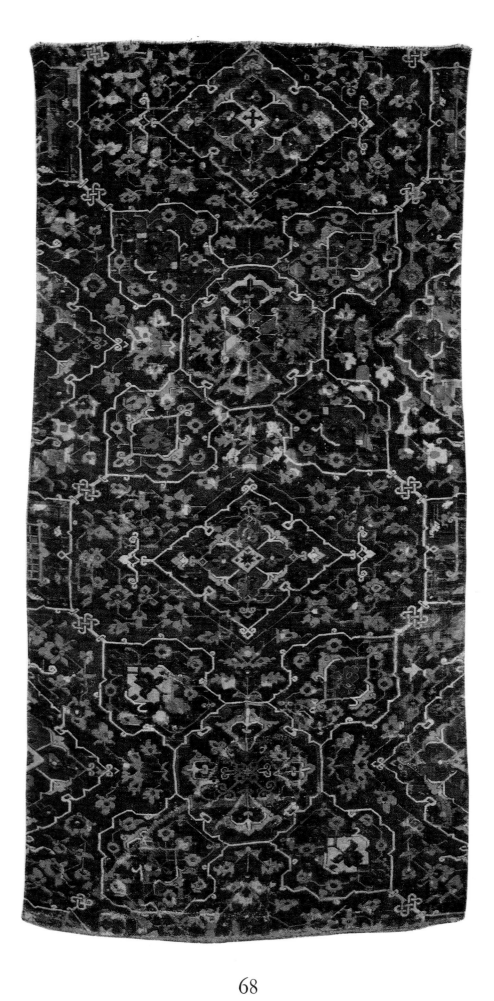

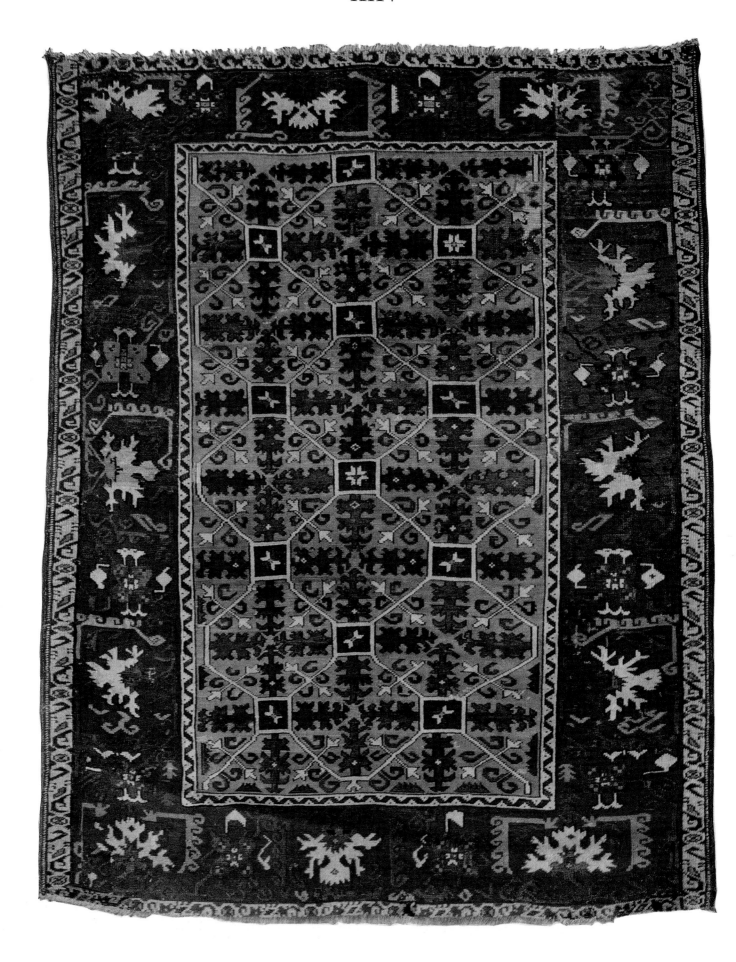

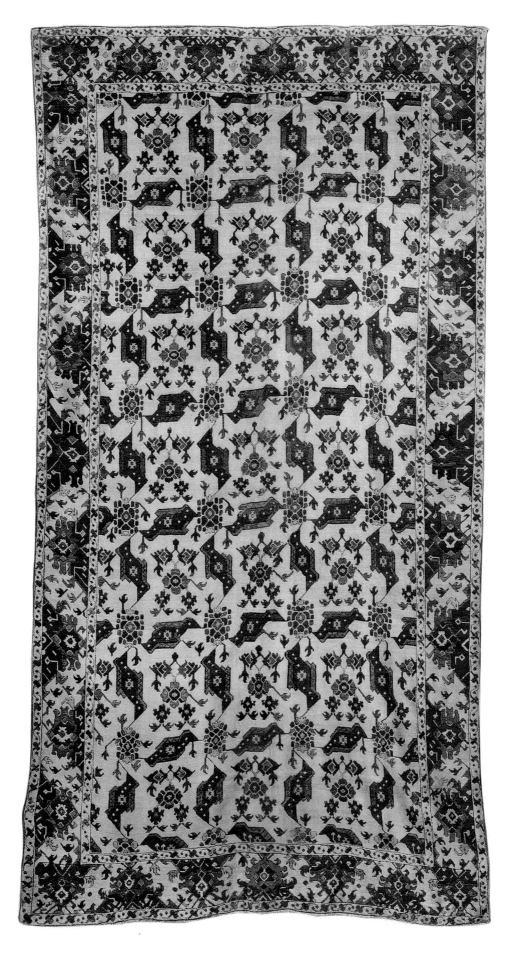

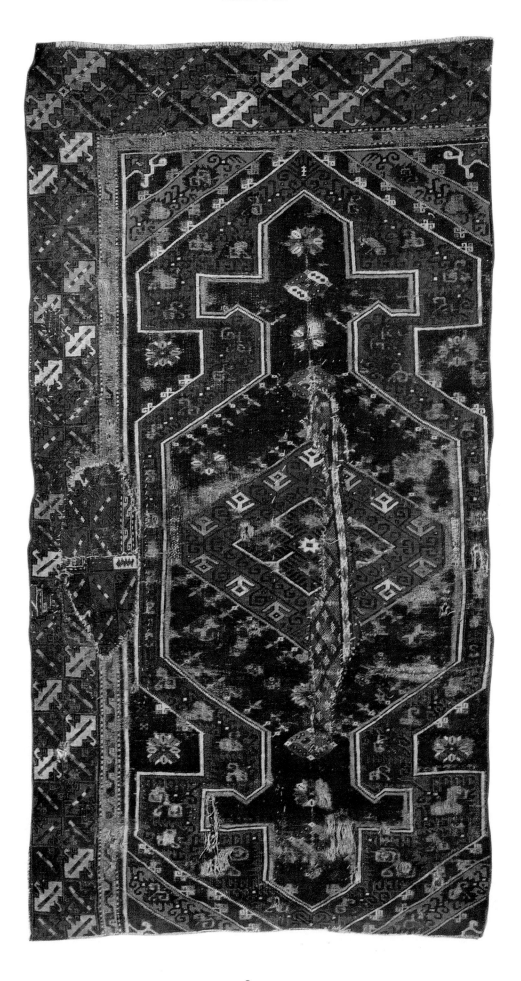

80

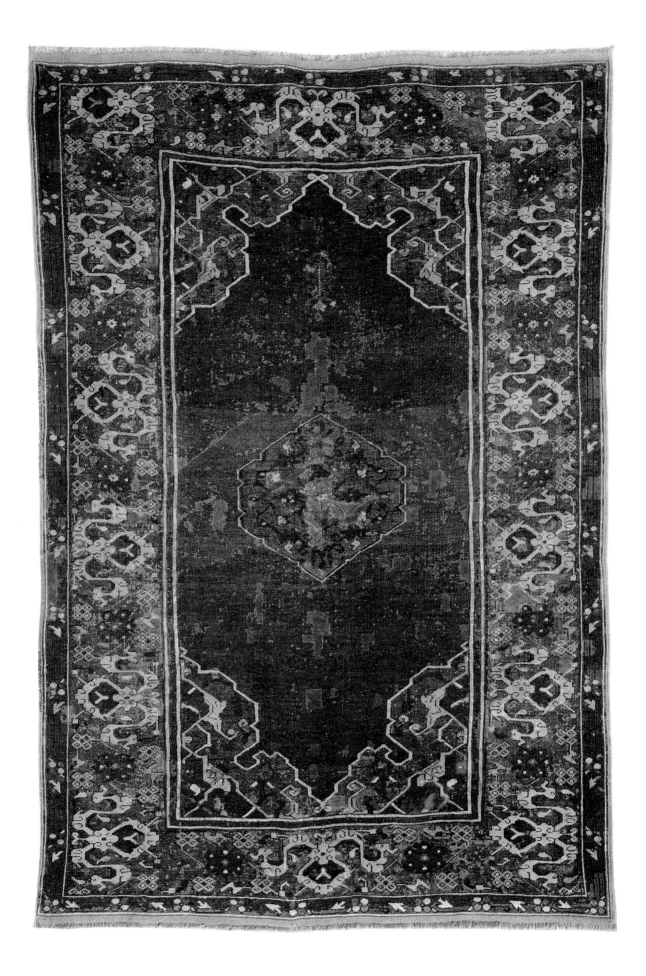

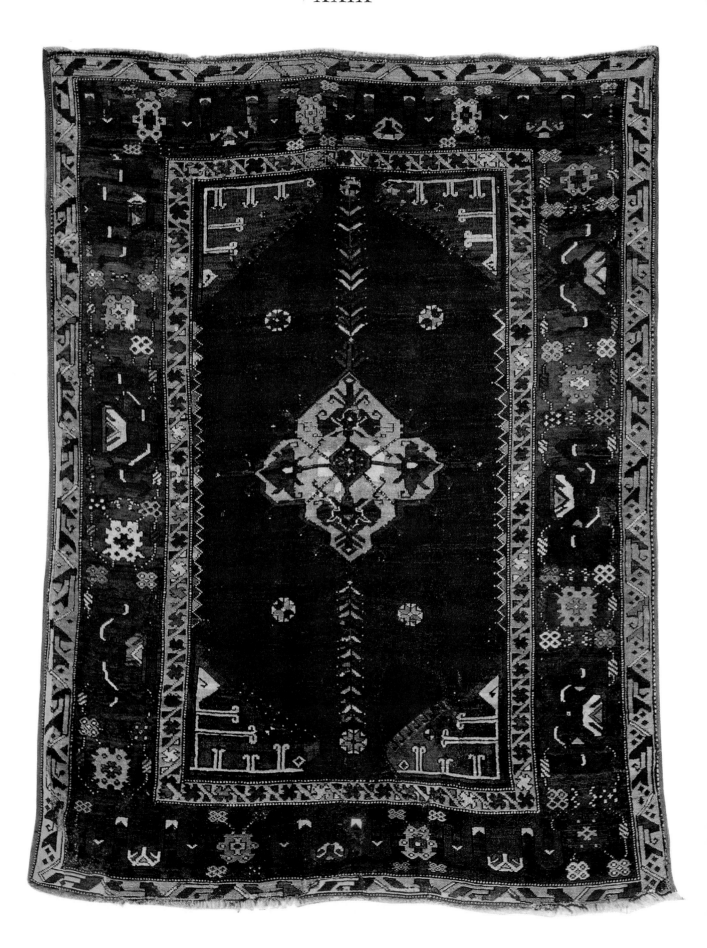

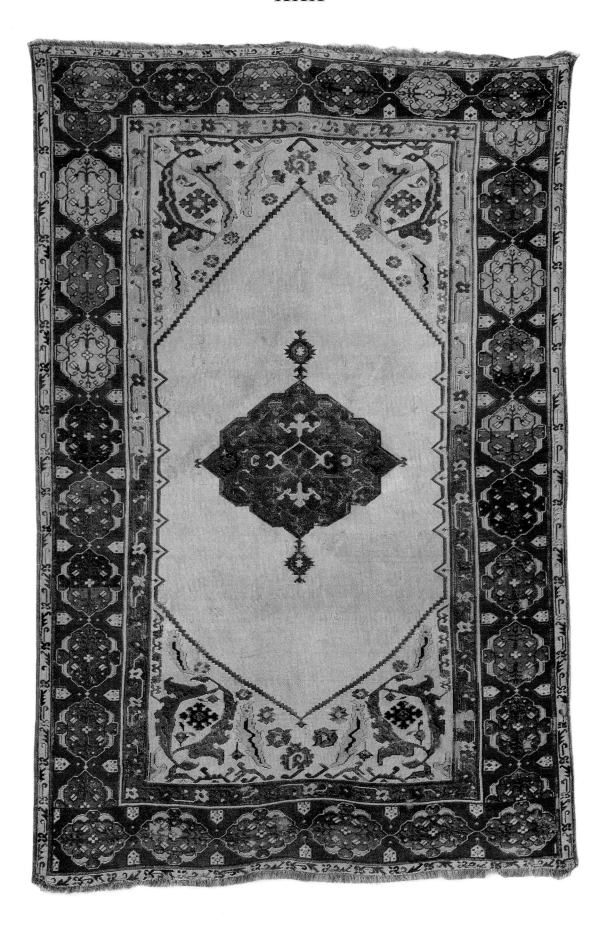

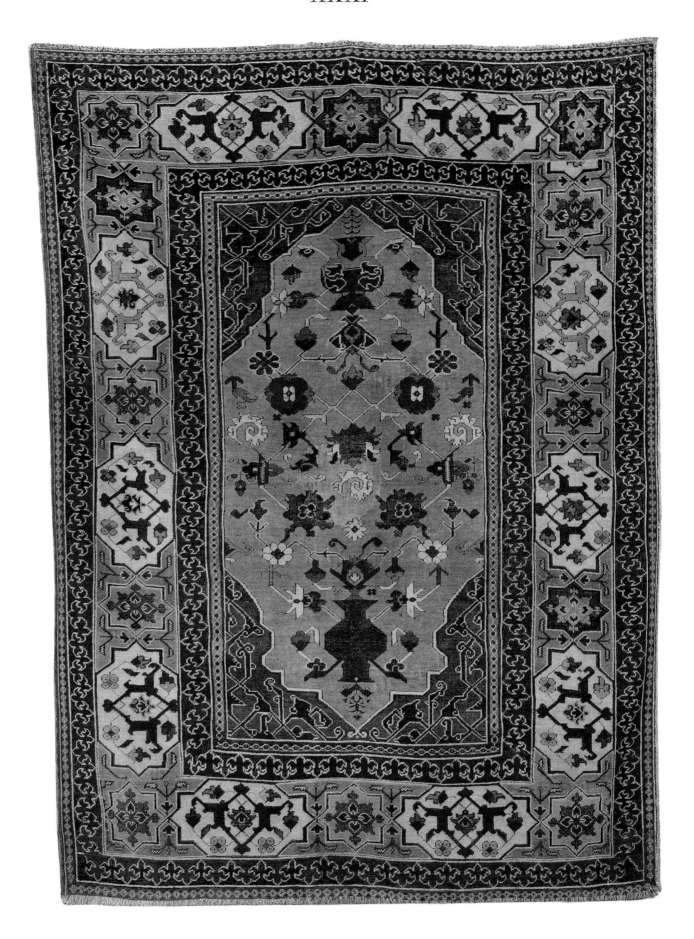

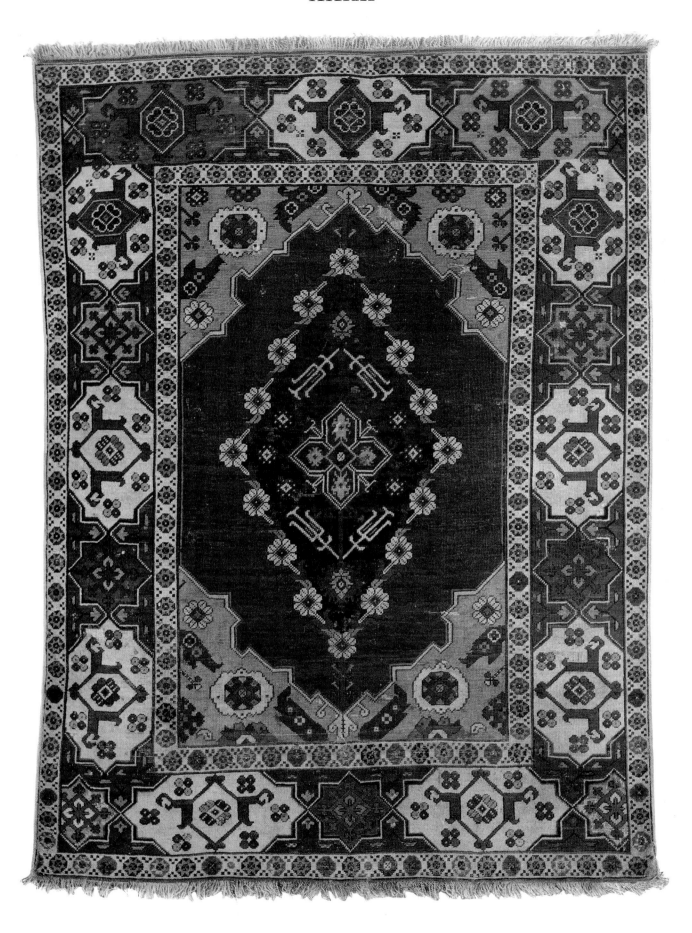

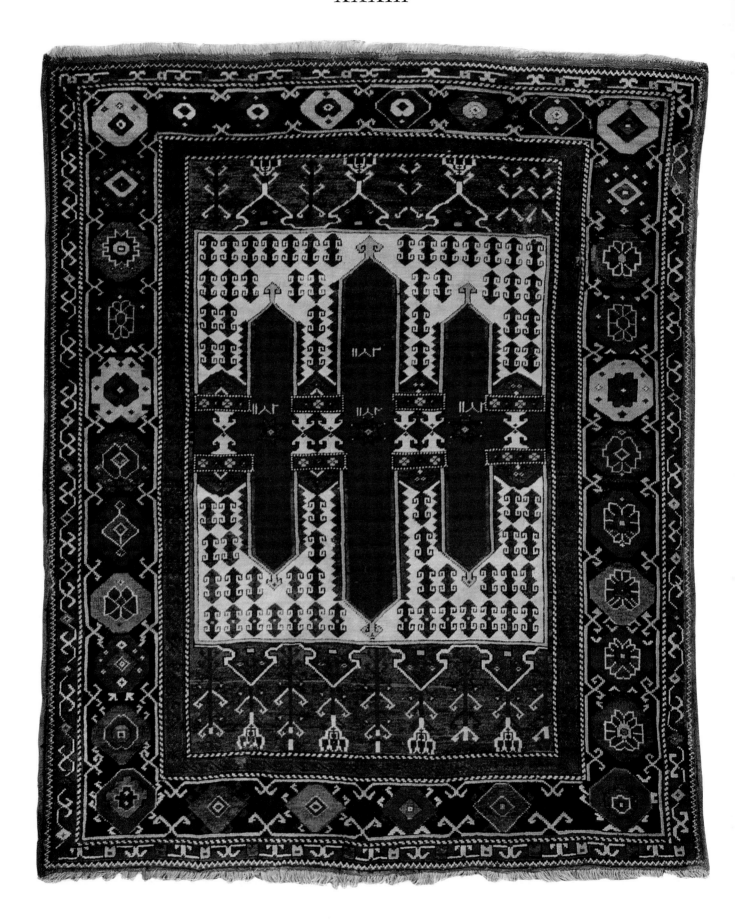

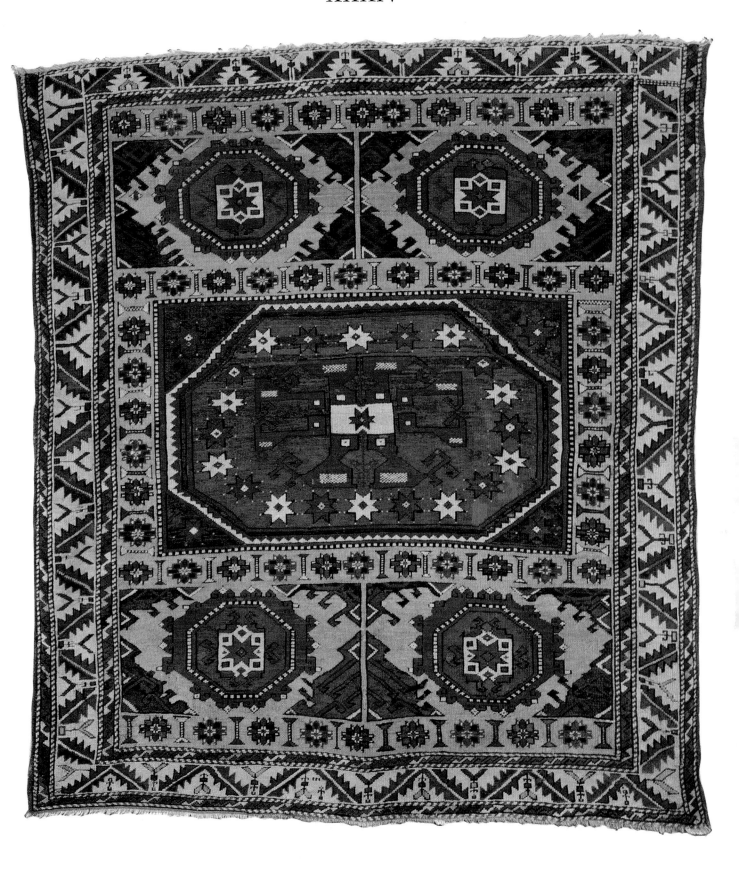

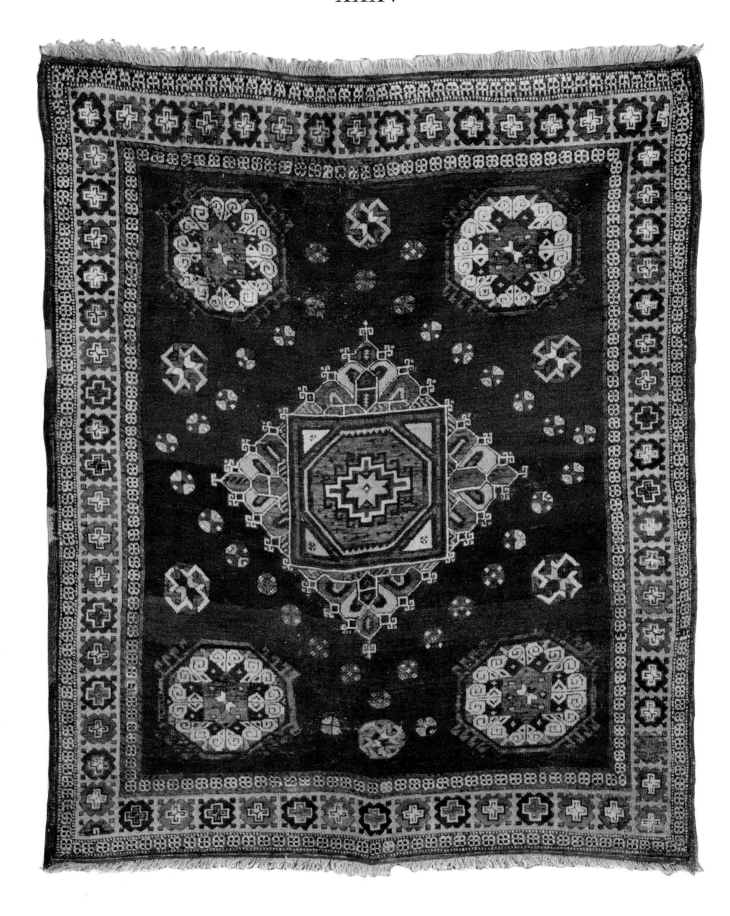

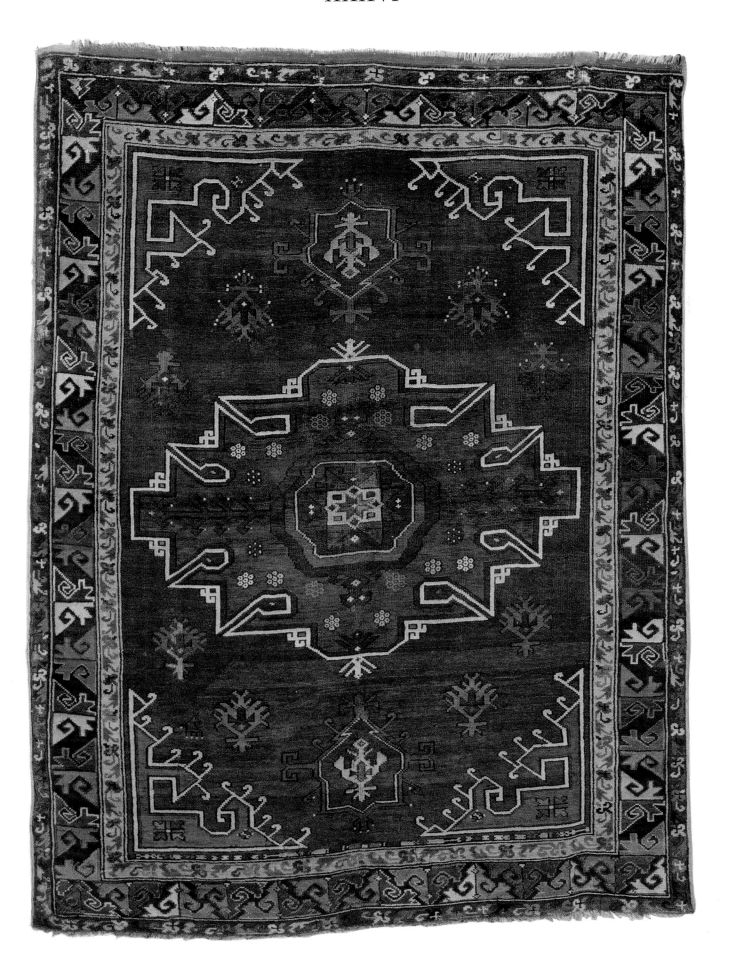

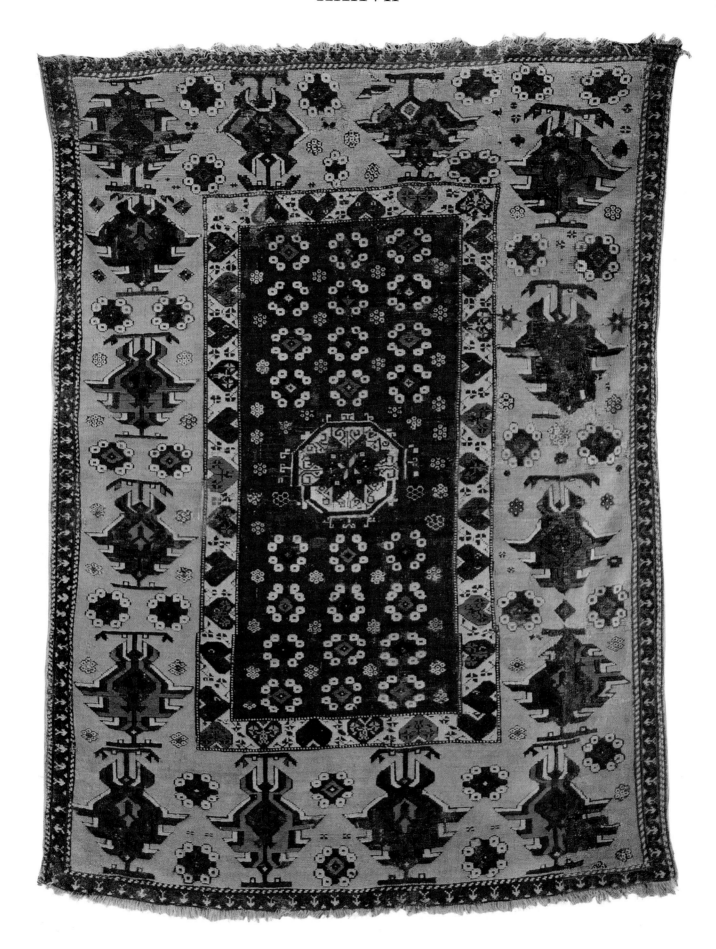

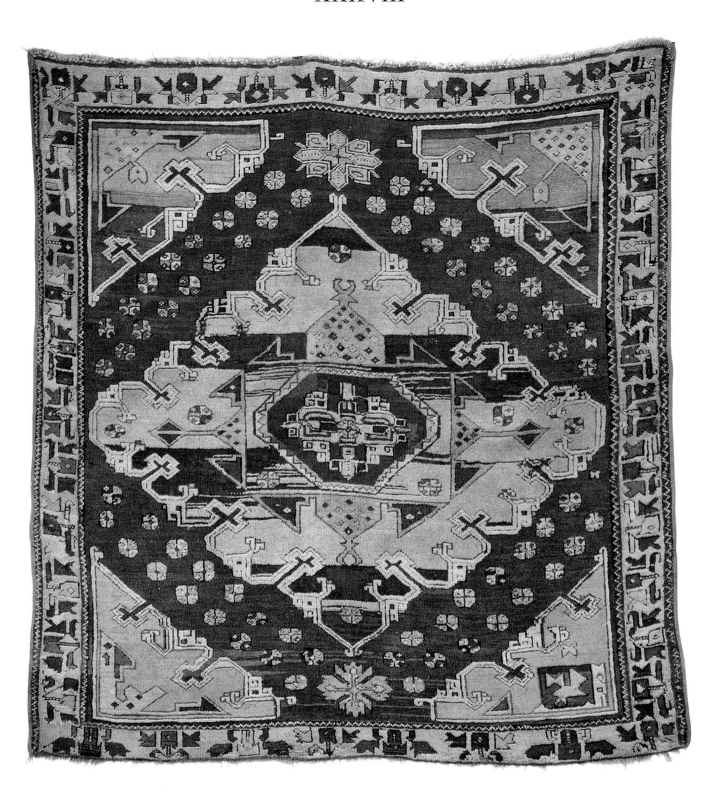

97 a

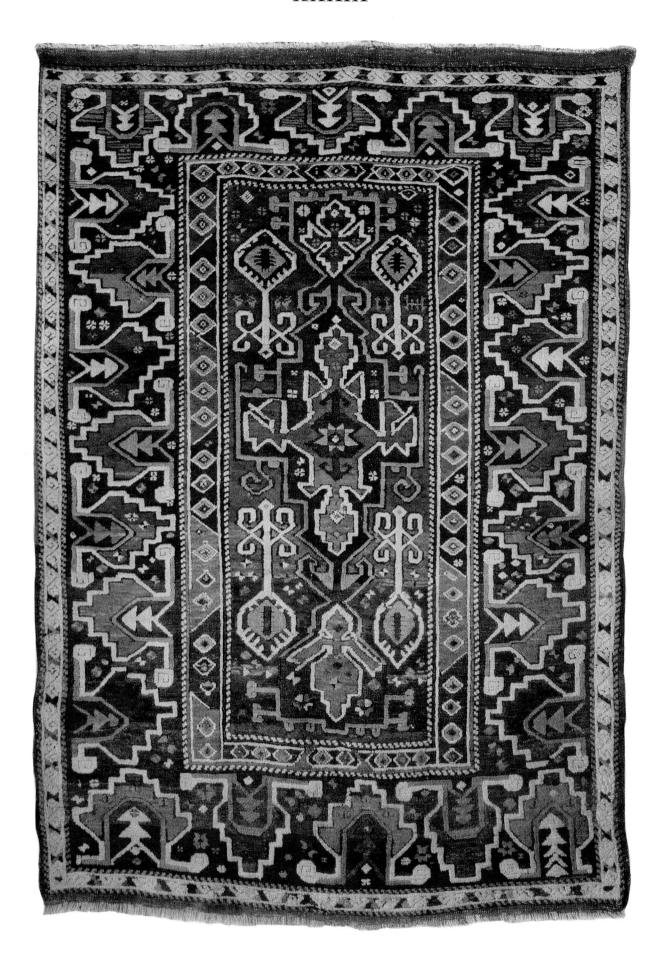

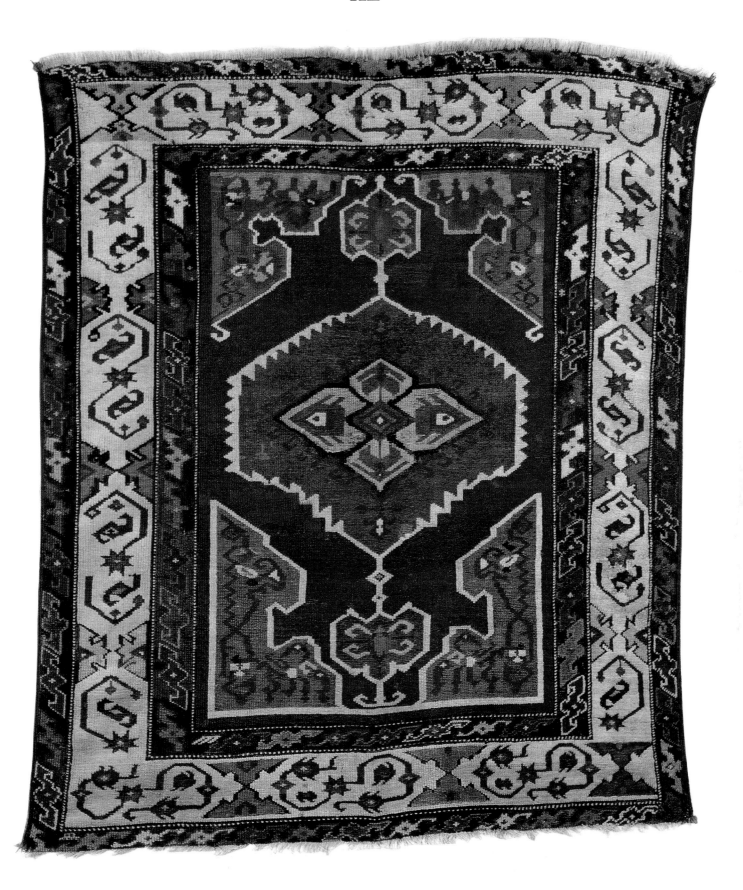

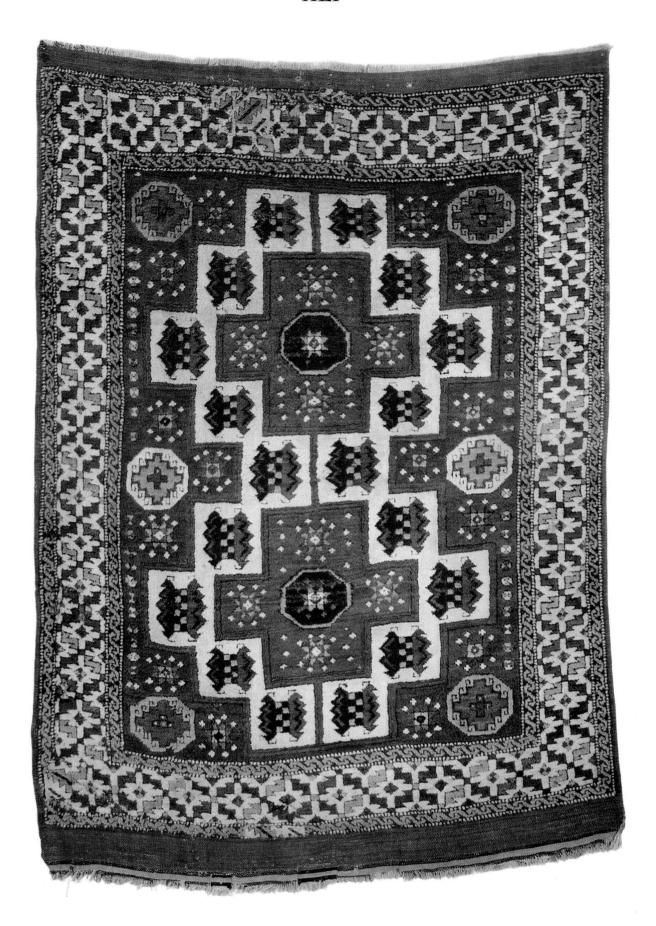

105 a

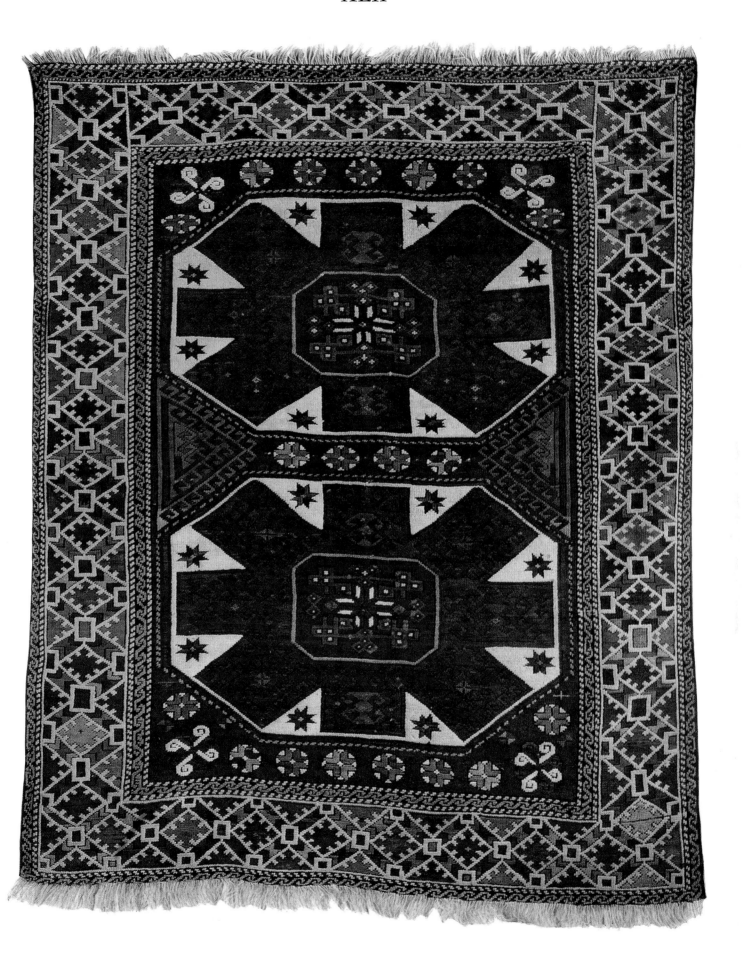

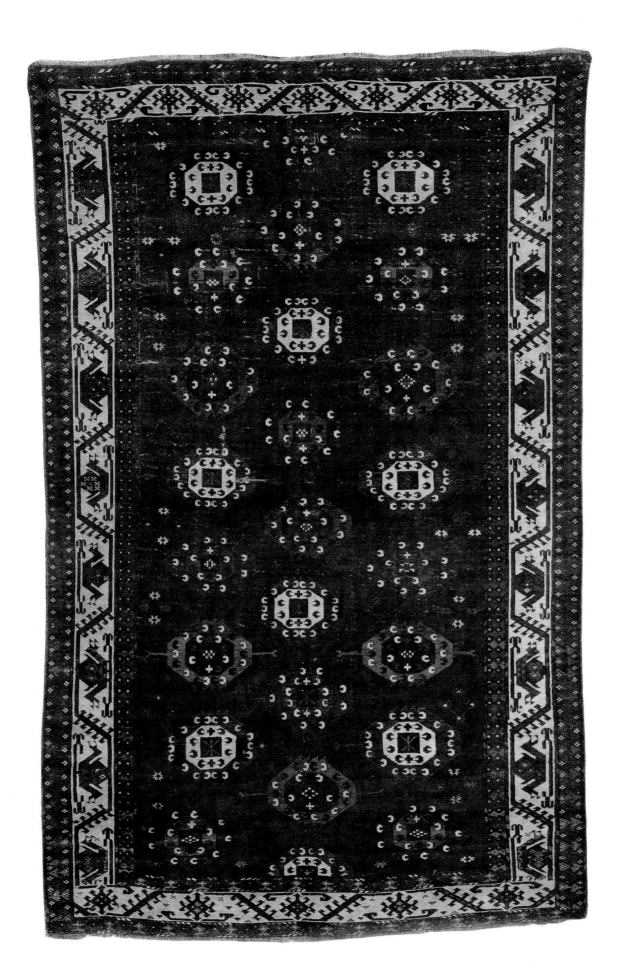

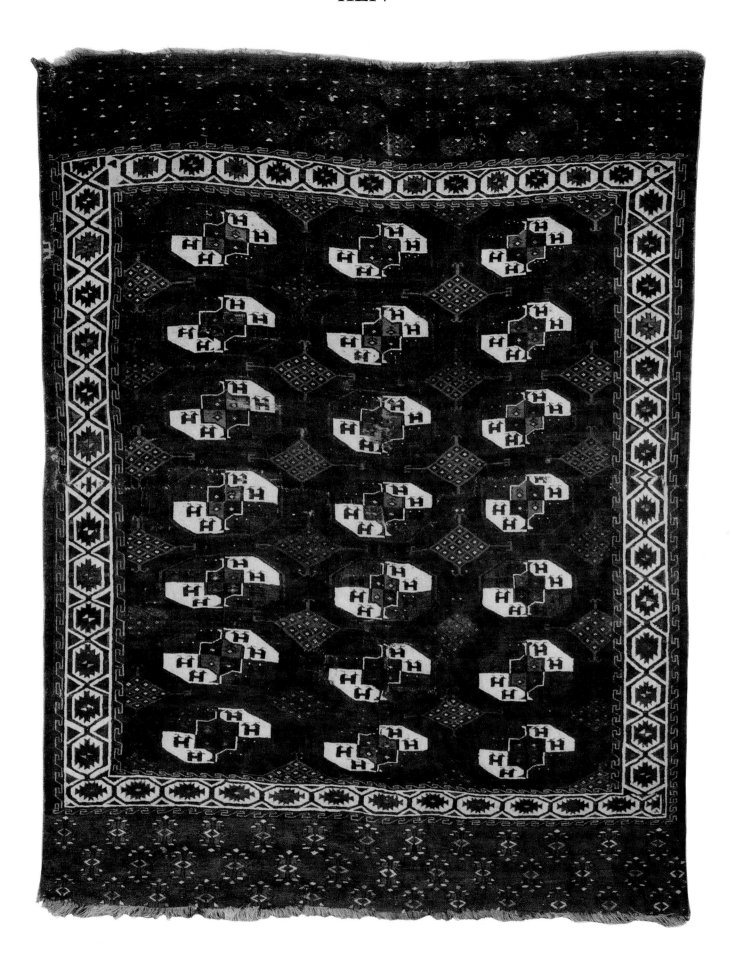

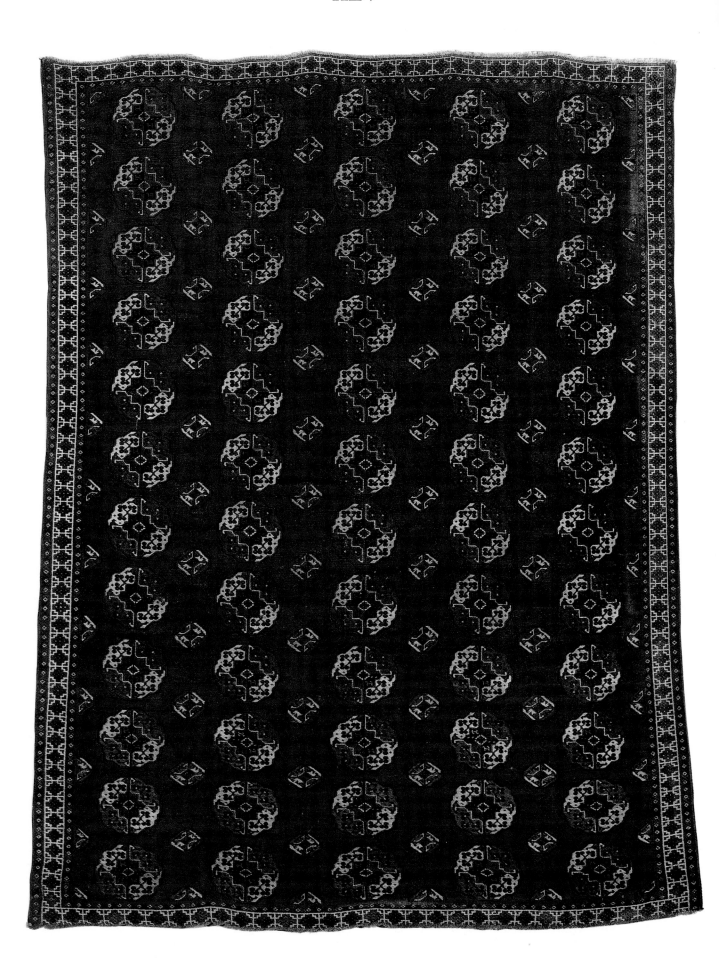

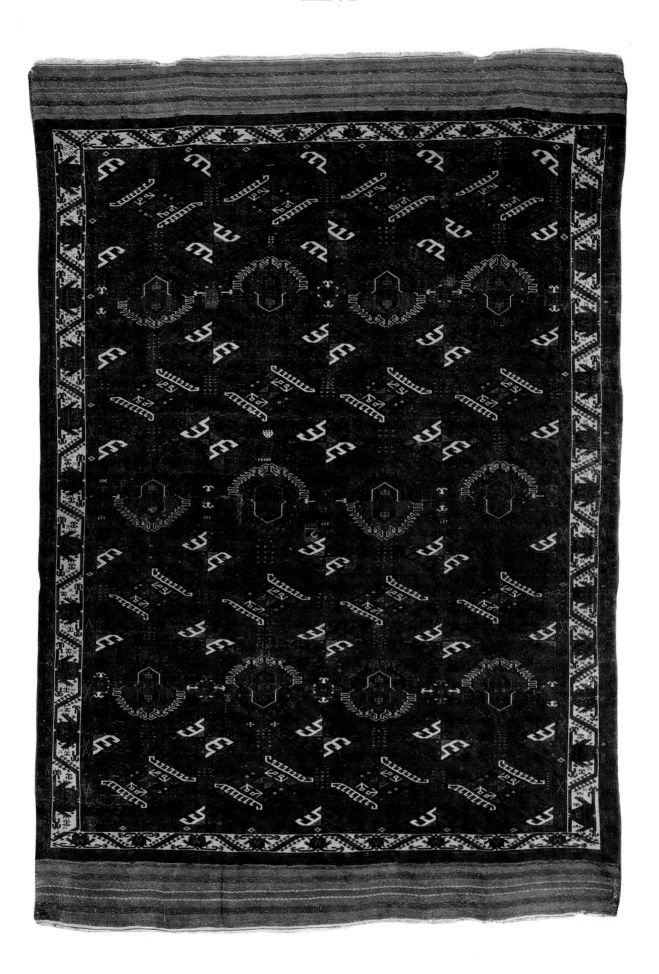

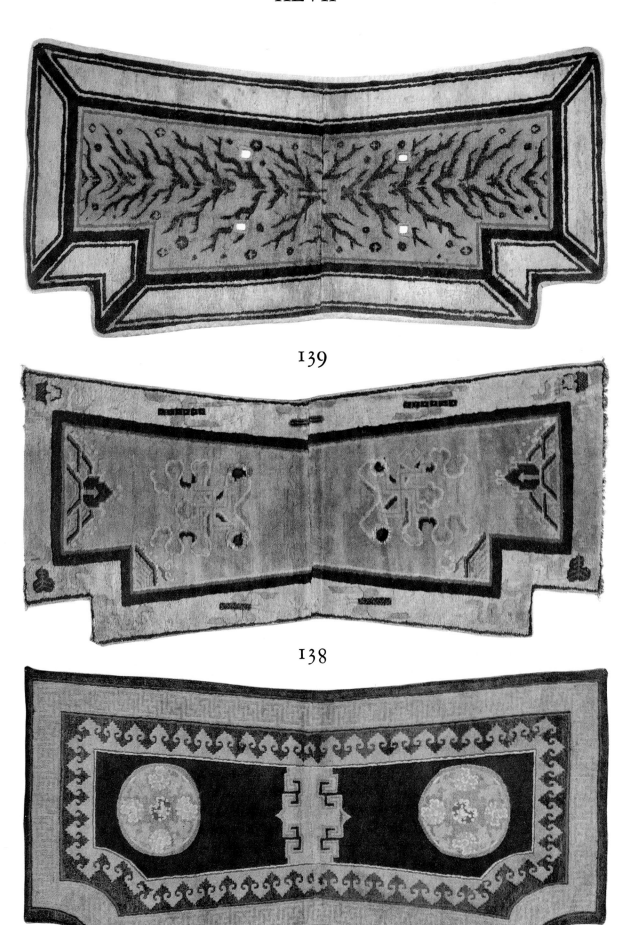

139

138

144

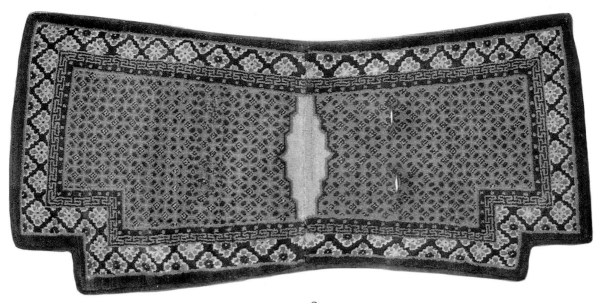

148

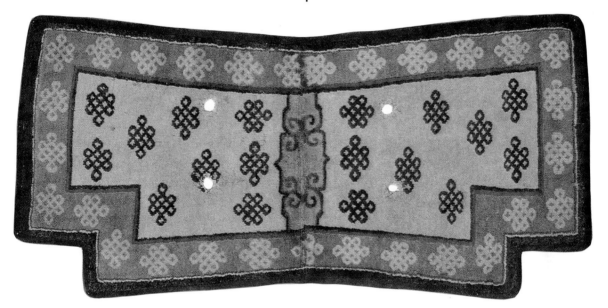

147

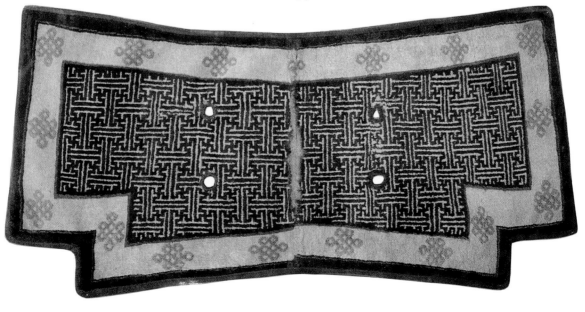

149

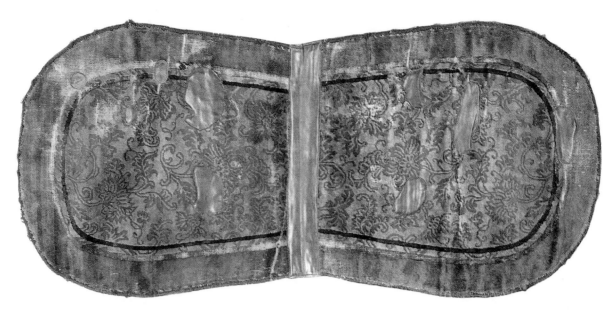

135

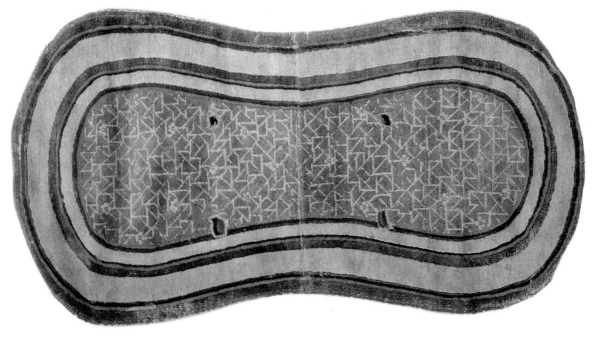

137